CW00957279

TRAVEL
PHOTOGRAPHER'S
WAY

PRACTICAL STEPS TO TAKING
UNFORGETTABLE TRAVEL PHOTOS

NORI JEMIL

Bradt GUIDES

First edition published October 2021
Bradt Guides Ltd
31a High Street, Chesham, Buckinghamshire, HP5 1BW, England
www.bradtguides.com
Print edition published in the USA by The Globe Pequot Press Inc,
PO Box 480, Guilford, Connecticut 06437-0480

Text copyright © 2021 Bradt Guides
Photographs © Nori Jemil and other photographers
Project Manager: Anna Moores
Design: Pepi Bluck, Perfect Picture

The author and publisher have made every effort to ensure the accuracy of the
information in this book at the time of going to press. However, they cannot
accept any responsibility for any loss, injury or inconvenience resulting from
the use of information contained in this guide. All rights reserved. No part of
this publication may be reproduced, stored in a retrieval system, or transmitted
in any form or by any means, electronic, mechanical, photocopying, recording
or otherwise without the prior consent of the publisher.

ISBN: 9781784778507

British Library Cataloguing in Publication Data
A catalogue record for this book is available from the British Library

Photographs
Front cover Grand Canal, Venice after sunset
Author photo (page 3) Michael Wyatt
Part openers Pages 16-17: Travertine terraces, Pamukkale, Turkey; Pages 54-5:
Elephants, Serengeti National Park, Kenya; Pages 370-1: Magellanic penguin,
Tierra del Fuego

Typeset by Pepi Bluck, Perfect Picture
Production managed by Zenith Media; printed in the UK
Digital conversion by www.dataworks.co.in

AUTHOR

An award-winning travel photographer, **Nori Jemil** is also a writer, teacher and videographer. Her work has appeared in numerous publications, including *National Geographic Traveller*, *BBC Travel*, *Conde Nast Traveller* and *Telegraph Travel*. Nori was named Photographer of the Year in 2017 by the British Guild of Travel Writers. She's won other accolades, including *Wanderlust* magazine's Photograph of the Year in 2011. She teaches film and photography in London and on specialist overseas tours, most recently in Patagonia and Iceland. Her photos have been exhibited in London, Milan, Barcelona and Madrid.

Alongside her regular contributions to *National Geographic Traveller UK*, Nori helped to judge their 2019 photography competition and has presented photography sessions for the past three years at their annual travel Masterclasses. In addition, she takes on regular public speaking engagements at travel events and as part of National Geographic Traveller's Travel Geeks programme.

CONTENTS

PART 3: BACK HOME

SHARE YOUR PHOTOS WITH US

Have you been inspired to take Nori's book on the road with you? Why not write and tell us about your experiences using this guide? You can send your feedback to us on **t 01753 893444** or **e info@bradtguides.com**. Alternatively you can add a review of the book to **w bradtguides.com** or Amazon. Please also share your photos with us on Twitter, Instagram and Facebook, and remember to tag us!

f **Bradt Guides** & **NoriJemilTravel**
𝕏 **@BradtGuides** & **@AndeanImaging**
◎ **@bradtguides** & **@nori.jemil.travel**

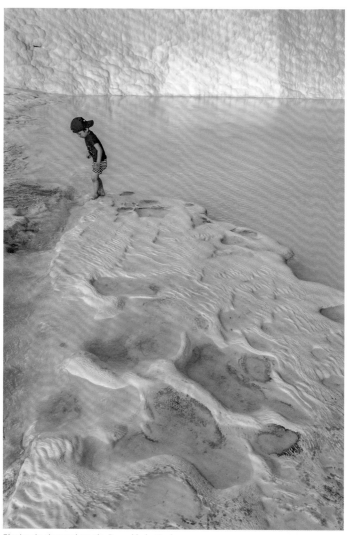

Playing in thermal pools, Pamukkale, Turkey
DSLR, 16MM, 1/160 SEC, F7.1, ISO 100

WAITING
ON A HILLSIDE

I'm hunkered down on a hillside in southern Turkey. My tripod stands on a limestone ledge, while my own feet are immersed in thermal water that flows gently from a small opening in the rock and down to the valley below. I'm waiting, looking out over the shimmering terraces of Pamukkale's turquoise pools, taking in the splendour of the landscape and the small town beneath.

Photographers tend to do a lot of waiting, but being in the big outdoors is one of life's great pleasures. It's no hardship for me, though it can be a little tough on a travelling companion, checking their watch every now and then, stomach rumbling with the distant hope of a cold beer or a hot meal. That's why this time I'm here alone.

There's hardly a soul around, but intermittently someone appears; a couple taking selfies, and a person who wades in too far and is whistled at by a hitherto unseen security guard. Then a crew of three photographers usher forward a just-married couple. If I wasn't certain before about my location, I am now – local photographers always know the best spots.

'*Merhaba*', we greet one another, and in sideways glances check out our respective photographic kit, trying to fathom how 'professional' we are just from branding and camera models. It doesn't take long to size up a fellow photographer and it can be a fun game to play, though unnerving perhaps for someone starting out.

It's a truism that the best camera is the one you have with you, so perhaps the pressure to be heavily kitted out shouldn't be felt so keenly

by beginners, especially in this era of fast-developing smartphone and camera technology. I was once told if my tripod was so heavy I might strain a wrist setting it up, I'd most likely leave it back in the hotel anyway. Travelling light is something we should aim for.

I have to admit that I trudged along this ridge a few days ago in the heat of the sun, lugging my own heavy gear and doing a recce for the perfect location. In my defence, I am here to photograph a story of culture and life in Turkey for a travel magazine, so though I've been as efficient as possible, there is still some considerable metal bulk about my person. I'm trying to scale it down, I really am, but the dichotomy is that photographers need to be well prepared.

On the outskirts of the site, with people and 'civilisation' thinning out, I come across the finest spot of all. It occurs to me now – as it has over the past few years – that photography is often about being in the moment. Yes, we need to plan ahead, but there's a balance between preparedness and our ability to react. There's something magical that often gets us in the right place at the right time. And the idea that knowing everything about the technical side of things – aperture, shutter speed, exposure metering and depth of field – will result in a perfect image is both over-simplifying and overcomplicating matters. Yes, of course, one needs to understand the technology, but we also need a sensory awareness and a sensitivity to people and place. Learning to look, knowing when to move and when to stop, and how to *feel* our way into a photograph, are all areas that are often swerved in favour of tangible, technical advice.

In fact, many travel photography books seem intent on top-loading the technicalities, with a mountain of information that needs ingesting, seemingly all at once. But the vast majority of what I've learned in my formative years of taking photographs has been experiential,

Miñiques Volcano and Lake Miscanti, Atacama, Chile >
DSLR, 70MM, 1/500 SEC, F11, ISO 200 >

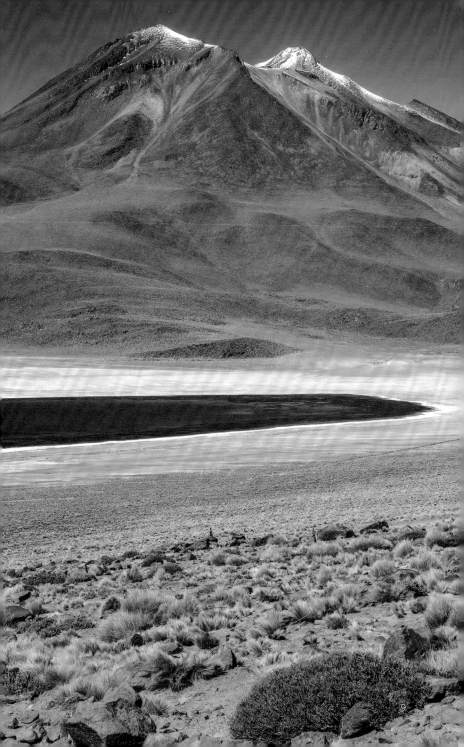

from travelling with other photographers and working things out practically because I wanted, or *needed*, to know how to do something. There's nothing like knowing you have a once-in-a-lifetime opportunity to photograph the ephemeral northern lights that will teach you to understand your camera's controls, and fast. And this is borne out too by my parallel life as an educator. Running workshops, teaching students and training teachers for more than 20 years has shown me that people learn most by doing, not by being told or given a manual to memorise (though they do come in handy, so please don't throw yours out!).

So what if there was a practical photography guidebook, something to keep in your daypack and travel with – a companion that offers help, encourages reflection and keeps you company on your sometimes solo endeavours? After all, standing on a hillside waiting for the light is just the place to consider why you're here – to capture that one moment in the story of this particular journey.

Your eye must see a composition or an expression that life itself offers you, and you must know with intuition when to click the camera. That is the moment the photographer is creative. Once you miss it, it is gone forever.
HENRI CARTIER-BRESSON

HOW TO USE THIS BOOK

WHAT THIS BOOK ISN'T

As a photography guide, this is not intended as a weighty, technical tome. Apart from the obvious difficulties of keeping pace with rapidly evolving technology, those books already exist, and have in many ways been superseded by online guides and video blogs. From downloading a digital camera manual to Googling 'How to take photos of the Milky Way', everything you need is already digitally at your fingertips.

It would also be folly to imagine that one book could contain the 'answer' to what decades of photographic practice might teach us. We're all at different stages of our development, and our pace will alter as life events and the time we can devote to our passions ebb and flow.

What's more, while the internet can demystify many aspects of the photographic process, it doesn't help to be given technical advice out of context. One of the best ways to improve camera know-how is to take a course or, better yet, travel with a guide who'll troubleshoot, should problems arise. When learning is done gradually, as part of a physical experience, it's usually taken on board quite effortlessly and remembered long after the 'lesson'.

WHAT THIS BOOK IS

This book is intended as a companion on the road, with hints and prods to help you reflect and improve. It aims to guide the reader through all the steps required to become a more confident travel photographer. Technical advice is offered in bite-size chunks, spreading out the fundamental aspects of how to get the best from any camera and

If I like a photograph, if it disturbs me,
I linger over it. What am I doing, during the
whole time I remain with it? I look at it,
I scrutinize it, as if I wanted to know more
about the thing or the person it represents.
ROLAND BARTHES

contextualising important points, so you learn as you go. Each chapter has key photographs, with frank and full explanations, not just of *how* they were taken, but *why*.

And whether you take a linear journey in reading this or a more circuitous one, dipping a toe into landscape one month and street photography the next, this is intended as a book you can revisit. Learning is circular, from conceptualisation and experimentation, to concrete experience and reflection, with the odd failure along the way. On the road to becoming a competent or even professional photographer, none of us ever stops learning.

Part 1 will set out the basics and will help you to get your photographic house in order: from trip planning and organising photographic kit to photography terminology and the chance to get hands-on with your camera. In *Part 2* there are seven chapters that will take you on location,

moving through locales, from wild places to urban spaces. Through text and imagery, you'll travel the world, hearing the stories of key images – and the rationale and creative and technical choices behind them, with a section called **The Fundamentals** to unpick and explain any technical concerns. From equipment and practical logistics, to the challenges of photographing in unfamiliar destinations, each chapter focuses on a different type of travel photography. Yet the skills and principles are transferable across your photographic practice, from people to wildlife, though the level of difficulty builds as you progress. And after your seven-chapter journey around the globe, *Part 3* will talk you through editing and publishing options.

In the **appendix** you will find additional explanations that elaborate on some of the technical terms referenced within each of the main chapters, many of which have been highlighted in bold.

Finally, templates of shot lists and planning sheets used by filmmakers and professional photographers demonstrate how to break down your assignment, and will help to structure your work.

VOICES OF EXPERTS TO GUIDE YOU

There's advice from some of the best photographers in the business, many working as specialists in wildlife, food or travel. Reading their words, alongside expert voices of the past, we're encouraged to go beyond the often sought-after 'trophy' or award-winning image to explore the methodology and creative processes 'behind the lens'. Hearing photographers reflect on their practice will hopefully help to yield better images for us all, and allow for the development of a personal philosophy. Photography isn't just about clicking the shutter – it's a way of seeing the world, having a relationship with our subjects and finding our own identity and style.

THREE PHOTOGRAPHERS TO FOLLOW

And just to inspire you further, after each of the *General information* sections in *Part 2*, there'll be three additional specialist photographers to check out.

ASSIGNMENTS TO HELP YOU IMPROVE

Like most creative endeavours, great photographs come about through an alchemy of preparation, inspiration and technical know-how, so the more you practise, the more chance you have of everything coming together. With this in mind, assignments are set for each chapter in *Part 2*, with some reflections on how things might have gone, a checklist of key goals and achievements for each stage, and advice on how to move forward.

While these assignments will transport you around the globe, from Antarctica to the Arctic, you could just as easily use your home town as your world: substitute your local river for ocean photography, or a hike on Glastonbury Tor for adventures in Patagonia. With climate change at the forefront of all our minds, travelling locally is to be encouraged. If there's one good thing to come out of the Covid-19 pandemic it's the realisation that the world on our own doorstep merits more investigation and greater appreciation.

Wherever you travel, you'll begin to know your camera so well you won't need to think too much about the controls. More importantly, you'll start to intuitively feel what to do and cultivate your own distinctive voice, grasping what Henri Cartier-Bresson described in his book *The Decisive Moment* (1952) as the perfect time to act, without hesitation or fear.

JOIN

THE TRAVEL CLUB

THE MEMBERSHIP CLUB FOR SERIOUS TRAVELLERS
FROM BRADT GUIDES

Be inspired
Free books and our monthly
e-zine, packed with travel tips
and inspiration

Save money
Exclusive offers and special
discounts from our favourite
travel brands

Plan the trip
of a lifetime
Access our exclusive concierge
service and have a bespoke
itinerary created for you
by a Bradt author

Join here:
bradtguides.com/travelclub

Membership levels to suit all budgets

Bradt GUIDES

TRAVEL TAKEN SERIOUSLY

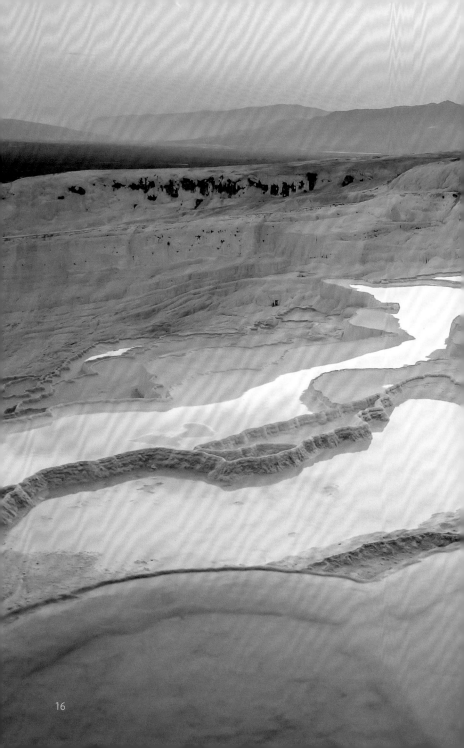

PREPARING
THE
GROUND

18

1

DO YOUR RESEARCH

All great photographs are the result of a few things coming together: the right time, right place and right conditions.

And this might just be the great leveller in travel photography – it doesn't matter how experienced you are, or how high-end your camera kit is, if the conditions aren't right, you're probably not going to get the photographs you've been dreaming of.

But this doesn't necessarily mean that Mother Nature has the upper hand – or that creating wonderful images is simply a matter of luck and chance. There is a lot we can control before we even pick up our cameras. Being in the *right place* at the *right time* comes about through careful research and planning. If you've done the preparation, your chances of being in a dream location at the optimal moment are hugely improved, so plan ahead and prioritise photography when devising any travel itinerary.

< Prayer man, Bhutan
< DSLR, 85MM, 1/250 SEC, F1.8, ISO 200

DO THE PREP

Professional travel photographers do extensive research before planning a trip, including calling up tourism boards or scouting for locations via photo libraries or Google Earth.

Their interest might even have been piqued by a chance encounter with a single photograph years before, and it could well be some time before a commission lands to make that dream destination and assignment a reality.

If there's time to dream, then reading around a location, learning a little of the language or discovering more about the cuisine that's connected to it are sensory ways of preparing. As we've all found from our virtual travels during the Covid-19 pandemic, this 'method acting' equivalent of travel immersion means we can have an almost-lived experience of a place we've not yet set foot in.

DECIDING WHERE AND WHY

It might seem harsh, but you should probably question your motives before even beginning to think about booking a ticket. If you've decided you want to recreate images you've seen elsewhere of people in remote communities, parachuting into a place that doesn't know you, with a large lens and limited time, is not going to serve anyone well.

You might also want to consider how ethical it is to photograph in popular destinations. Instead of visiting a town that sees thousands of visitors every week, perhaps choosing somewhere with a little less footfall could result in a trip that's transformational for you, as well as the community you interact with.

Are there peoples whose stories are seldom told, that might serve as more interesting subjects? It's a fine balance to tread, but it often seems to be the case that towns and villages off the beaten track can be

Transformation requires that we explore ourselves
even as we explore the world. When we recognize
that our perspective defines our experience,
our participation matters, and by setting intention,
being mindful, reflecting, and applying the benefits
back home, travel becomes transformational.

JAKE HAUPERT

more welcoming and photographic subjects more amenable than those who've been at the centre of tourism for decades. You're also more likely to come away with original images, rather than the usual Instagram fare – and that will increase your chances of getting published too.

Joining a group tour where photography isn't front and centre might seem like it will take the strain out of planning, but you'll be constantly on the hop, reacting when and wherever you can to what's around you – passive and at the mercy of everyone else's whims. It can be incredibly frustrating to be sitting on a bus as you pull out of a town just when the

light begins to glow on a mountainous backdrop. Tour guides will want to keep everyone well fed and safe, so your poetic remonstrations on the 'heavenly light' will be politely ignored as it fades into the distance, with your distraught face pressed to the glass. If you do join a tour that isn't dedicated to photography, look carefully at the itinerary and the amount of time allocated to each spot. If it looks like you won't have room to manoeuvre, think at least about adding some days at the start or the end of the trip, or forego one or two of the group meals.

STAY LONGER

One of the best bits of advice I received at the start of my career was to stay in one destination for longer, to allow enough time for conditions to be just so. As you plan your journey, allocate time to bed down in one location – whether that's a landscape for a series of sunsets or a

What is that feeling when you're driving away from people and they recede on the plain till you see their specks dispersing? It's the too-huge world vaulting us, and it's good-bye. But we lean forward to the next crazy venture beneath the skies.
JACK KEROUAC

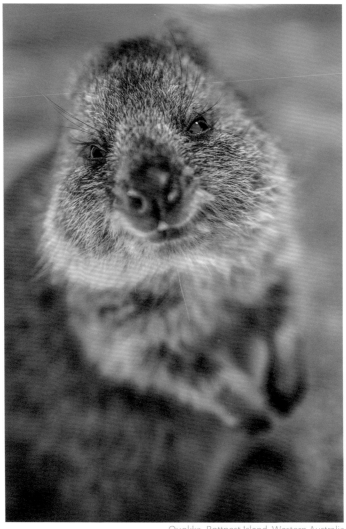

Quokka, Rottnest Island, Western Australia
DSLR, 16MM, 1/500 SEC, F2.8, ISO 100

No changing of place at a hundred miles an hour will make us one whit stronger, happier, or wiser. There was always more in the world than [wo]men could see, walked they ever so slowly; they will see it no better for going fast. The really precious things are thought and sight, not pace.

JOHN RUSKIN

town for the weekend's festivities. Get to know your destination. Making a photograph should be a process of immersion – in a place for long enough to feel a connection, or by building relationships through conversation or time. It's true for all travel, but fundamental for photographers – unhurried journeys will reap all sorts of benefits, so ensure slow travel is part of your itinerary whenever possible.

CHOOSE YOUR SEASON

Natural light and the length of the day will vary with the season, as will weather patterns and the behaviour or prevalence of wildlife. Deciding on your photographic priorities will help you determine exactly when to go. Reputable travel photography tours are always organised with these considerations in mind, but do your own checks too.

HAVE TIME TO GO SOLO

Think carefully about who you choose to travel with. Of course, it's wonderful to have your partner or a close friend along for the ride, and you'll doubtless have no shortage of offers to accompany you when excited friends see you packing your kit for Kyrgyzstan! But travelling alone is what most working travel photographers prefer. It's easy to be distracted when you are chatting away, and mostly impossible to 'see' what potential photographs are around you. Feeling your way in a destination is not about hitting the hotspots that everyone has photographed before you, but sensing the atmosphere, staying attuned to changes in weather or picking up local advice in a café while you're having some downtime. Those chance encounters happen more frequently when you travel solo – there's nothing like a lone stranger to attract hospitality and small acts of kindness. And it may well lead you down all sorts of exciting avenues you could never have planned for.

Our responses to the world are crucially moulded by whom we are with, we temper our curiosity to fit in with the expectations of others. They may have a particular vision of who we are and hence subtly prevent certain sides of us from emerging.

ALAIN DE BOTTON

Breakfast in Turkey
MIRRORLESS, 14MM, 1/250 SEC, F2.8, ISO 200

PLAN AHEAD

The best light is often when everyone else is having breakfast or dinner, and, while you'll be happy to eat snacks on the move or wait two days for the weather to improve, your companion may not. Ensure any travel buddies know exactly what your plans are and work in time for each of you to explore at your own pace.

Even better, travel with a group that's dedicated to photography, as everything will be optimised for seeing places when the light is at its best. Be warned though – it can be difficult to take original images if you're always side by side. Again, find time to head off on your own, to feel your way, and to find your subjects and compose shots without the pressure of someone looking over your shoulder.

REVISIT A DESTINATION

Many of us are inspired by new cultures and places we've never encountered before. For photographers though, going back to a familiar destination allows us to pick up where we left off, and removes any anxiety that we might have missed something important. You can prioritise where you want to go, safe in the knowledge that you've done your homework and photographed your key shots already. Time now to go off piste, and maybe even get a bit lost.

ORGANISE YOUR TIME LIKE A PRO

Once you've decided when and where you're going, it's time to start thinking about exactly what you want to photograph. With the initial research completed, you can draw sketches, write out a shot list of images you'd like to capture, and previsualise the 'hero shot' – maybe a particular landscape or landmark that is the inspiration for your journey. If you can pre-imagine those photographs, it's a simple matter

to devise a specific itinerary that prioritises where you need to be and when, with time for recces, to wait things out or to practise.

Once those dawn or golden-hour locations are mapped out, with daytime visits to museums or markets when outdoor light is at its harshest, your travel photography itinerary will begin to take shape. And those gaps in between are where you allow for flow – to relax and be in the moment, opening yourself up to spontaneity and on-the-ground inspiration. Oh, and yes, you might also find time for some fine dining or culinary experiences! Alternatively, just make like a pro, and fill the tiny spaces of your backpack with oatcakes, protein bars and tangerines, just in case that heavenly light reappears.

Now, with the best-laid plans in place, you can start to think about your kit!

Develop an ongoing relationship with the story, the place and the people. Return to a place at different times of the day, in different seasons.

BEN WELLER

Pudakul Aboriginal Experience guide, Kakadu, NT >
DSLR, 85MM, 1/640 SEC, F1.8, ISO 400 >

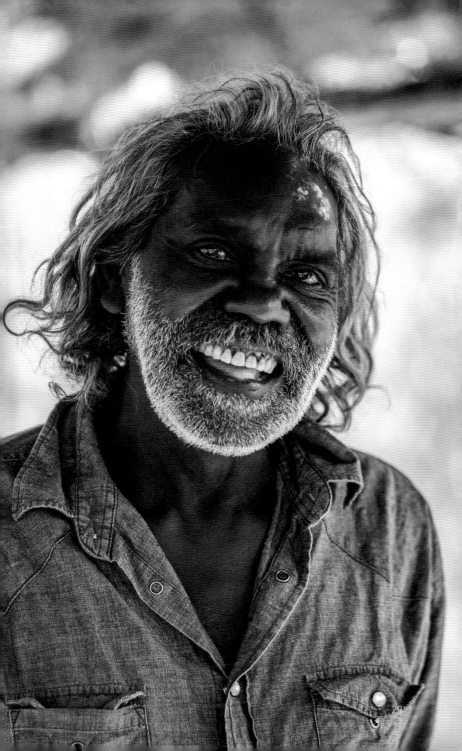

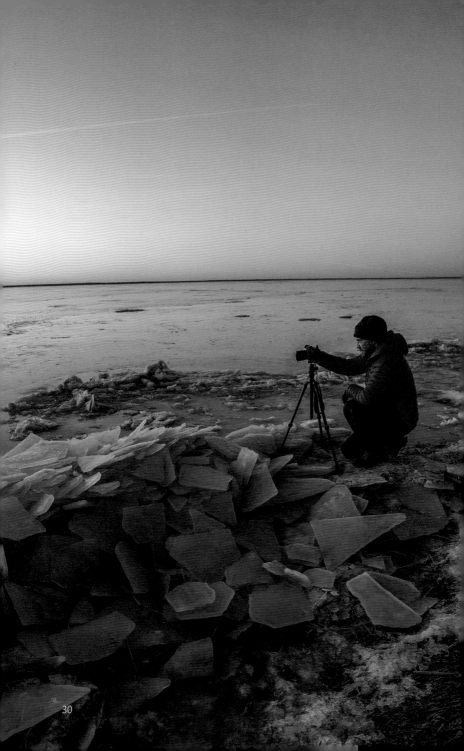

RIGHT TOOLS
FOR THE JOB

Now that you know where you're headed, it's time to sort out
your equipment. While it's a given that the best camera is
the one you have with you, it's also evident that great camera
optics and systems with up-to-date, low-light-capable **sensors** will
result in sharp images that are high resolution and full of detail.
So how do you decide what to take with you, and optimise the
equipment you do have, to get the best travel images?

If you follow any professional photographers on Instagram, then
you'll probably have seen one of those top-down images of what they
pack for an assignment. From a variety of changeable lenses to tripods,
flash guns, an extra camera body and a back-up compact camera, it's a
pretty picture that costs a pretty penny too.

But for travellers who don't aspire to become professional
photographers, a heavy investment in often hefty equipment isn't

< Photographing the sunrise, southeast Iceland
< DSLR, 16MM, 1/40 SEC, F22, ISO 110

The mere fact of transposing something seen to a photograph already implies a total invention: the recording of an unprecedented reality.

SALVADOR DALI

usually an option. You might think about hiring a telephoto lens for a special polar adventure, borrow a tripod for a short northern lights jaunt or perhaps buy a second-hand DSLR. I've also had many participants on day tours who only have a smartphone on them – any snobbery from well-kitted-out photographers is soon nipped in the bud when they see the results of what can be achieved – and that's only going to increase as technology evolves, with high-end Bluetooth lenses and lighting accessories.

However, if travel photography has become your passion and you want to invest in some professional kit, then start with the most important elements and build on them with every trip. Getting to grips with each new item is the key to being a better photographer – take it slow and learn your craft. Lenses, if used regularly, will begin to feel like an extension of your own vision – and your camera should feel so comfortable in your hands that you almost don't notice its weight and shape anymore, finding its dials and buttons with your eyes closed.

THE BASICS

Although no list can ever be exhaustive, this range of kit covers more or less what most photographers have in their bag of tricks:

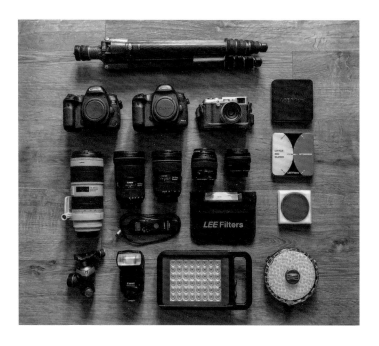

CAMERAS	DSLR, bridge, mirrorless, compact, smartphone
LENSES	From fixed and prime, to wide, zoom and telephoto
STABILISATION	Tripods, safari beanbags, gimbals and monopods
LIGHTING	In-camera, external flash guns and continuous LEDs
FILTER SYSTEMS	Graduated, ultra violet, neutral density and circular polarising filters

SPECIAL TRIPS AND PRIORITISING KIT

While professionals may own a huge range of kit, they're mostly as limited as anyone else when it comes to carry-on baggage or suitcase weight limitations. I often get asked what my go-to lens is, if I could only take one with me. And of course, there's no easy answer to that. If I'm largely working in a city, I won't prioritise a wildlife lens, and on safari, a wide-angle will be less useful at a distance. Prime lenses are usually much sharper and better quality than adjustable zooms – but can be weighty, providing fewer focal range options too.

It's always a difficult choice, and one that needs to take everything into consideration – how you plan to travel, how much you're prepared to carry and what the photographic priorities are. If you're just starting out, a good-quality lens that allows for some scope between wide and long range seems to be the best option. I usually travel with single wide, mid- and long-range lenses, and usually one prime, depending on the job. If you're unsure, talk to a local camera shop and explain where you're going and what you want to achieve when you get there.

Taking photographs can assuage the itch for possession sparked by the beauty of a place; our anxiety about losing a precious scene can decline with every click of the shutter.

ALAIN DE BOTTON

With some very reputable online equipment review sites and photography blogs, it's worth reading articles that compare and test new camera equipment as it comes on to the market.

And as we're trying to be mindful travellers, enjoying the journey and the experience of photography equally, it's worth saying that you shouldn't berate yourself when you realise you've arrived a bit under-equipped. Once you're in a destination make the best of what you do have with you, take a deep breath, and make a mental note to bring that extra lens next time.

PHOTOGRAPHING PEOPLE AND REPORTAGE

COMPACT, BRIDGE AND MIRRORLESS CAMERAS

A smaller mirrorless or compact camera often works best in street and reportage photography, putting people at ease and allowing photographers to work largely unnoticed. The best focal length for portraits is around 80–100mm; however, some of the fixed 35mm lenses on hybrid or bridge models are fabulous for street and reportage. If you're using a fixed lens, then you just need to use your feet more – which is very good practice for a novice photographer who wants to understand framing and camera angles in a physical way. More on this in *Chapter 4*.

PHOTOGRAPHING LANDSCAPES

WIDE-ANGLE LENS | DSLR | FILTER SYSTEM | TRIPOD

Landscape photography requires decent stabilisation, especially in low-light settings, a good **sensor** capable of recording sufficient detail, and usually a wide-angle lens. The typical **focal length** for landscapes, depending on the model and sensor, is somewhere between 16mm and 35mm. Most landscape photographers use a filter system to enable them to work when lighting conditions are at their most challenging.

A graduated **neutral density filter** (ND grad) darkens the sky, while keeping the other elements perfectly exposed, and stronger ND filters cut out more light for very bright situations. A cable or remote shutter release helps to curb camera shake.

PHOTOGRAPHING WILDLIFE

TELEPHOTO OR OPTICAL ZOOM | DSLR | STABILISATION

When it comes to wildlife, from breaching humpback whales to lions in the Serengeti, size really does matter. I prefer to use a DSLR for wildlife trips, as the weight helps to keep a steady hand, especially on a moving ship or when tracking a bird in flight. Monopods provide good stabilisation on the move, and can be used to support large lenses in a Zodiac, as can beanbags in safari jeeps. Serious wildlife photographers will use something like a 600mm lens, or possibly a teleconverter, a secondary lens attached between camera and main lens to enlarge the centre of an image. If you don't have a super long lens, then get creative, shooting the environment and the habitat too – many magazine photo editors prefer the big picture anyway.

PHOTOGRAPHING CITIES AND ARCHITECTURE

PHONE | COMPACT AND MIRRORLESS

Like reportage, working in urban settings is often easier with a compact camera. From city landscapes to interiors and historic buildings, you'll again want to go unnoticed, snapping atmospheric scenes without causing disruption. If you do set up a tripod, you may well be asked for your permit or requested to move on, so keep it light and handheld for more flexibility. Shoot architecture with a tilt-shift lens to keep vertical lines straight – some systems have this in-camera.

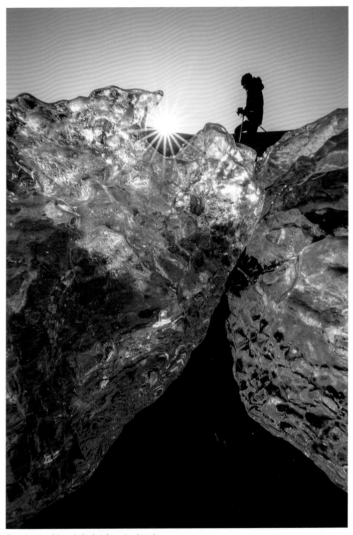

Sunrise and ice, Jökulsárlón, Iceland
DSLR, 16MM, 1/60 SEC, F5.6, ISO 200

PHOTOGRAPHING ADVENTURE AND EXTREME CONDITIONS

GOPRO | UNDERWATER HOUSING | POLARISING FILTER | DRONE

Depending on the adventure, you might be looking at underwater casing, a helmet-mounted GoPro or even a drone. If it's a long trip, then consider travelling light and take a smaller, hybrid kit with you. Whatever camera system you opt for, it's likely you'll be out in the bright glare of snow or sun, so a polarising or ND filter can help – some camera systems have these built in. Whether it's the night sky in Australia's vast outback, or the northern lights in the Arctic Circle, astrophotography and other low-light situations call for good 'fast' lenses (so f2.8 or larger maximum aperture capability), stabilisation, a remote shutter or cable release, and cameras that won't fail as the temperature drops.

PHOTOGRAPHING FOOD

MACRO LENS | LED LIGHT | COMPACT OR MIRRORLESS CAMERAS

The difference between travel and food, and general food photography is that you won't be able to control the environment, and will need to be flexible about lighting and backgrounds. Smaller cameras are less obtrusive in restaurants and kitchens, and you can use additional lighting and lens kits on your mobile phone, as well as carrying your own wipeable mats to create a studio wherever you are. For additional lighting, you could use your phone as a backlight, or if you're very serious, invest in some continuous lighting kits. Macro lenses on DSLRs will allow for a closer look and extra detail – and with some camera systems you can even get up close and personal with the smallest of food items.

ESSENTIAL NON-ESSENTIALS

As well as the technical equipment, it's the non-photographic items that can make or break a trip. Photographing in cold conditions requires different preparation to the red dirt of an Australian road trip.

- **A waterproof cover for camera and lens** – for rainy, urban photography or working with a tripod, even an umbrella will allow you to set up and work in the wettest conditions.
- **A head torch** – for finding your way and checking settings at night.
- **Photography gloves** – for cold places and night-time assignments. Take latex gloves for extra waterproofing, or when you need to clean your husky harness.
- **A soft camera bag for when out on assignment** – as well as a sturdier one with wheels for travelling.
- **Sensor cleaning kit** – a dust blower to remove accessible dirt from the sensor, and optical lens cleaning fluid and tissues for wiping away smears. A small micro-fibre cloth is good for keeping the camera dry in damp conditions.
- **Cards and card holders** – always take more than you think you will need, and keep precious data safe in waterproof, hard-shell cases.
- **Storage and back-up devices** – external hard drives allow you to keep an extra copy, in addition to what's stored on your cards (never wipe a card until you're back home and have checked you've downloaded everything).
- **Multiple slot card reader** – especially if you're switching between camera systems or card types.
- **A laptop** – usually required if you want to back things up, and allows for editing and archiving at the end of every day, which is a godsend if you have a deadline.

- **Spare batteries** – especially for cold places. (I can't tell you the number of times I've seen someone run out of batteries or cards at the most crucial moment of a trip.)
- **Gaffer tape** – keeps dials and lenses in place if you've set them up for astrophotography, and generally good for any equipment mishaps.
- **Rolltop waterproof and dustproof bags** – essential for extreme conditions or longer trips. Take smaller Ziplock bags too, to keep camera sundries dry and clean, as well as for general food and waste purposes when out and about.

So, whatever your budget and whichever kit you can lay your hands on, just make sure you have prioritised what you need for each particular trip, and don't forget the other 'non'-essentials.

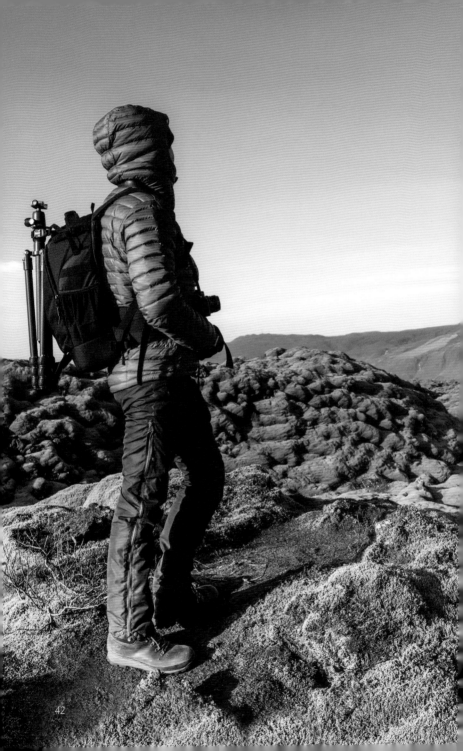

KNOW BEFORE YOU GO

Now that you know where you're going, why and for how long, and you've assembled the best equipment available to you, it's time to practise! Having a great camera system is one thing, but knowing it like the back of your hand will make all the difference to your images, whatever kit you have.

You are going to improve your technical knowledge as we move through *Part 2* of this guide, but before that it will help to go over the key language of photography first, exploring how the basic functions allow us to open up a camera's creativity.

If this is all old hat to you, then skip to *Chapter 4*.

KNOWING YOUR EQUIPMENT

From a phone camera to the most expensive full-frame digital DSLR, it's vital that you know what your camera can do. Have your manual to

< On assignment, southern Iceland
< DSLR, 24MM, 1/160 SEC, F9, ISO 160

Photography for me is not looking, it's feeling.
If you can't feel what you're looking at,
then you're never going to get others to feel
anything when they look at your pictures.
DON MCCULLIN

hand as you progress through this guide and, when you travel, take a digital version with you. Get online and research what your equipment can do, through YouTube tutorials or photography blogs.

For most beginner photographers using a DSLR, compact, bridge or mirrorless camera, the automatic settings, often indicated by a green square, are usually the default. And there's nothing wrong with that. Nowadays, technology is so good that your camera will usually figure out the best settings – and by understanding what *it* thinks is best, you'll soon learn how to override things for the better.

One of the first questions asked by participants on photography courses is – should they always photograph in manual? My advice is usually to take this in stages, shooting in aperture or shutter priority to understand how each can be an effective way to work, especially on the hoof. Manual photography takes time to change the settings and dials, often as conditions evolve – so not always a good idea when a cheetah is flying past! If you're already at the stage where you've figured

High vantage point, Central Australia
DSLR. 35MM, 1/80 SEC, F16, ISO 400

out when to use your aperture, and when to prioritise the shutter, then manual's something to practise more. The proof is usually in whether you're happy with your images.

As you become more technical and start to challenge yourself, it's natural that you'll make a few mistakes – and you may even feel as though you're going backwards. With this in mind, if you can at all help it, you shouldn't try things out for the first time while you're away – you'll kick yourself if you miss that one chance to capture a fleeting subject, especially if it's in a location you're unlikely to be able to revisit easily.

It's also important to note that professional travel photographers favour different approaches, usually alternating between aperture, shutter or manual settings. There isn't a 'best' way – it's what seems to work effortlessly for you that will eventually become your modus operandi. Personally, shooting aperture priority is my go-to, and I always use manual for starry skies, long shutter exposures and landscapes, which is where I first began and my true passions lie.

KEY PHOTOGRAPHY TERMS
AUTOMATIC SETTING

From the green square to the sports, wildlife and portrait settings, your camera has been constructed to compensate for the conditions you'll find yourself in, increasing the shutter speed for action and opening up the aperture for night settings. If you're a beginner or in doubt, shoot in automatic, and check your display afterwards to see what your camera considers to be the optimum settings. Program or P mode offers another alternative, where individual automatic decisions made by the camera can be overridden as you begin to gain knowledge and confidence about basic functions.

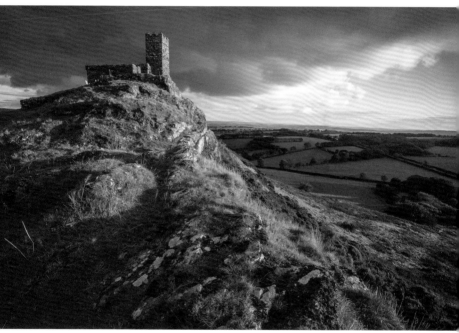

St Michael's Church and Brent Tor, Devon, England
DSLR, 16MM, 1/200 SEC, F11, ISO 200

A portrait is not made in the camera
but on either side of it.
EDWARD STEICHEN

APERTURE

Shooting in aperture priority means that you are controlling how much light enters the camera through the aperture. This is often used for portraiture or low-light conditions. If you set your aperture, the camera will set the shutter speed accordingly, as the two work together. Like your eye, an aperture needs to be wide open in the darkness to allow light in. In what might seem contradictory, it's the smallest number that creates the widest aperture – so commit that to memory. The aperture is also known as the f-stop, and there are key numbers that work with different styles of photography. For everything to be sharp, for example in a landscape, you'll want a higher number like f11, whereas when picking out a person amid a slightly blurred background, then the lowest number your camera is capable of is best – a wide aperture of something between f1.8 and f3.5. Creative use of aperture for different photography styles will be covered throughout the book.

SHUTTER PRIORITY

Prioritising the shutter speed is often, although not always, the go-to choice of action or wildlife photographers. If something is moving, then you'll need to make sure you're fast enough to freeze the action. Like everything else, your shutter speed will depend on how much available light there is, as well as the camera's sensor and type of lens.

In broad daylight, it's easier to whack the shutter speed up, as the faster it closes, the more any natural daylight will compensate. If your shots seem dark though, you may need a faster lens, or to dial up the ISO (see below). More on capturing speed in *chapters 6* and *10*.

EXPOSURE

Exposure is probably the most important element to understand, given that all photography is about light hitting and being captured by a sensor. DSLRs will indicate in their displays whether the shot is balanced for light and shade, but – as an over-exposed digital photograph can never be fully rescued – you should always take care. A bright sky is one of the reasons you may have clipped highlights (where there's no data at all in the whites of the shot), so if you don't have filters, you may need to underexpose or 'stop down'. In bright sunshine or daylight, it can help to use exposure compensation to dial it down one or two notches. What this does is make the image darker, but you could lighten the shadows a little afterwards, especially if shooting in RAW. A circular polariser or ND filter allows for control over daytime exposures. Photograph in manual when light is tricky, or use the camera's **exposure bracketing** options, blending or choosing the best exposures in editing software later.

HISTOGRAM

Knowing where and how to use your histogram is the key to great images. Somewhere on your camera back you'll have an INFO button that, when pressed enough times, will reveal a graph image. Contrary to some advice, a bell-shaped curve will not result in the perfect image, but you are looking to see if the graph is heavily concentrated to the right (which might indicate it is overexposed) or to the left

(probably too dark). Once you've taken a shot you can check this or use live view on your LCD to see the histogram before the image is taken – no more overexposed images for you! Your camera will most likely have a highlights alert, fondly known as the blinkies, which will flash in horror like an Edvard Munch painting if your images are too bright. Always take test shots in advance and check your histogram alongside the exposure indicator.

HDR

If you've ever wondered why smartphones take such incredible pictures, it's mostly down to the High Dynamic Range that enables several shots to be blended together. On smartphones with good cameras, the 'automatic' setting will nearly always outperform a single 'automatic' shot in a DSLR, simply because it's exposing for the darker parts of the image as well as the bright ones, so make sure you enable HDR when you use a camera phone. It's the dynamic range that's also on show in your histogram, so get used to thinking about the interplay between light and shadow in any photography, just as the original black and white photographers had to.

The contemplation of things as they are, without error or confusion, without substitution or imposture, is in itself a nobler thing than a whole harvest of invention.

FRANCIS BACON

ISO

ISO works alongside your shutter and aperture, allowing for more sensitivity to light and a faster shutter speed. The default ISO for most photographers is 100 or 200, usually because the best images are always taken with the lowest ISO. However, in low-light conditions where a sensor is struggling to record detail, turning up the ISO will allow for an image to be captured more easily, and is necessary for recording sharp movement in action and wildlife photography. The problem with that is that you increase the chances of noise or grain. Some large sensor cameras deal better with a high ISO, so practise to see how your camera copes and check your manual to find its low-light sweet spot. Newer cameras handle low-light conditions more readily as technology has improved, and this seems likely to continue.

NOISE

Noise or grain occurs either when the sensor can't cope with poor light conditions or when an image has been over-edited or sharpened. You'll notice images look pixelated or blurry, especially in the shadows and when they're enlarged on a computer screen. Using a tripod will allow for a very slow shutter, alleviating the need for a higher ISO in some situations, like shooting skies or buildings at night. Try to avoid using a high ISO as much as possible, and do not over edit images or lighten the shadows too much. More of this in *chapters 8* and *11*.

MANUAL

Shooting in manual means you control everything, from shutter and aperture to exposure and ISO. As you set each individual component, you'll need to take test shots to see if things are under control – properly exposed without clipped highlights and in focus. As each part of the

camera is connected, you'll soon begin to find out what happens if the shutter's too fast for the aperture setting, but checking your exposure indicator will also help. If you know your camera well enough, you'll be able to hear when the shutter's too slow to be hand held. I have a friend who will shout out 'slow!' as he passes an unwitting photographer with a lethargic shutter – it's only funny if you know him, but it does make you start to listen to your kit!

WHITE BALANCE

Depending on the colour temperature of the light around you, your camera will adjust its white balance if you have it on automatic setting. A very strong interior light might result in a strong yellow colour cast, but if you photograph in RAW you can adjust this later. Generally, photographing with auto white balance is fine unless you are shooting sunsets, when it will desaturate the warm tones and take away the very beauty you are trying to record. Use the cloud or rain white balance settings if you're photographing in JPEG, and switch to these on very dull days too, in order to bring out the best in your images.

If the photographer is interested in the people in front of his lens, and if he is compassionate, it's already a lot. The instrument is not the camera but the photographer.

EVE ARNOLD

RAW

JPEGs are the finished article, locking information into the final image, so they're flatter and smaller file types. Trying to edit a JPEG will result in a loss of resolution and is to be avoided! Professional photographers will always shoot in RAW and usually convert them to **TIFFs** in Photoshop or other software. RAW files are a bit like digital negatives, leaving the untouched image to be developed in the digital darkroom. The bigger and better the sensor in your camera, the more information there is to play with, so RAW is the professional's choice. Of course, if you do not want to spend hours converting files, you might prefer to photograph in JPEG, particularly if you are running out of space on your cards (what did we say about making sure you had enough?).

PRACTICE MAKES PERFECT

Knowing your own camera is key. As you become more accomplished, try to use your camera without looking too much at the dials and functions. Practise at home, download your manual and watch online tutorials to explore what your equipment can do. Upload and scrutinise any test shots by enlarging the screen to 100% or more, and check closely for focus and detail. Take regular test shots, especially when getting set to travel or embark upon a new type of photography.

And you know what they say about the 10,000-hour rule? In *The Role of Deliberate Practice in the Acquisition of Expert Performance*, Professor Anders Ericsson posited a notion that has been repeated and repackaged by many authors and success coaches - that to master anything from piano playing to language acquisition, about 2,000 days of five hours' practice gets one close to becoming an expert. So, if you can work with your camera daily for 5½ years, you'll pretty much be a pro.

Motion blur waves and child, Brighton, England >
DSLR, 16MM, 8 SEC, F11, ISO 100 >

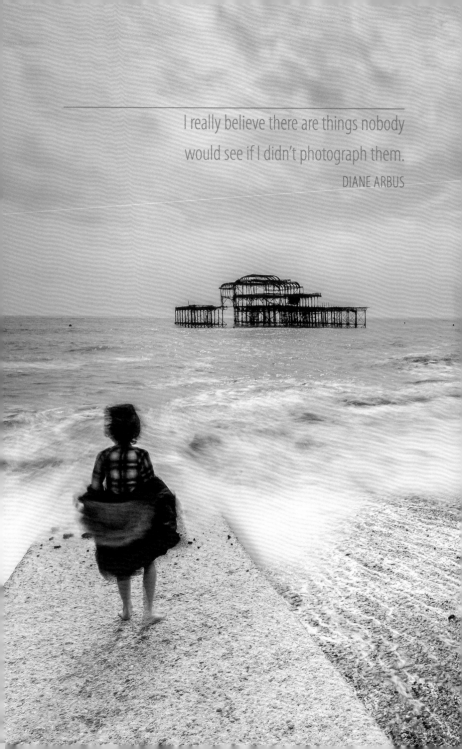

I really believe there are things nobody would see if I didn't photograph them.

DIANE ARBUS

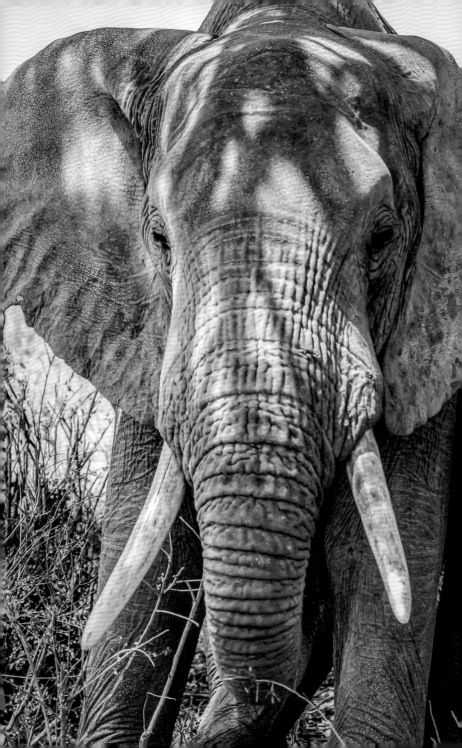

ON
THE
ROAD

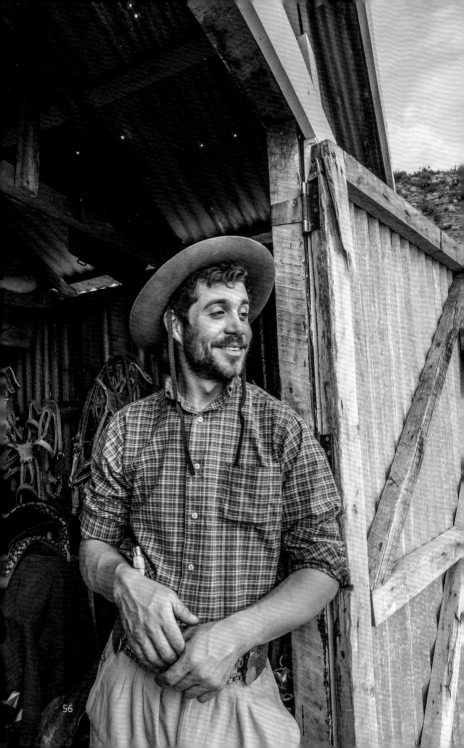

PEOPLE

FOCUS ON
CENTRAL AND
SOUTH AMERICA

Making portraits has long been a challenge for travel photographers and remains a tricky form of travel imagery, especially in parts of Central and South America. How do we approach a stranger if we're not sure how they might react to our request, and what's to be done if we don't speak the local language? For some, it's a case of clicking the shutter at a reasonable distance and hoping for the best, but there are parts of the world where that might get us into serious trouble.

We all accept that you shouldn't just point a camera at someone's face without asking, yet still we see people doing just this – a kind of hit-and-run affair, without any prior discussion or eye contact. Furthermore, it's not likely to yield a great photograph either if it's taken on the hoof. Similarly, thinking that because a person is different

< ENVIRONMENTAL PORTRAIT Gaucho Victor Sharp, Chilean Patagonia
< MIRRORLESS, 14MM, 1/60 SEC, F8, ISO 400

To photograph is to appropriate the thing photographed. It means putting oneself into a certain relation to the world that feels like knowledge – and, therefore, like power.
SUSAN SONTAG

to you they'll make an interesting subject, even if your intentions are full of kindness, can also be problematical. I know just from travelling with people with red hair or black skin in countries where this is rare, they are seen as 'exotic', becoming the focus of local attention and a photography subject themselves, despite their obvious discomfort.

Can you imagine being photographed day in and day out while doing your job, or for wearing colourfully woven clothes in a country where that's just the norm? And with the proliferation of mobile phones and selfie sticks too, there are even more cameras around than a decade ago, creating a problem in destinations that have long suffered the ignominy of over-tourism. I know that if I'm inadvertently caught in the middle of someone's travel snap, I will automatically duck. The more I think about this, the more amazing it is to me that anyone would ever consent to having their picture taken in the first place!

Yet all of us who travel seem to be a little in love with the world – and photographing people is simply a part of documenting the experiences and encounters we've had along the way. Far from home, in a culture that isn't ours, we often become intoxicated, attempting to capture every second of what makes it special. And who can blame

a traveller from wanting to pick up their camera when they meet a smiling stranger? I know I only have to look into the eyes of a person I photographed ten years ago, and the memory of the place and of our interaction becomes vivid.

Portraiture is one of the finest, most powerful forms of art and photography, and that will never change. Of all the types of travel imagery, it requires a tacit contract between subject and photographer, and is a collaborative process, especially if the person's gaze is directly down the lens. It's almost impossible to get a great image unless the individual is at ease, and this won't happen if we rush and take a picture without warning. Trying to sneak a quick snap or zooming in from a distance and then scurrying away is also to be avoided. Go about things carefully, and you'll get an image you'll be proud to have taken. More importantly, you're likely to have a wonderful exchange, and make the subject of the photograph very happy too.

In my view, people are the most sensitive of 'subjects' to be photographed…
These experiences, along with the resulting images, stir my soul. These people are not my subjects; they are my mentors.

LISA KRISTINE

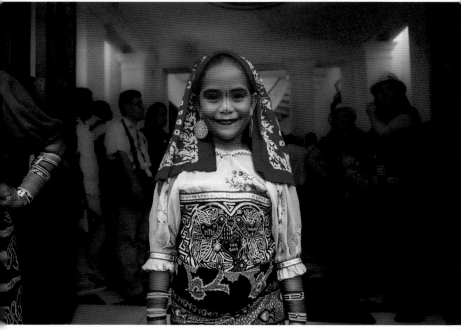

Guna girl, Fiestas Patrias, Panama City
MIRRORLESS, 14MM, 1/60 SEC, F2.8, ISO 500

THE PORTRAIT

OFTEN POSED | DIRECT ADDRESS TO THE LENS |
FOCUS ON SHARP EYES | FILL THE FRAME

The most compelling form of travel imagery is often the single-person portrait, where the lens is addressed directly. It requires time, a focus on the eyes and for the subject to be as relaxed as possible. These images can be taken quickly, while the person retains something of the grace or expression you initially saw in them. It's important that the camera is set up first and you do not ruin your chances by hesitating too much. The subject may become awkward or shy once you ask permission, and you may need time and conversation to restore their calm. Asking them to look at something in the distance or slightly away from the lens can reduce self-consciousness, and often results in a more natural image. A wide aperture will allow the background to be softer, and give the subject prominence.

As a woman, I sometimes feel I have a slight advantage in photographing women and girls. I'm fairly small in stature myself, so perhaps not an intimidating stranger. Speaking the language is also a big help – several years of living in Chile and learning Spanish have served me well, though throughout the Americas there are many indigenous languages.

While I was being guided in a small group around one of the San Blas or Guna Yala island communities, I was beckoned over by an elderly Guna woman. She had seen my camera and gestured for me to take her picture. Proud of her handmade *molas* and her grand age of 'over 80', she wanted a formal shot, and offered me this posture and expression. Had I been alone I would have remained at her side for longer but, aware of the tight schedule that our guide Domasino had put in place, I returned to my group. It's one of the drawbacks of joining tours – deciding how long to break away to grab the photographic opportunities, without being *that* person everyone is waiting for!

And there will always be times when you would have wished to have stayed longer, to have created a relationship with the subject of a portrait, and there are moments when you are offered a glimpse of another person's life. How they want you to record them is more important than the photo you might have liked to capture, so it's best to take your lead from them. It's always a two-way collaboration, and you have to respond to how things flow, including your conversation and any non-verbal communication.

For me, allowing subjects to present themselves hands much of the power back to them. This collaborative endeavour makes the photographer as vulnerable as the sitter on occasion, and can result in a photograph of immense truth and authenticity, drawing the viewer in to ask questions about the person and place.

Guna Yala woman >
MIRRORLESS, 14MM, 1/100 SEC, F2.8, ISO 200 >

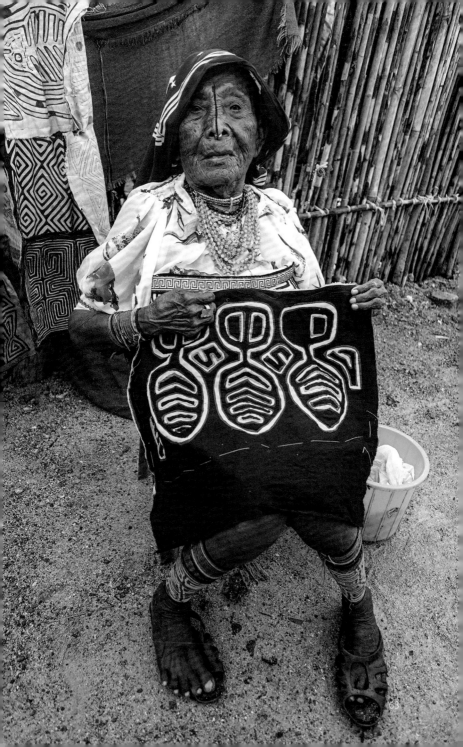

It is sometimes tempting to want to change a subject's expression. In parts of the world, we're so used to the instruction 'Smile!' that our first instinct is to make a happy photograph, to present the world in the way we want to tell it.

There is often something vulnerable, even melancholy in the expression of a portrait, especially – from my experience – in the people of Central and South America. Perhaps it is a throwback to Victorian wet-plate photographs where subjects were compelled to stand still for several minutes, or modern passport and ID images in which any form of expression is a no-no.

The users and viewers of photographs are also important factors related to understanding portraiture or really any image. Each individual brings his or her own experiences, knowledge, biases, thoughts, and beliefs to each visual encounter that may be outside of what the photographer or sitter intends.

SHANNON THOMAS PERICH

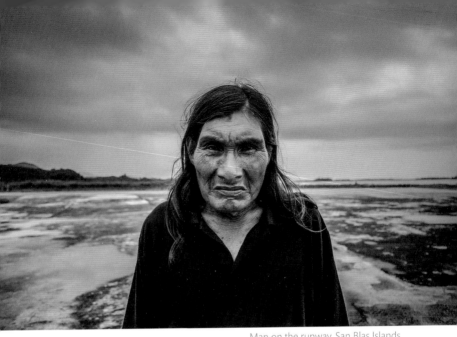

Man on the runway, San Blas Islands
MIRRORLESS, 14MM, 1/420 SEC, F2.8, ISO 200

Flying back to Panama City from the San Blas islands, the skies were stormy. The light aircraft that ferry locals and tourists to the mainland and back were unable to take off or land, and we were milling about on the 'runway' with pilots and locals, just passing the time. I was busy being bitten by pesky sand flies when I looked up, and saw a man standing apart from everyone. Something about his demeanour and the gathering clouds behind him said forget about the ankle biters and any anxiety over crashing in the archipelago, and go and take his portrait. I didn't get much out of him when I tried to chat, but he was very amenable, and more than happy to have his portrait made, standing very still and then suddenly becoming quite serious. I placed him in the centre of the frame, allowing for the converging clouds and ground to add drama. Making this image black and white suited the monochrome skies and his intent gaze (which he only held for as long as I photographed him, breaking back into a huge smile once we were done.).

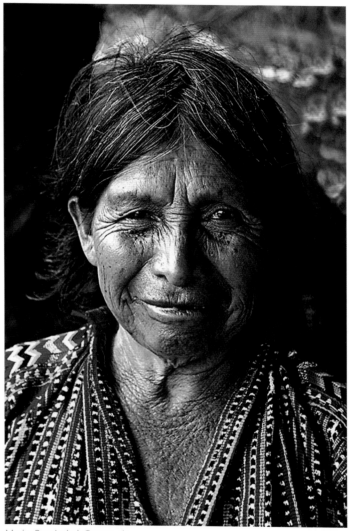

Maria, Panajachel, Guatemala
DSLR, 85MM, 1/60 SEC, F5.6, ISO 400

Maria was selling textiles in Panajachel, near Lake Atitlán in Guatemala, and everything about her drew me to want to photograph her. Extremely shy and unwilling, she lowered her eyes and shook her head no. And that was that.

I put my camera away and went to have lunch in an adjacent café with a friend. After a leisurely hour we came out. Maria was still there, and had now spread out her brightly coloured wares. We started to chat as I looked at the textiles, and she began to open up, even beginning to smile. It was then that I again expressed my genuine wish to photograph her, and she told me I couldn't because she was ugly.

So, her reluctance was not an absolute rejection of a stranger taking her picture, but everything to do with something I completely relate to – a fear of having herself represented unflatteringly. It's also a basic human reaction to being faced with a large camera, and certainly more common with women in some cultures. Yet our conversation and connection – and the fact that she definitely wasn't '*fea*' – resulted, somehow, eventually, in me taking a few quick photos of Maria. It wasn't forced, and I had no agenda. The conversation had flowed, and the final image captured Maria's gentle warmth and expression. When I showed her the picture on the camera screen she blushed. Fully aware of her initial reluctance, I didn't take too long or worry about getting extra shots or changing settings. This definitely isn't my most technical image – I simply wanted to capture the look in her eyes. And we both smiled at her surprise when seeing her own beautiful face reflected back in the LCD display.

Had I not stayed in the area, I would never have photographed Maria. It's doubtful that we would have spoken for as long as we did or I would have asked her name – something that comes with experience, and is a prerequisite for any published photojournalism.

THE ENVIRONMENTAL PORTRAIT

INCLUDES BACKGROUND | WIDE LENS | WIDE DEPTH OF FIELD

A wider-angled environmental portrait has the person, usually, as part of a bigger scene. This can be easier to ask for than a portrait, as you are not zooming in on a face and subjects feel more at ease if it's about the context, not simply themselves. A wide depth of field allows for the background to be in focus too. Give yourself time to photograph your subject in different positions and lighting conditions, and offer them some direction. Photographing someone working is part of a two-way process – documenting what they're doing, while you also learn something. Show a genuine interest in their life and work – even put down the camera to listen and watch – and it will invariably result in a more relaxed, natural atmosphere and, subsequently, better images.

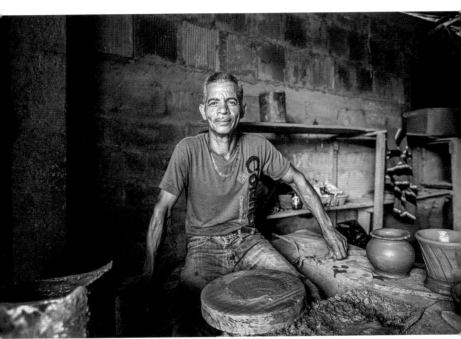

José Calderón, Azuero, Panama
DSLR, 19MM, 1/40 SEC, F2.8, ISO 320

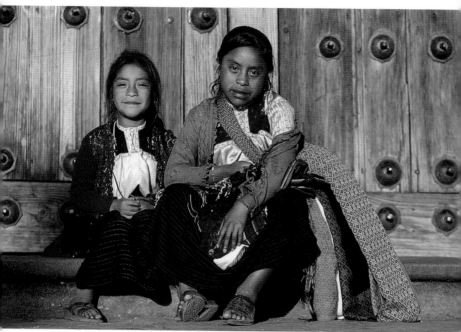

Chiapas Chicas, St Cristóbal de las Casas
DSLR, 70MM, 1/125 SEC, F5.6, ISO 100

Like many areas in Latin America, Chiapas (Mexico) is a place where you think very carefully before taking pictures of children, even if you have asked for permission. There have been incidents over the years, both here and in Guatemala where camera-wielding tourists have been accused of abducting children or exploiting indigenous peoples for profit. Intentionally avoiding portraits, I was focused on the cathedral in the main square when I felt a tugging at my sleeve. 'Take our picture, take OUR picture!' My initial reaction was to just walk away, but looking down at their imploring faces I explained to them that I couldn't.

I ask them if their mother is nearby, and they tell me she is selling textiles in the square, so before I can utter another syllable they drag me by the arm. To my surprise she is very happy to have the girls in a picture, and there is no discussion of money or any kind of exchange. I ask again to make sure it's ok, and tell her that we will sit in front of the cathedral doors. The girls decide they want to be very formal and not smile, but the little one starts to grin. They are too excited about about the final result to sit still, so it takes a few attempts before I can stop them from jumping up to see themselves on my camera's LCD screen. The experience for me was more about the interaction I had than the photo itself, but when I look at it now I am totally transported back to that early evening, to the square, to those people and the person I was then.

IT'S IN THE DETAIL

CLOSE UP ON DETAIL | FILL THE FRAME | SHALLOW DEPTH OF FIELD

Close-ups of hands at work are often used in magazine features as part of cultural storytelling, where a light is shone on the detail of a people or a place. Asking to take a photograph like this is often easier still, as you can explain you are not going to make that subject's face part of the image – usually, very few people will object. It might also be a way in if you find talking to strangers challenging. Show them your photograph and see if that starts a conversation where you might be able to get a little closer, take a whole body shot or even a head-and-shoulders portrait.

MIRRORLESS, 14MM, 1/60 SEC, F2.8, ISO 640
DSLR, 35MM, 1/80 SEC, F2.8, ISO 200 >

DSLR, 50MM, 1/60 SEC, F2.8, ISO 200

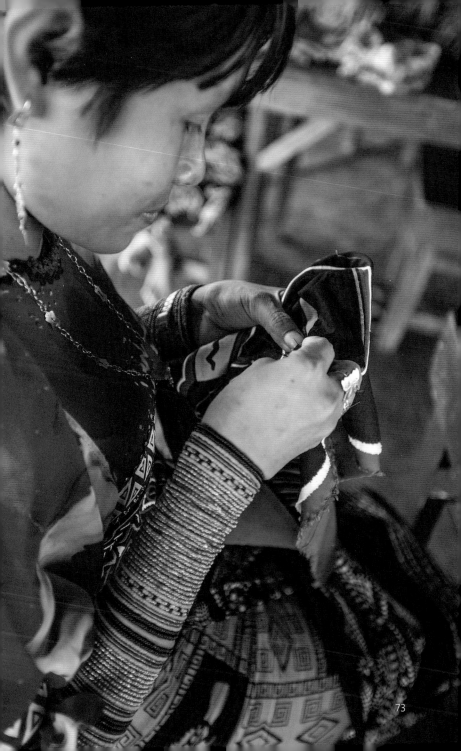

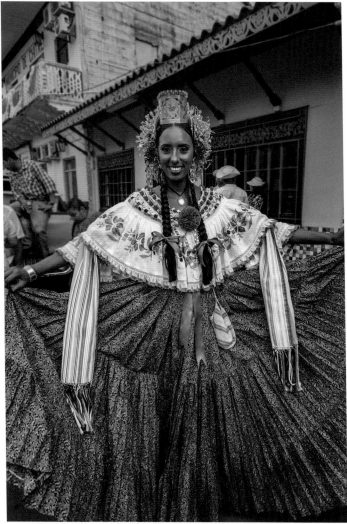

Festival woman, Chitré
MIRRORLESS, 14MM, 1/800 SEC, F5.6, ISO 200

FESTIVALS, GROUPS AND ACTION

ACTION OR MOVEMENT | FAST SHUTTER SPEED

Events and festivals usually involve a public display of some form, so photography is not only expected but encouraged. Again, it depends on the country and cultural mores, but you can usually gauge if it's ok to work with your camera from what people around you are doing, especially at an open event like carnival. With formal religious festivals such as Easter processions you will need to be more respectful, perhaps working at a greater distance. I've found that wedding guests and newly married couples make for very happy subjects, especially if photographed in reportage style. Capturing the essence of a place through a local event is a good way to start with photographing people. As you grow in confidence after watching from the sidelines, you may decide to venture closer in and speak to one or two people. And as you become part of the celebrations yourself, you can move seamlessly in and outside of the action.

Immersing oneself in a place for long enough is the best way to build some kind of connection and allows time to form relationships, especially on a one-to-one basis. For group and festival images though, it is possible to parachute in and just become part of the action!

In this image I had absolutely no idea that a huge festival was taking place in the small Panamanian town of Chitré. Throughout October and November there are a number of celebrations all over the country, and it's probably only locals who know every date and location. Maintaining good contacts and revisiting a place always pays dividends, as does having extra time to seek out local leads. The beauty of travelling solo is that you get to follow new advice and your own rhythms.

Once I discovered this was happening, I ventured out with minimal kit (one camera, two lenses and enough cards and batteries to last the whole day). I started early, chatting to people setting up, to work out the best vantage points and route of the procession. To get into the flow, I photographed a few ice-cream sellers and musicians.

Relaxed and fully immersed in the experience, I had been walking with one particular group for some time. From non-verbal clues including eye contact and body language, I knew the lead female was comfortable with my presence and inviting me to photograph her. The images I took that day felt effortless, as I became part of the festivities.

Stopping to eat and drink, and soaking up the atmosphere, I was soon fully immersed in the celebrations. I began my photographic career in Latin America as a backpacker, and I never want to lose the joy and immediacy of the travel experience in my search for a story.

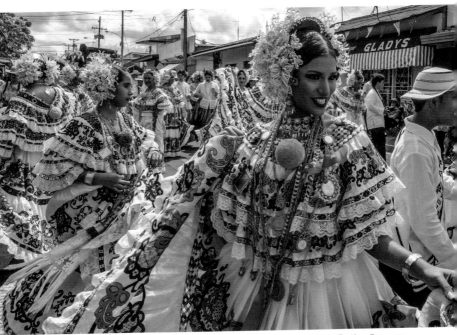

Fiestas Patrias, Panama
MIRRORLESS: 14MM, 1/400 SEC, F11, ISO 200

DSLR, 35MM, 1/40 SEC, F5, ISO 400

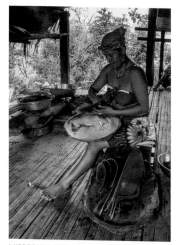

MIRRORLESS, 14MM, 1/25 SEC, F11, ISO 1600

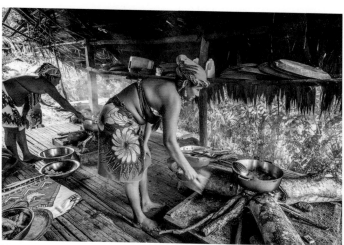

MIRRORLESS, 14MM, 1/50 SEC, F8, ISO 1600

REPORTAGE STYLE

CANDID | NATURAL BEHAVIOUR | IN CONTEXT | OBSERVATIONAL

With the reportage style of photography, there is an argument that it's more candid, so one should shoot from the hip and explain later. This is covered in more detail in *Chapter 7* on urban and street photography where we'll discuss whether it's ethical or even possible to inform everyone you come into contact with of your intentions. The general rule is that if they're passing by, or walking into your frame, then it's ok to include them anonymously as part of the scene.

However, if you do want to photograph someone going about their business and get a number of different editorial images, ask them first if it's ok for you to hang around. Having time to stand still means you'll probably blend into the background, and they may even forget you're there. Remember to show them your photo before you go, or at least let them know you're finished and offer your thanks. In markets and other places, I usually find that I stay much longer than people expect me to, and they've long stopped paying me any attention, acting naturally and carrying on with their day – which is exactly what we want to capture.

THE FUNDAMENTALS

APERTURE

A shallow depth of field for focused faces and a slight blur on the background requires a larger aperture (f4 or wider).

Smartphones have a portrait setting that emulates this shallow depth of field, blurring the background and keeping the subject in sharp focus, with simulated 'studio' **lighting** options.

For environmental portraits, a wider depth of field, f5.6 or higher, keeps the background in focus. Check that the shutter is fast enough if not using lighting. Increase the ISO if necessary.

FOCUS POINTS

Ensure you know how to change the focus priority. With portraits, it's important to keep the eyes sharp, so a single focal point is better.

CONTINUOUS SHOOTING OR BURST MODE

For portraits it's a good idea to kill any focus beep and change the camera to one shot. If anything will kill the mood, it's shooting like a paparazza. Some photographers use the burst mode to guarantee they'll capture one perfect image, but this can be off-putting for the subject. Shutter slap isn't an issue for mirrorless cameras, but for DSLRs, be sure to enable quiet shutter mode wherever possible.

MOVEMENT AND TRACKING

With action shots, using the continuous focusing or **servo mode** (page 428) means the camera will refocus as your subject moves. This is

helpful if there's only one, isolated subject, but not in environments where the camera might pick up on other unrelated action.

COMPOSITION

The **rule of thirds** (page 122) is a good one to break with single portrait images, as a centrally placed subject is often extremely powerful. Asking your subject to stand at a diagonal to the camera can be more flattering, as is photographing from a high angle. Remember to move between portrait and landscape orientation, and vary the composition.

Be aware of the fact that a super wide angle will distort the figures of those on the edges of the frame, so move back rather than going wider with the lens. Find a higher vantage point on a balcony or stairwell when taking large group portraits, but stay safe.

FOCAL RANGE

The best focal length for portraits is around 80–100mm, as this keeps you at a good distance from the subject, while allowing the portrait to fill the frame. Use a wide angle and include the setting or background.

LIGHTING

An on-camera flash works well in daytime, outdoor environments, often when the subject is facing away from a brightly backlit scene, like a sunset. In indoor settings, flash can be bounced on to the subject, via an off-camera system. Reflectors are a good alternative, redirecting light from any other light sources (see also page 425).

STABILISATION

It isn't always possible to set up a tripod when taking travel photographs, but if you know your subject is happy to wait, you'll get sharper images.

AN EXPERT'S VIEW
LOLA AKINMADE ÅKERSTRÖM

Lola Akinmade Åkerström is an award-winning photographer, author and entrepreneur. Her work has been featured in *National Geographic*, *New York Times*, *The Guardian*, BBC, CNN, Travel Channel, Travel + Leisure and more. Lola was the 2018 Bill Muster Travel Photographer of the Year award and she's the author of several books. She has collaborated with commercial brands from Mercedes-Benz and Dove to Intrepid Travel and National Geographic Channel. **akinmade.com academy.geotravelermedia.com**

What kind of research do you undertake before travelling?
The most important thing I do is research about cultural customs and taboos. Since I will be approaching strangers in a new land, I need to learn how to acknowledge them properly without offending them. I also do a quick search to see the types of images other photographers have taken from that destination so I can be more creative with mine or shoot from different angles to create more original imagery.

Do you ask for permission, and what happens if you're refused?
I always ask for permission. I often say that getting a complete stranger to relax long enough to grant you momentary access into their world is one of the hardest parts of travel photography. Rejection sucks.

It is one human emotion we can all collectively say we would like to get rid of (alongside hate). Rejection causes a momentary shift in power and pushes us into an emotional space where we question ourselves and the decision we made to warrant that rejection. And that is the power of a good portrait photographer. Putting one's ego aside so the subject retains the power to grant or deny access to their own space.

Do you ever shoot first and ask for permission later?
As an experienced photographer now, I very rarely ever sneak photos of people. Unless the person isn't the main focus of the scene and adds to it – for example, walking through a natural sun spotlight – I usually ask for permission. If no common language is shared, I often lift my camera in question with a smile.

Do you ever get subjects to sign a model release form?
If I am on a commercial assignment, then I get model releases signed. Most often, since I work within an editorial context, model releases are not required because the photos are being published within the original context they were taken and are not used to sell products or market an unrelated brand.

Photographing people during your travels means being vulnerable and humble – putting your subject in charge.

LOLA AKINMADE ÅKERSTRÖM

A local woman in Panauti, Nepal >>
DSLR, 70MM, 1/200 SEC, F13, ISO 800 >>

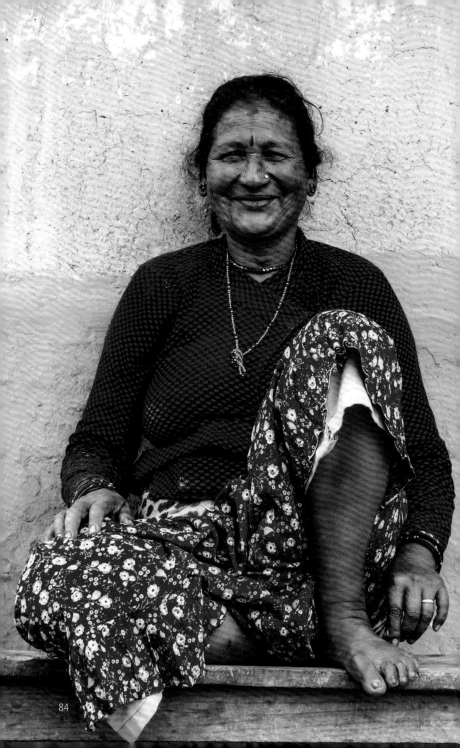

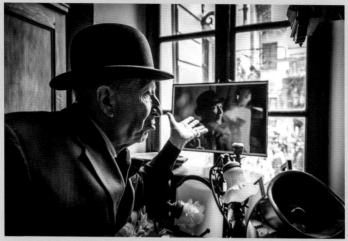

The late Count Michelangelo Moretti I in Sabbioneta, Italy
DSLR, 24MM, 1/80 SEC, F4, ISO 560

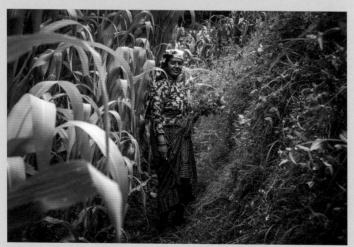

A Nepalese farmer in her field
DSLR, 55MM, 1/200 SEC, F10, ISO 450

Are there special considerations for photographing overseas?

It's always important to know what the local laws are when it comes to photographing men, women or children. Some regions like the Middle East might be more sensitive to people photographing veiled women. Some regions in Africa and South America believe direct eye contact in photos is stealing a bit of their souls. There are also some regions like the Nordics, which on paper may sound open and approachable, but where people are actually quite reserved and don't quickly warm to strangers. So, in essence, do your homework.

What's your general advice for photographing people?

Photographing people during your travels means being vulnerable and humble – putting your subject in charge. Yes, oftentimes you have to give up control and be willing to let them reject you. Proper acknowledgement of strangers you meet often starts by asking for and calling them by their name.

ASSIGNMENT 1

TAKE A PORTRAIT OF A STRANGER

- Look around and find a person you'd like to photograph.
- Set your aperture accordingly.
- Are there any distracting objects or people in the background? Decide on the angle you want to shoot from.
- Double check the available light, and decide whether you need to use a wider aperture to compensate, or increase the ISO.
- If there's ambient or available light that might improve the shot, be ready to ask your subject to move into it.
- Ensure your focus point is ready to fix on the subject's eyes. Using auto focus is fine, but it must be on a single focus point so that you don't home in on the wrong element by accident.
- Take a test shot and quickly check everything is how it should be.
- Time your introduction for when there's a quiet moment.
- Ask permission first, either through gesture, eye contact or conversation. Try to put your subject at ease by chatting or smiling.
- Work swiftly, but not so fast that that the image is blurred.
- If they seem amenable, ask them to move into an area of better light. Side lighting through a window, perhaps diffused through a curtain or cloth, will be better than harsh artificial light or a bright flash. Often, telling a subject that flatteringly soft, directional, or Rembrandt lighting (page 425) can be achieved by standing near a window is all you need to do to encourage them to move!

- Is your subject still happy being photographed? If not, stop, and allow them time or space. Follow their lead, be sensitive to the situation but confident enough to get the best image you can.
- Take care with the direction of the sun or any strong light sources to avoid an uncomfortable or squinting subject.
- Position your subject in the environment, then take a variety of shots – close-ups, mid-shots and wide. Remember to think about where the light is coming from, and move around yourself. Try to keep the camera as still as possible.

REFLECTIONS

It's not always easy to tell how well you did with a portrait until you see it on a larger screen. What looks great in-camera can be a disappointment once it's enlarged.

But weighing up the technical against the creative, how perfect should your shot be? If you have a sharp focus on the eyes, that is most important, but often not the easiest thing to achieve. People can move imperceptibly, as can you, especially if you're nervous, in a rush or talking. Capturing something of the character of your subject is key.

Choose your best three to five images to review:

- ☐ Did you compose the images well enough – is the subject well framed?
- ☐ Does your subject look relaxed?
- ☐ Did you speak to them first or spend time so that they became comfortable with you?
- ☐ Were there smiles or laughter during your exchange?
- ☐ Did you ask them to move, or tell them to relax their shoulders?
- ☐ Are the eyes sharp?

- ☐ Did you take a variety of images, including vertical and horizontal?
- ☐ Did you ask your subject to also look away from the lens?
- ☐ Did you move around yourself?
- ☐ Was there enough available light, and did it enhance your subject?

If you have one favourite image from this assignment, can you see what has worked well and why? For the images you are not so happy with, consider what didn't quite work out. Be ready to address one or two of those areas for the next assignment. Remember that sometimes a situation can be out of your control, so don't be too hard on yourself if you have the odd 'Dutch' or blurry one.

I'm really not that interested in technical perfection. I would much rather a slightly blurry, slightly 'dutch', slightly wrong photo that makes you feel lots of emotion than a clinical, precise, perfect one that doesn't.
GREG WILLIAMS

ASSIGNMENT 2

PHOTOGRAPH PEOPLE IN THEIR ENVIRONMENT

- Establish whether this is going to be a static portrait, a candid or action shot.
- In an environmental shot it's important to capture the context and sense of place. Using a wider angle or moving back will include more of the surroundings, but don't place people at the edges of a very wide frame.
- Compose the shot in different ways – centrally placed or in one of the thirds, perhaps.
- Use an aperture that keeps more of the background and other people in focus too, then go for a different style, with a shallow depth of field.
- Try to learn from what didn't go right last time. Was it nerves that made you rush or take an unsteady image? This time, take a deep breath before you shoot, and exhale slowly through your nose. Once you've exhaled you should be at your most stable.
- If your subjects are happy for you to hang around, stay close by and try to relax into the scene yourself. You will probably become more confident the longer you are there and begin to see different compositions, angles, backgrounds and light sources.
- Remember to ask your subject's name and offer yours. If there's time to chat, showing a genuine interest in who you're photographing is likely to be reciprocated with kindness and trust.

GENERAL ADVICE

- Read travel guidance and your guidebook notes on local customs before travelling. If in doubt about how to proceed, ask a local.
- The golden rule is to always be considerate. Photograph the people you have time to connect with – like those selling wares in markets for example, and café or shop owners.
- If someone refuses you, accept this with grace and move on.
- Don't be put off by rejection – you have nothing to lose by asking.
- Be extremely careful of photographing children in all parts of the world, especially if they are not with their parents or guardians.

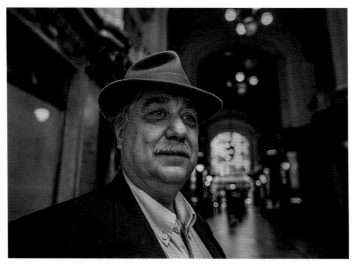

Porteño, Buenos Aires
DSLR, 25MM, 1/100 SEC, F2.8, ISO 320

- If travelling with other photographers, don't crowd around and focus on the same subject.
- Remember to make eye contact and smile – gesture with your camera so that it's clear what you want to do.
- Work quickly, and have your camera and lens settings ready.
- Be prepared to show your photograph once you've taken it – this can be the most rewarding part of the experience.
- Always try to get your subject's name, and offer yours.
- Sometimes we need to pause and reflect before automatically wielding our cameras. Consider using a smaller, inconspicuous compact over a large DSLR, or putting the camera down if your instincts tell you it's not welcome.
- If someone asks for payment in return for posing for your shot, this is something to consider. Many photographers tip their subject afterwards or offer small gifts. If you have a Polaroid or ever plan to return, photos are usually gratefully received.
- You might be asked to send or email a copy of the image, or to let your subject know if it gets included in an article. Don't promise if it's unlikely. With the best will in the world, once you start photographing professionally, you won't be able to email *everyone* you meet.

THREE PHOTOGRAPHERS TO FOLLOW

Lisa Kristine lisakristine.com
Greg Williams gregwilliams.com
Genevieve Hathaway genevievehathaway.com

brigade of midges, you'll mostly be left to your own devices. But that's not to say landscape photography is easy. Some joke that it's just a case of pointing the lens at a static scene that won't become shy or bored, but I'd argue that a landscape is one of the toughest subjects to master. Exposing for sky against a dark foreground or making a wide expanse of land look as interesting or beautiful as it was in your mind's eye is more challenging than it might seem. Smartphone technology allows any of us to tap the HDR setting and let the camera stitch a few exposures together, resulting in an instantly perfect image. It's rather disconcerting, initially, for the DSLR-toting photographer looking over a companion's relaxed shoulder, unencumbered by heavy gear, to see a better image. And it might just make you question why you've carted so much equipment halfway around the world – though, of course, after processing, the DSLR image will almost always be more magnificent. It can also be overwhelming to be faced by the choices that immense landscapes like Australia or Patagonia offer. What to include, where to look and what to leave out are all important considerations, but questions Constable or Canaletto can help us with.

Although there is a sense in which the camera does indeed capture reality, not just interpret it, photographs are as much an interpretation of the world as paintings and drawings are.

SUSAN SONTAG

Aerial view of Purnululu National Park
DSLR, 24MM, 1/400 SEC, F11, ISO 500

There are other complications too, like the physical difficulty and distances involved in getting to some of the most remote, photogenic locations on our beautiful planet. Unlike local landscape photographers, travellers won't have the luxury of their full complement of kit, or be able return to a favourite place when conditions are ripe. And if we're part of an organised itinerary, timings are also out of our control. Worse still, trekking means moving at pace and the need to travel light; but this is when compact cameras and carbon-fibre tripods can come into their own.

So, what can we do to optimise our travel landscapes? First and foremost, composition is fundamental. Knowing the laws of perspective, from leading lines which transport the viewer into the image itself, to the rule of thirds (where the most powerful points occur) are all helpful aids. Of course, understanding the rules means intentionally breaking them to create more arresting images. Shooting either side of dawn and dusk, and using a tripod and filters, also allow for greater creative control, enabling the landscape to be represented just as a painter might render it. Rather than pointing a camera at a passive landscape then, we are creatively teasing out and interpreting what's around us, through light and form.

THE PASTORAL LANDSCAPE

APERTURE PRIORITY | SHOT HORIZONTALLY | WIDE DEPTH OF FIELD

The pastoral landscape is probably the most recognisable form of traditional landscape photography. From rolling green fields to mist-covered hillsides, these big open spaces are usually shot horizontally and often with a wide angle to show as much of the impressive surroundings as possible. Prioritising the aperture and choosing a wide depth of field ensures most of the scene is in focus. Travel landscapes may offer slightly different versions of this, from jungles and national parks to tea fields and the Arctic tundra. In Australia, the vast Outback invites being viewed from the air, with deserts, red earth and rocky outcrops under daytime cerulean or clear night skies. What connects these types of image, apart from the outdoor setting, is their focus on composition and the aesthetic of unblemished nature.

Uluru at dusk
DSLR, 16MM, 0.6 SEC, F11, ISO 400

Nature's Window, Kalbarri National Park >>
DSLR, 24MM, 1/60 SEC, F11, ISO 500 >>

True possession of a scene is a matter of making a conscious effort to notice elements and understand their construction. We can see beauty well enough just by opening our eyes, but how long this beauty survives in memory depends on how intentionally we have apprehended it.

ALAIN DE BOTTON

The Blue Boat House, Swan River, Perth
DSLR, 16MM, 5 SEC, F11, ISO 100

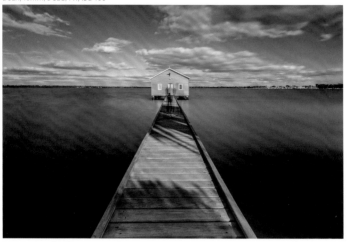

Shell Beach, Coral Coast
DSLR, 16MM, 1/800 SEC, F2.8, ISO 200

The pastoral landscape is usually shown without trace of human interference. And while I've seen many a photographer become impatient while waiting for a scene to clear, I'd suggest using what nature and chance have given us to enhance the image with a human or building for scale. It's often these photos that are chosen by editors, so compose your shot around fellow travellers or wait for them to wander into the frame. And, if there's a crowd ruining the composition, use a filter and a long exposure to blur them out and smooth the water in one fell swoop. A little blue boathouse on the Swan River in Perth has become a bit of an Instagram sensation, and I was dismayed to find a long queue there to photograph it. One group stayed for so long there was nothing for it but to whip out the LEE Little Stopper and use their opaque figures as an integral but unobtrusive part of the scene.

One of the hardest things about photographing Australia is the long distances between locations. On any road trip, especially an escorted one, you're likely to hit some hot spots in the middle of the day – not a time one usually wants to photograph, especially in harsh sunlight. It's doubtful you'll photograph Shell Beach on the Coral Coast at dawn or dusk, unless you've arranged to overnight nearby – with so much else to see in the area, itineraries usually have it pegged for mid-morning. On my second visit, I planned ahead, taking my tripod and an ND filter. Instead of capturing the scene in sharp focus, I lay down on the beach and opened up the aperture. Creating waves and blur through a shallow depth of field, I foregrounded the detail of one of the planet's only two pure shell beaches, eschewing the usual straight lines of land, water, horizon and sky.

THE
SEASCAPE

FOCUS ON WATER | ND FILTERS | LONG EXPOSURES | TRIPOD

Seascapes have been the darling of painters since time immemorial, and provide the kind of dreamy backdrop to many a photographic advertising campaign. Think sand and sea, and possibly one single person taking in the view, and you've summed up most summer holiday brochures. With reflected light and the possibility of sunsets or moon risings, a straight horizon that separates sky from open ocean and the smooth, becalmed surfaces created by long exposures, there are a myriad of possibilities to choose from. With changing tides, crashing waves and the gentle morphing of the shoreline as driftwood or seaweed comes and goes, it's the ebb and flow of the water's edge that makes capturing ocean scenes a mindful practice for the unhurried photographer.

Denham by dusk, Gutharraguda (Shark Bay)
DSLR, 16MM, 10 SEC, F22, ISO 200

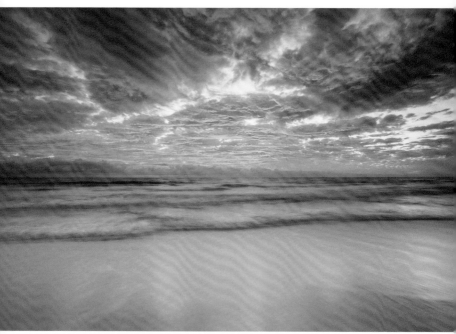

Mullaloo Beach at sunset, Western Australia
DSLR, 16MM, 2.5 SEC, F2.8, ISO 200

Photographing West Australia's coastline has become a long-time practice for me. I have a number of favourite locations, all within a short drive of my parents' house, north of Perth. What began as a simple desire to be alongside the Indian Ocean when the light is perfect became a bit of a photographic obsession. And I know that my Aussie family doesn't quite understand my need for a daily outing to the coast before sunset. After all, they see flaming red skies at the close of most days in WA.

With the movement of water, much depends on the weather. If the wind's not blowing or the water is static, you can capture some wonderful reflections but you won't be able to do much in terms of long exposures. However, a windy day at the beach will give you the choice to freeze the moment of dramatic waves, or slow down the shutter to capture the milky, mellifluous flow of the sea.

With tripod and filters, I'm always waiting for the optimal light, for the chance of that one spectacular sunset that's going to make the waves dance and glow. I started here with a wide depth of field (f16), shooting manually to ensure the correct exposure, and using live view on my camera display to check both the histogram and the area I wanted in focus. I used a LEE Big Stopper while it was still too light to slow any movement, but as sunset drew closer, I replaced it with a graduated ND filter to allow for detail in the sky. Finally, as the sun disappeared, I was left only with the afterglow. Shooting manually with long exposures of between 1 and 30 seconds, I played with the scene to create some impressionistic waves even Mr Turner might like.

Knowing a place well puts photographers on to a good footing. The only way to truly know how natural light will affect a landscape is to see it over time. In different seasons the tides will change and the direction of the sun's path will alter, demanding that we work from a new perspective or angle.

At Denham in the UNESCO area of Shark Bay, or Gutharraguda, the small town borders the ocean, making it easy to slip from a hotel on the main strip, whenever the light is at its best. Having a couple of nights here allowed me to recce for a dawn shoot the evening before – the next best thing to photographing somewhere familiar. Having chosen the lens, set up the camera and mounted it on the tripod, I cleaned the ND filters and put on an early alarm. Taking only minutes to dress and don a pair of sunglasses, I was on location within ten minutes of waking. It was August, and still the midst of winter in WA – a chill wind meant there wasn't another soul around until the sun well and truly appeared. Weathered and cold, I headed back for coffee, having shot the scene with different exposures and compositions, before any of my fellow travellers had even stirred.

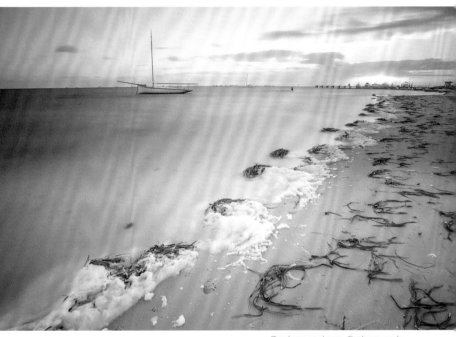

Denham at dawn, Gutharraguda
DSLR, 16MM, 30 SEC, F9, ISO 640

THE LOW-LIGHT LANDSCAPE

LONG EXPOSURE | SHUTTER RELEASE | HIGH ISO | WIDE APERTURE

From capturing stars and storms to the elusive southern and northern lights, low-light photography has become more popular as technology has developed, with better sensors and ISO capability to reduce **noise** (page 50). Astrophotography is a specialist field in itself, with international competitions and a growing number of dark sky reserves where star trails and meteor showers can be captured in all their celestial glory. And while composition can be challenging in the dark, especially focusing on and finding foreground action or subjects, there are a number of technical and practical things a photographer can do – from opening up the aperture and increasing the ISO, to using prime lenses, long exposures, cable shutter releases and decent stabilisation.

This starry scene from Purnululu National Park, in the Kimberley region, close to the Northern Territory border, just demanded to be shot in portrait orientation. The little hut was my home for a couple of nights, so it was easy to set up my tripod when everyone had gone to bed. If you are travelling in a non-photography group, be prepared to sometimes be the first one up and the last to sleep, if you really want to capture a location at its best.

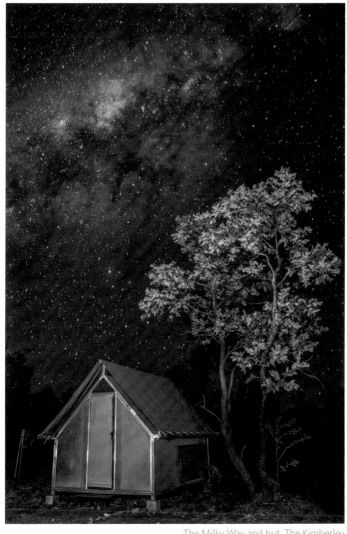

The Milky Way and hut, The Kimberley
DSLR, 28MM, 30 SEC, F2.8, ISO 1600

Australia's Golden Outback is one of the best places to see the night sky. Like Chile's Atacama Desert, it has virtually no light pollution and rarely clouds or rain to obscure the view. On a Gibb River Road group trip, I was camping in the Kimberley. I walked away from the crowd and campfire to a relatively dark spot behind our vehicle. Allowing my eyes to adjust to the scene, I used my head torch to find a tree that worked well with the very visible Milky Way. I set the aperture wide (because it was dark, and I wanted to avoid noise from an overly high ISO) with shutter speeds of up to 30 seconds (to keep the stars from forming a mini trail or blobs). Using a remote shutter release I took a number of images, painting the scene with soft strokes from my head torch. Trial and error helps to work out how much is too much light, but the trick is to keep the torch moving gently and to cease before the end of the exposure. Unfortunately, the foreground became lit up by the headlights of an arriving camper van, but I suppose this is an authentic part of the 'camping' story.

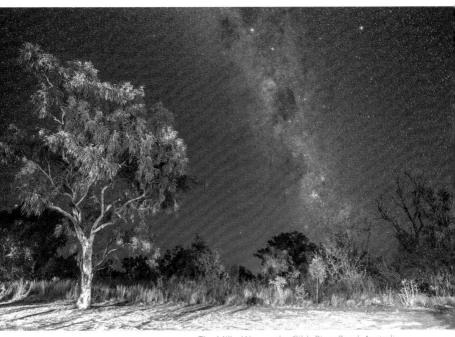

The Milky Way on the Gibb River Road, Australia
DSLR, 24MM, 30 SEC, F2.8, ISO 800

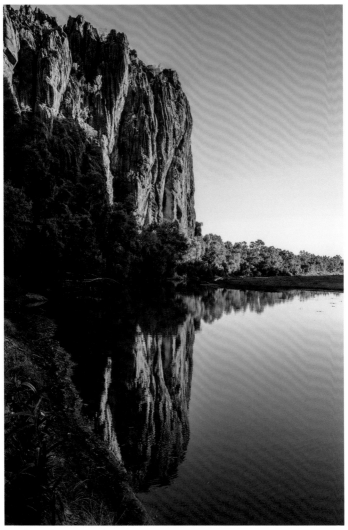

Windjana Gorge, Australia
DSLR, 35MM, 1/40 SEC, F11, ISO 200

THE VERTICAL LANDSCAPE

FOCUS ON DETAIL | VERTICAL COMPOSITION | COVER SHOTS

Although the vast majority of landscape photographers do not favour portrait orientation for landscape images (the clue's in the name!), verticals work well for magazine covers and are always required by photo editors. A vertical landscape draws our attention to different elements of a scene, from the downward flow of a waterfall to cliffs or vertical precipices. Using a telephoto lens allows the focus to be on something in the distance, like a lone tree, and the compression that comes from long lenses creates powerful and interesting scenes, varying the field of view and allowing for a greater depth of field.

There is something about capturing that fleeting moment in time, unexpected and often gone as quickly as it arrived.

JORDAN BANKS

THE AERIAL LANDSCAPE

HIGH ANGLE | DRONE OR FLIGHT | FAST SHUTTER

Aerial photographs were once rare, and only taken by the likes of Jason Hawkes or Yann Arthurs-Bertrand, so difficult or expensive was it to hire a helicopter or ride in a hot-air balloon. But with affordable drone technology and better stabilised lenses, it's possible to get great shots more easily now. From commercial aeroplane windows to bridges, or even the top floor of skyscrapers, you can be creative even if you're not able to pay for a scenic flight. If in a moving aircraft, depending on the speed of movement, you may want to prioritise the shutter rather than the aperture, though you'll need a wide depth of field for detail.

Before a camera is even touched much of the hard work of photography is done. The elements that make a photograph – those of location finding, pre-visualising, composing and planning – all come before a lens is fitted.

DAVID NOTON

Francois Peron National Park, Australia
DSLR, 24MM, 1/640 SEC, F11, ISO 200

Useless Loop, Gutharraguda (Shark Bay)
DSLR, 24MM, 1/400 SEC, F11, ISO 200

119

Wulyibidi, Francois Peron National Park
DSLR, 24MM, 1/500 SEC, F11, ISO 200

The first time I saw Australia's vast interior from the air, I was struck by how much it resembled Indigenous Australian dot paintings, with swirls and patterns one doesn't notice at ground level. Looking at my own archive of images of Australia, it's quite apparent that a lot of what I've photographed has been aerial, and some of my best ever travel experiences have been in a hot-air balloon or helicopter, so definitely worth the expense! I always love getting a bird's eye view of things, especially in a country as vast and unpopulated as Oz.

Seeing the remote landscape over WA's Shark Bay area is very different to the dolphin's eye view one gets at Monkey Mia beach, so getting up high gives another perspective and a real sense of scale. I tend to have two cameras when I fly for photography, one with either a 100–400mm or 70–200mm lens and the other something wider or prime – perhaps 24–70mm. This image of Wulyibidi, or Francois Peron National Park was taken at 24mm, so relatively wide to take in the curves of the water and inlets.

THE FUNDAMENTALS

APERTURE

Landscape photography demands that the aperture is given priority. A wide depth of field to keep the scene in sharp focus requires f11 or higher. Smartphones have an HDR setting that enables bracketed exposures to be stitched together in camera, as well as the option to make sweeping panoramas.

THE RULE OF THIRDS AND COMPOSITION

The rule of thirds divides the frame equally by two vertical and horizontal lines. Where those lines intersect, it is argued, lies the most power. Leading lines that draw the spectator in will often cross in from the bottom third, through the middle to the top.

FOCUS POINTS

Aim to focus about a third of the way into the composition, and look for foreground interest as well as paths and streams that create natural leading lines.

FOCAL RANGE

A wide angle of around 16mm or 17mm is often favoured by landscape specialists, though some go even wider, with panoramas or ultra-wide lenses. For verticals or picking out detail, focusing in from a distance with a telephoto lens works well. With aerial photography, 35mm or 50mm angles give something of a human-eye view of the scene, and prime, fast lenses are good when not on solid ground.

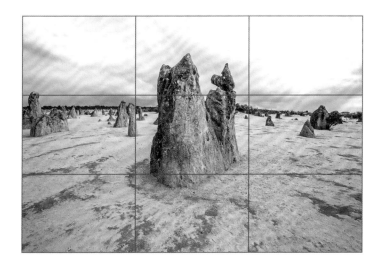

WHITE BALANCE

With sunsets and warm light, auto white balance (AWB) will often reduce the depth and saturation of red and orange tones in JPEGs. Choose the cloud or rain settings to compensate. In editing software, adjust RAW images by switching from 'auto' to 'custom' white balance, and use the sliders to restore hue, tone and saturation.

EXPOSURE AND METERING

In manual or aperture priority, check the histogram and exposure meter to ensure the sky is not overexposed. Point the camera towards the brightest part of the scene and take the meter reading from that, adjusting as necessary for what else is in the frame.

ND AND POLARISING FILTERS

From graduated ND filters which darken the sky to full-on Big Stoppers, filters are the landscape photographer's best friend. A good polariser can be turned to adjust reflections on water, and work well for rainforests and waterfalls, while a graduated ND is essential for daylight land and seascapes.

EXPOSURE BRACKETING

If working without filter systems, use the camera's **exposure bracketing** mode to reduce the chance of over or under exposing, and blend them together in processing.

LONG EXPOSURES

Keep the shutter open for low-light scenes and smooth waterscapes. Experiment with anything from one to 30 seconds, and use a timer or a cable shutter release to avoid camera shake.

The Milky Way over The Outback, Northern Territory
DSLR, 24MM, 30 SEC, F2.8, ISO 800

STABILISATION

A tripod and head are de rigueur for photographing landscapes. Go for a lightweight but sturdy carbon-fibre option – it'll be worth its weight in gold once you've trudged up a few hills with it.

AERIAL PHOTOGRAPHY AND SHUTTER SPEED

Constant movement makes photographing from the air more challenging, so prioritise the shutter and increase it to around 1/500 seconds – as fast as you need for the conditions – and take care with vibrations from windows in planes and helicopters.

125

AN EXPERT'S VIEW
JORDAN BANKS

Jordan Banks is an award-winning London-based photographer, with over 20 years' experience in travel and commercial content for clients like British Airways and Panasonic. His work appears regularly in travel publications, from *National Geographic Traveller* and *Wanderlust* to Bradt Guides. A brand ambassador for LEE filters and f-stop gear, Jordan is the 2020 *National Geographic Traveller* (UK) Cities photographer of the year. Jordan gives talks and teaches for photographic training company That Wild Idea. He's recently become the picture editor of travel magazine, *JRNY*. **jordanbanksphoto.com**

How do you organise your schedule if you only have limited time in a destination?
As much as I'd love it not to be, there is always a deadline just around the corner so making the best use of my time on location is extremely important. I will put together a detailed shoot schedule and route plan that ties locations together to avoid any unnecessary time spent travelling. How much time I spend at a location varies from assignment to assignment, but as a general rule I will allow for a hero shot at sunset and sunrise in roughly the same area. I use the times either side of these periods to capture some variant images and scout locations when required.

Aurora borealis at Kirkjufell on the Snæfellsnes Peninsula, Iceland
DSLR, 16MM, 25 SEC, F4, ISO 3200

Thor's Hammer, Bryce Canyon National Park, Utah, USA >>
DSLR, 16MM, 0.8 SEC, F16, ISO 100 >>

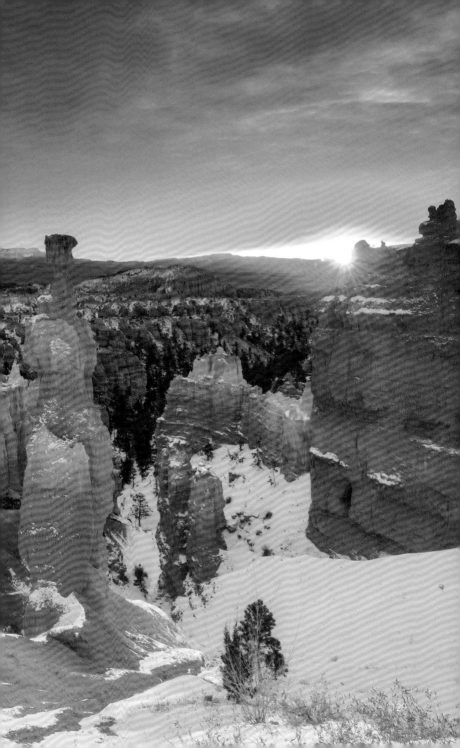

What kind of research do you undertake before embarking on a landscape shoot?

I am a big believer that 70–90% of a great photograph is created in the research/planning stage. Before an image is ever taken, I will have spent hours researching locations in search of the best views, angles and, most importantly, timings. I use apps to research, and reference images from the web, magazines and social media for the ideal time of day and year to shoot certain locations.

Do you ever previsualise the shots you want to get?

I fully previsualise the shots I want to get. The atmosphere, the light, the feeling and the emotional connection with the viewer are all playing a part in my process. In recent years I have found myself using Google Earth in 3D to allow me to compose certain shots from my studio. Even if it is a very rudimentary method of visualisation, I have found this process to be a helpful addition to my workflow.

What's the most important equipment for you when out and about photographing landscapes?

Aside from the obvious camera and lens, my most important tools are my LEE filters. Ninety per cent of my landscape images will have some form of filter applied. I don't believe in adjusting the image to be something it's not, but filters give me the power to control and direct the light which is very important in my workflow.

Have you even taken a great landscape shot without a great deal of pre-planning?

It doesn't happen often but yes. Every so often everything comes together, and a perfect scene just appears in front of you. I often find

these are some of my personal favourite images from a shoot. There is something about capturing that fleeting moment in time, unexpected and often gone as quickly as it arrived.

Do you have a preferred style for landscape photography?
While there is not one particular aspect, I am a big fan of landscapes that include some life or reference points. This may be breaking away from traditional landscape photography, but I feel including relatable aspects within the landscape helps entice viewers and make the scene appear more realistic.

What advice would you give to someone keen to improve their landscape photography?
Get out, shoot and practise. Landscape photography is all about trial and error so the more you practise, the quicker you will improve. There is also an element of luck involved, so the more you put yourself out there, the better. Amazing scenes appear every day – it's just a matter of being in the right place at the right time.

The atmosphere, the light, the feeling and the emotional connection with the viewer are all playing a part in my process.

JORDAN BANKS

ASSIGNMENT 1
PHOTOGRAPH
A LOCAL LANDSCAPE

- Find a place close to home that would make a good subject for a landscape image.
- Check the weather ahead of time, and plan accordingly.
- If possible, visit the location a day or two before your shoot, and locate where the sun rises and sets.
- If you can only visit once, make it when the light is at its best, either in the early morning or late afternoon. In mountainous or hilly terrain, there can be shadows, even during golden hour.
- Walk around and take some recce shots, changing your angle until you find a spot you feel works well in terms of composition.
- Are there any structures that could provide a focal point? Look for leading lines, rocks or trees.
- If you have a tripod, set it up in readiness for optimal light conditions. Be ready with enough time to spare.
- Set up the cable or remote shutter release, or use the timer to avoid camera shake.
- Aim to focus about a third of the way into the scene. Use a single focus point and try to manually or automatically focus exactly where you want the viewer to look. Touch screen LCDs in live view make this extremely simple.
- Point your camera at the sky and check the exposure, adjusting the aperture accordingly. Use a deep, wide depth of field, like f11.

- If the landscape is an open one, consider how much of the frame will be taken up by sky, especially if you are not using a filter system and need to avoid clipped highlights.
- Shift the horizon up to the upper third if the sky is too bright, or down to the lower third if the foreground is distracting.
- Take a test shot and check for focus, exposure and composition.
- Recompose and change your settings if necessary, adjusting by a third of a stop each time, regularly checking the histogram.

REFLECTIONS

Check your images on a computer screen and enlarge them to ascertain quality. If the majority of the image is in focus, and you're happy with the composition, that's wonderful.

Look at the histogram in your photo-editing software and check whether the graph is weighted more towards the right or the left. Are parts of the image too bright or dark, and did you compensate for exposure well enough, with a white balance that reflects the colour palette of the scene as you remember it?

Choose your best three to five images to review:

- ☐ Is the image aesthetically pleasing and does it live up to how you previsualised it?
- ☐ Is there foreground interest?
- ☐ Are there leading lines that guide the viewer into the frame?
- ☐ Did you focus one third of the way into the image?
- ☐ Is the majority of the photograph in focus?
- ☐ Is there a good dynamic range, or balance of dark and light tones?
- ☐ Did you experience a state of flow while you were working?
- ☐ Did you shift position once you had set up the tripod?

☐ Did you adjust your settings with the changing light?
☐ Does the image need to be heavily processed or was it captured well in camera?

Many photographers use editing software to creatively enhance their pictures, so much so that reality often cannot live up to the comparison. There is a tendency to overprocess landscape images, especially for Instagram. What's most important is that you try to capture the best image possible in the camera itself. Once you begin working with filters and long exposures you'll be more able to take creative control of the image, taking less time for processing – which, in my opinion, can only be a good thing!

ASSIGNMENT 2
PHOTOGRAPH WATER OR A SEASCAPE

- Find a place where water is prominent.
- Compose the shot in different ways. Try changing the angle by adjusting the legs of the tripod or tilting the head to experiment with the horizon.
- Keep the depth of field wide and take sharp images of the waves or water. Still ponds and pools are great for reflections, especially from a low angle.
- Shoot either in manual or aperture priority.
- If previous photographs had an over exposed sky, stop down one-third and take test shots, checking your histogram.
- Turn on the highlight alert so you know when there are blown highlights or clipping.
- Check settings and adjust with the changing light. Stay after the sun has disappeared and take long exposures for movement.
- Use a cable or remote shutter release, or set the timer to avoid camera shake.
- If using a filter kit, give yourself time to experiment and take test shots. Exposure times depend on the available light, cloud cover and the strength of the sun, all of which can transform in seconds.
- It's best to focus the shot manually before putting on strong filters. When photographing at night, use manual focusing and a head torch to help locate key subjects.

GENERAL ADVICE

- Do an advance Google image search to recce the landscape.
- Write out a shot list.
- Previsualise the ideal, 'hero' images.
- Stay in key locations for more than 48 hours to maximise the recce time and options to wait things out; think one daytime recce, two sunsets and at least one sunrise.
- Download the Photographer's Ephemeris app to check times and angles of the sun.
- Remember that the season will alter the sun's path and intensity, as will other atmospheric conditions.
- Try to shoot RAW where possible. If shooting in JPEG, take the white balance off auto for sunsets.
- Revisit a location you know well at different times, year after year.
- Always use a tripod and timer or remote/cable shutter release for long exposures.
- Invest in a set of filters, and practise before travelling.
- Always take trial shots on location, then look for an original viewpoint. Walk around and look for a fresh perspective.
- People, trees or animals can provide a sense of scale in otherwise overwhelming landscapes.
- Remember the rule of thirds for the placement of focal points or subjects, and look for diagonal or curved leading lines.
- Change your angle – get low to include rocks and other foreground interest or climb higher for a vantage point – in a hot-air balloon, aircraft or on a rooftop.

- Shoot a variety of types and angles to cover the bases and give photo editors choices.
- Generally, aim to get landscapes in focus, but play with aperture and exposure for creative effects, especially when photographing water and low-light scenes.
- Be flexible. If the weather changes, or if it's just not happening, look in the opposite direction or just pick up and move.
- Be well prepared. There's a lot of waiting for the light, so have snacks and a drink. Make sure you have a fully charged phone if you're photographing alone.
- Imitation is the sincerest form of flattery and there's nothing wrong with being inspired by other photographers initially – students learn technical lessons from recreating great shots. You'll soon find your own, unique style, and begin to spot original compositions.

THREE PHOTOGRAPHERS TO FOLLOW
David Noton davidnoton.com
Babak Tafreshi babaktafreshi.com
Max Rive maxrivephotography.com

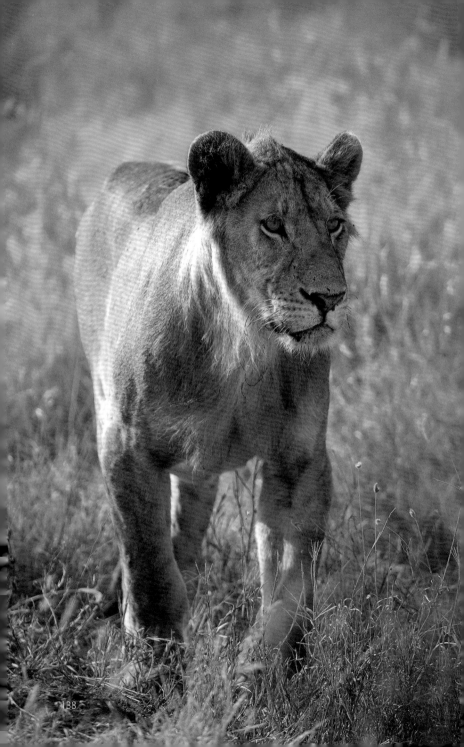

Amber-eyed lioness extreme close-up
DSLR, 350MM, 1/1600, F5.6, ISO 640

Lilac-breasted roller
DSLR, 400MM, 1/400, F5.6, ISO 100

145

THE PORTRAIT

SINGLE ANIMAL | FULL BODY OR HEAD AND SHOULDERS |
SHUTTER PRIORITY

Unlike humans, wild animals don't play ball when it comes to sitting still for their portrait! You'll mostly need to prioritise the shutter and activate **AI servo** or continuous autofocusing mode, as well as increase the ISO. It's also hard to change position or angle if you're embedded in a quiet hide or safari vehicle, likely ensconced next to people with their elbows out. In those situations, a range of lenses or an adjustable zoom allows for more flexibility. A beanbag or monopod provides good stabilisation in cramped conditions like Zodiacs where movement makes fast shutter speeds essential. Static animals can be photographed in aperture priority, opened up to defocus an unappealing background or bring the subject to the fore. And it goes without saying that flash should be disabled.

The sky is my canvas and it's amazing what you
can see when you look up; birds of prey,
swirling swifts, migrating thrushes,
raucous crows. It's a beautiful world up there.
DAVID LINDO

> If you want evidence of how life is struggling to cope in our rapidly changing world, you need to look no further than here in Africa.
>
> SIR DAVID ATTENBOROUGH

In Africa we're now looking at safari tourism from a very different perspective. The double whammy of drought and almost zero international travel during the Covid-19 pandemic years has put Africa's wildlife under serious threat, with poachers continuing to wreak havoc. But if global warming is creating a series of climatic changes that will exacerbate drought in years to come, there's even more of a dichotomy between choosing to fly to Africa to see its wildlife, adding to our own carbon footprint, and actively supporting nature and communities through our visits. There is no easy answer, but we can be guided by ethical tour companies – and listen to the climate change scientists.

Booking your trip with a trusted operator will put dollars where they really matter or, better still, you could photograph locally. If using a long lens, you'll mostly be far enough away to not encroach on an animal's space. What's more, at a respectful distance, you're highly unlikely to disturb by using continuous burst mode. This is the one time to bring out the super long lenses – and be proud about it. And, of course, if you're going to get up close and personal, work as you would with people – quietly, respectfully and with a much smaller camera set-up.

Photographing animals in the wild is a magnificent privilege. I've been fortunate to have seen humpbacks breach and fluke in the Kimberley and Antarctica, polar bears hunt in the Arctic and giant pandas munch on bamboo in Chengdu. None of us should ever take these experiences for granted, and it's vital that we understand the role that sustainable tourism can play in protecting wild habitats and the species that live in them.

For wildlife photographers, the big hitters like megafauna and apex predators will understandably be the major draw, but the little critters can be just as endearing. I shouldn't have been surprised that on his first ever visit to London, my Australian nephew Miles was as fascinated by grey squirrels as I have been by Rottnest Island's quokkas. Similarly, using a macro lens to photograph insects and microfauna reveals a backyard world as fascinatingly biodiverse as any savannah or Arctic tundra.

We must keep reminding travellers that places like the Masai Mara conservancies represent our last chance of protecting iconic wildlife. They desperately need tourism to provide local communities with an incentive to value and care for these animals and their wild spaces.

SIMON REEVE

Images can help us understand the urgency many photographers feel to protect wild places. My work is about building a greater awareness of the responsibility of what it means to be human. It is about understanding that the history of every living thing that has ever existed on this planet also lives within us. It is about the ethical imperative – the urgent reminder that we are linked to all other species on this planet and that we have a duty to act as the keepers of our fellow life forms.

CRISTINA MITTERMEIER

photographing wildlife on trips out of reach for many. Still, it didn't stop me from being dubious about high-end tours and luxury lodges all over Africa that seemed so out of touch with local life and, well, a bit postcolonial for my liking. The idea of taking trophy photos when so recently – and still in some places – going to Africa to 'bag' the big five was synonymous with shooting, stuffing and wall-mounting a majestic animal just didn't sit very well with me.

It took a professional photographer friend in Canada to talk me round. We travelled with one of the world's largest adventure tour operators that has long been at the forefront of sustainable and ethical travel. With its own not-for-profit foundation, they are now leading the way in certified B Corp travel, where the social and environmental impact of their tours is as important as any profits made. Instead of 'adventure', they talk of *sustainable, experience-rich travel*, and there are many other great B Corps and ethical tour companies doing similarly good work. So, my notion that the trip might be a bit 'Out of Africa' was, well, wrong. However, we all know of many examples where profit is put before animal welfare, from performing orcas to zoo animals kept in too-small cages, and it's very important to be vigilant about who we choose to give our money to.

In Kenya and Tanzania, the drivers and guides were local and knew everything there was to know about their environment. They guided us in how to get the best out of the trip, not simply the best photos, and thought about the well-being of the wildlife as much as the human animals who had come to view them. What's more they took us to towns and villages to meet and spend time with locals, teaching us Swahili phrases, the most memorable of which was *nimechoka sana* (I am very tired) – easily remembered after more than a week of consecutive 3am alarms for dawn safari drives.

WILDLIFE

FOCUS ON
AFRICA

Wildlife photographers are a breed in themselves, dedicating their practice to documenting all the world's creatures, large and small. But despite loving nature and having a slight obsession with Sir David Attenborough myself, photographing Africa's wildlife had not featured high on my wish list. I suppose I had preconceived notions about what 'expensive' safaris in Africa might look like. A long stint living in Latin America had altered my perspective on travel, giving me an insight into the advantages of journeying independently and sometimes solo, finding my way in local communities and staying for longer than a two-week itinerary might allow.

But my views about luxury lodges and elite safari travel were, I concede, rather hypocritical and ill-judged. While living in Chile I'd happily paid to visit the Galapagos Islands and Antarctica,

< ANIMALS IN THEIR ENVIRONMENT Lion in the Serengeti
< DSLR, 400MM, 1/250, F5.6, ISO 100

On a dawn drive in Tanzania, we had stopped for some time to watch a lioness. Just when we weren't expecting it, she then got to her feet and strolled towards us, crossing close to the front of the vehicle without so much as a second glance. She'd obviously seen it all before and had learned not to fear the truck. We remained silent, transfixed by her beauty, her amber eyes and the experience of being in such close proximity. It's difficult not to get overwhelmed when animals come very near. (I once froze when a walrus looked about to take a chunk out of our Zodiac and I was next in line for dinner, and being chased by a leopard seal had me more concerned about sinking in the Southern Ocean than getting the shot!). When animals approach, try to remain calm, stay safe and go with the flow, cropping in for a headshot if using a telephoto lens. Then photograph, as they begin to move away from you, capturing more of the surroundings and context. Play with the shutter and aperture for different effects on the background, and, if you're able to get a high or low angle by crouching or standing on a seat or platform, the altered perspective can be dramatic. With only seconds to act, you'll need to be prepared.

ANIMALS IN THEIR ENVIRONMENT

FOCUS ON HABITAT | RULE OF THIRDS | WIDE DEPTH OF FIELD

The beauty of photographing animals in their environment is that we don't need to get too close. Those without long lenses can capture the landscape as well as the fauna at 35mm or wider. Look for natural structures that work sculpturally and use a deep depth of field to get the entire scene in focus, with the subject as priority. For large groups or moving animals you may need to motion-track them, but mostly slow-moving wildlife can be captured in one shot mode from a distance, in shutter or manual mode. When surveying large vistas like an African savannah, look around for different compositions as there's likely to be something going on behind you. Where possible, get low, change angle, look up and keep moving.

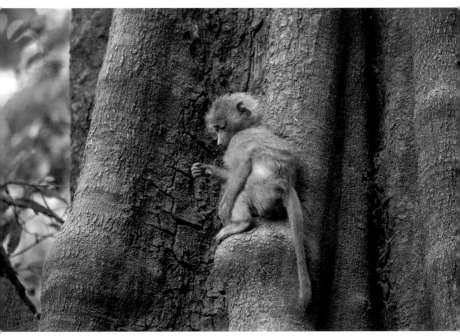

Taking a breather
DSLR, 400MM, 1/125 SEC, F5.6, ISO 3200

King of all he surveys >>
DSLR, 400MM, 1/400 SEC, F5.6, ISO 320 >>

Capturing an animal doing its thing in its own natural environment can open windows into worlds we often overlook. It needn't be a polar bear on an ice floe: a turnstone on the shingle or a bumble-bee exploring a foxglove can be just as powerful, reminding us that the planet is shaped for species other than our own.

MIKE UNWIN

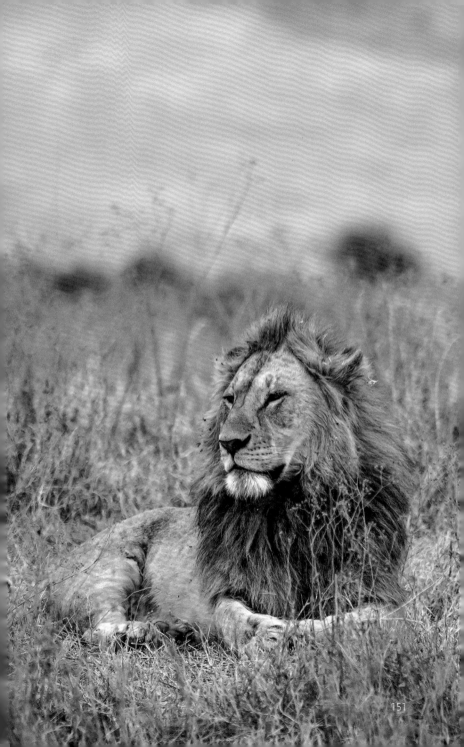

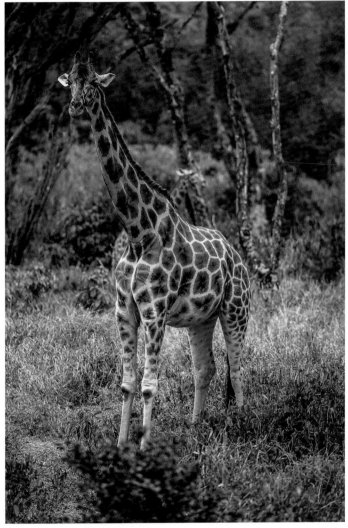

Standing tall at the Giraffe Centre, Kenya
DSLR, 400MM, 1/320 SEC, F5.6, ISO 200

Giraffes in the wild are often difficult to separate from their background, camouflaged as they are by similarly coloured tree bark or their neighbours. Given their long necks and limbs, it can also be challenging to compose the image so it's not a mess of legs, with the head lost between a tree's leafy canopy.

In wildlife sanctuaries, like the Giraffe Centre near Nairobi, giraffes are quite used to the company of humans – so much so that they'll stand still in the open for longer periods than seems normal in the wild. Created in 1979 by the African Fund for Endangered Wildlife, the centre protects this near-threatened subspecies that inhabits the grasslands of East Africa. Working with local schools and communities on education and conservation awareness, the support that comes from overseas visitors and donations is invaluable.

Some would argue that photography isn't as challenging in sanctuaries – and they'd be right! – but this is definitely part of a travel story, experienced by many and definitely worthy of documenting. Of course, you could never enter the Wildlife Photographer of the Year without acknowledging that the animal was brought to meet you, but wilderness parks are a great place to see and photograph fauna you wouldn't ordinarily get close to. Again, check the credentials of any park or nature reserve you visit. Most are providing sanctuary, rearing orphans or nursing injured animals back to life. Working with wildlife that's likely being decimated in the wild, it makes the idea of 'captive' animals very much a misnomer, and our visits are a necessary part of the funding for breeding programmes and care. >>

Photographers often heed good advice and rent or buy the longest lens possible for a magnificent, once-in-a-lifetime wildlife tour. They've quite likely splurged on the trip itself and waited many years to make the dream come true. The thought of missing a brilliant photo opportunity creates an extra piquancy and jeopardy – we're on high alert, staying on the deck of an Arctic expedition ship long after everyone else has retired or crouched in a cold hide for hours. And then, to add insult to the credit card bill, an animal pops out of nowhere, saunters nonchalantly within metres of a colossal lens, and the image is out of focus!

I've learned over the years that it's vital to have two cameras on the go for wildlife – one with a wide enough lens to get environmental shots or close-ups, and the other a good, sharp telephoto for capturing detail or animals that stay well in the distance. You'll never have time to change lenses in those circumstances, and it can be rather distressing to miss the shot because we're closer than expected. Compact and mirrorless cameras are light enough to carry as an additional piece of kit, or a good smartphone can do the job in an emergency, as well as shoot a little bit of video or slow-motion footage.

At the Giraffe Centre, the excitement I felt when a thick-lashed beauty stuck its head next to mine on the observation deck cannot be fully expressed in words. They were literally eating out of the palms of our hands – so close in fact, that a photograph could only be taken by stepping away. It's times like these when I want to choose the experience over the perfect photograph, but when balancing between being in the moment and getting the job done, things obviously have to tip towards the latter.

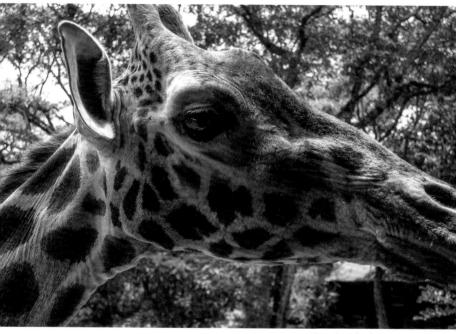

Too close for focus
DSLR, 35MM, 1/400 SEC, F5.6, ISO 400

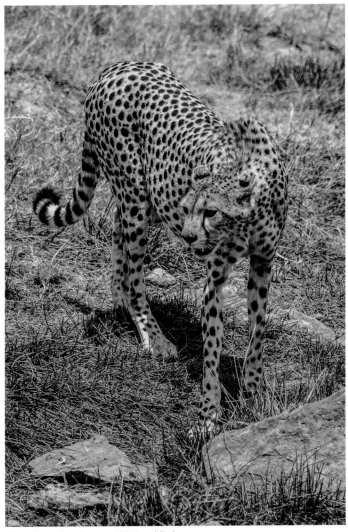

Cheetah on alert, Serengeti National Park
DSLR, 400MM, 1/3200 SEC, F5.6, ISO 640

ANIMAL BEHAVIOUR

MOVEMENT AND TRACKING | GROUPS | MOTION BLUR | STABILISATION

Many animals hunt or hide by blending into their surroundings, often through camouflaged coats and plumage. Subsequently, this can make picking them out from their background a challenge. Safari drivers will position vehicles at a decent angle, but not anywhere that might stress the wildlife. Editing in black and white or desaturating a little can subdue distractions, as can panning with a moving subject to blur backgrounds. Local guides know the best vantage points and times, and photographers who specialise in geographical areas often become familiar with their subjects, almost being a part of the ecosystem themselves. Photographing local or urban wildlife is advantageous, allowing for patient observation over days and even years, with time to be well prepared, anticipate activity and document a range of behaviours.

You can always sense when an animal is at ease in an image, and I would trade one hundred photos of elephants in protective herds, however beautiful, for one photo of an animal at complete ease.

HARRY SKEGGS

There are places in the world where elephants can be observed in their natural habitat, without causing them stress or harm. Again, the balance between wildlife tourism and conservation is a delicate one. Like many of the world's great fauna, they are under threat from poachers and the effects of climate change. As Sir David Attenborough explained on the BBC's *A Perfect Planet*, adult elephants need to drink around 200 litres of water a day, and when the rains failed in 2020 in Kenya, thousands of elephants died.

Seeing elephants in the wild both in Africa and Asia has been thrilling. On drives in Kenya and Tanzania, we viewed giant herds in their natural habitat, behaving in the ways we'd only seen on natural history programmes. We cut the engine to watch adults spraying water and helping calves emerge safely from steep-sided water holes. If elephants feel stressed or under duress they will gather in protective groups, using each other and any nearby trees to create a place of security. When they're in herds but behaving naturally, you can be sure they're in their element, despite the presence of onlookers. Watching them wallow in the water and wrap their trunks affectionately round each other, it seemed to me that we weren't too close to affect their natural activity. Being at a safe distance is the most rewarding way to see animals in the wild, but I will admit I've been in other countries where this has not been the case. It's important to speak out about unethical operators, even talking to the guide at the time if you feel an animal's welfare is being compromised.

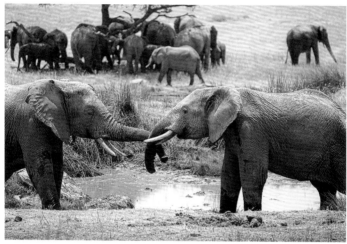

Elephants at play
DSLR, 200MM, 1/2500 SEC, F5, ISO 640

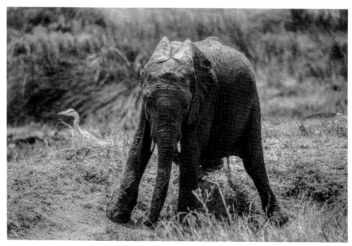

Unsteady legs
DSLR, 400MM, 1/2500 SEC, F5.6, ISO 640

DSLR, 400MM, 1/800 SEC, F5.6, ISO 640

DSLR, 400MM, 1/500 SEC, F5.6, ISO 320

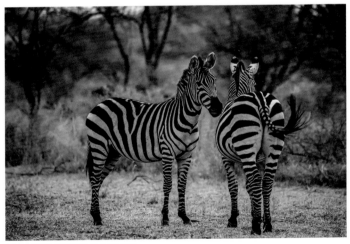

DSLR, 360MM, 1/200 SEC, F5.6, ISO 3200

IT'S IN THE DETAIL

CLOSE IN ON DETAIL | MACRO OR ZOOM | SHALLOW DEPTH OF FIELD

From macro lenses that amplify features of a mini-beast not discernible to the human eye, to prime telephoto lenses that pick out elements of a faraway scene, it's the detail of wildlife that adds variety to storytelling. The underside of a predator's paw or a swishing, furry tail brings it closer to the viewer, sometimes seemingly rendered in 3D. Similarly, facial expressions, feathers on birds or the scales on a reptile help to create character, much the same as unique detail does for human subjects. Eyeball to eyeball, the personality of an animal becomes prominent. Humour or drama can be foregrounded in the sweep of a brow, bared teeth or the view of a beast's bottom, with relationships expressed through contrasts and similarities.

Alert photographers notice the detail of an animal encounter, conveying unexpected intimacy: the reflective sheen of a moth's wings, or the startling compound eyes of a dragonfly.

JAMES LOWEN

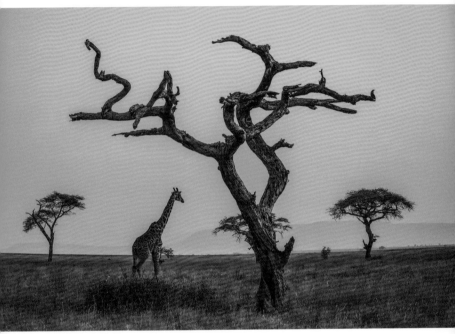

Sculptural giraffe and acacia trees
DSLR, 100MM, 1/100 SEC, F5.6, ISO 400

GETTING CREATIVE

COMPOSITION | COLOUR PALETTE | JUXTAPOSITIONS

Shooting at dawn and dusk means working with some of the best available light, and in Africa that will often be sublime. From backlit lions and silhouetted giraffes, look for patterns in the environment that work alongside the wildlife. Groups of three work well together (and often seem to be a natural composition with mothers and offspring in tow). Leopard cubs silhouetted on a tree branch and small birds hitching a ride on a buffalo form juxtapositions in shape, colour and size. The dust kicked up by a herd of wildebeest creates an atmosphere of its own, particularly when infused by shafts of light. And when animals don't materialise, capturing acacia trees at sunset will employ your landscape photography skills to create fine-art prints or creatively rendered images that work well as magazine double-page spreads (DPS) or **establishing** openers.

REPORTAGE AND PHOTO STORIES

THEMATIC PORTFOLIO | VARIETY OF SHOTS | TONALLY LINKED

Telling the wider story of an animal and its habitat might well lead you into a report on climate change, conservation or poaching. Documenting the whole story is as important as getting great images, so aim for a variety of shot types, from close-ups to wide, establishing ones. Don't be afraid to show the human element in the story, be it onlookers at an animal sanctuary, animal rangers and even negative behaviour. It's a jungle out there, and wildlife stories do not always need to be warm and fuzzy. Aim to tie the story together through the colour palette or tone and atmosphere, perhaps shooting consecutively at the same time each day or by **colour grading** in the digital darkroom. Think about the message or story you want to convey as this will inform everything, from the tone of your shoot to what you choose to focus on, highlight or leave out.

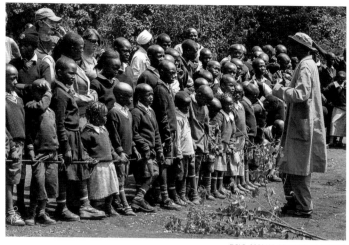

DSLR, 100MM, 1/80 SEC, F9, ISO 320

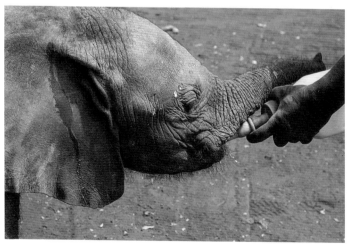

DSLR, 85MM, 1/400 SEC, F9, ISO 400

At the Sheldrick Wildlife Trust's Tsavo East National Park elephant sanctuary, the behaviour of the species is seen in close quarters. Feeding time is joyous and energetic: orphaned babies run headlong towards their keepers, knowing that there's a bottle of milk waiting – they drink gallons every day. Afterwards, a good hosing creates a mud bath the elephants just cannot resist. Photographing the whole story meant capturing the build-up, the anticipation of local school children, the arrival of the elephants in clouds of dust and the thrill of them running towards their feed – and us! – followed by the feeding frenzy and energetic water-play.

The thought of Africa devoid of
elephants is heart-breaking enough –
but the impacts of losing these animals
will be of extreme detriment to the environment
and beyond; entire ecosystems could follow
as they are a keystone species and
important ecosystem engineers.

HOLLY BUDGE

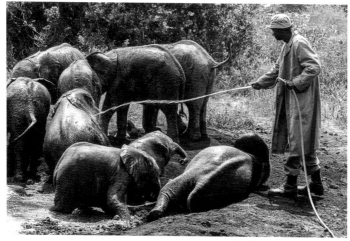

DSLR, 100MM, 1/100 SEC, F9, ISO 500

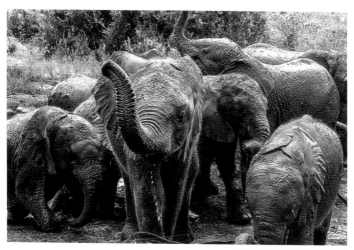

DSLR, 50MM, 1/125 SEC, F9, ISO 400

THE FUNDAMENTALS

FOCAL LENGTH AND SHUTTER SPEED

The general rule for hand-held long lenses is that for every 100mm of lens we need 1/100 of a second – so a 300mm lens requires something like 1/300th of a second to avoid blur. In-built lens and camera image stabilisation can also help reduce shake.

ISO

In suboptimal lighting, increase the ISO for sharp, hand-held images. Experiment with local wildlife to explore your camera and lens combo. At dawn and dusk the ISO needs to be fast. Adjust it back down to 100 when the day brightens, after a morning shoot.

HALF DEPRESS FOCUS BUTTON

Half depress the focus button, and look for the indicator that the subject has been locked on to. This allows you to then move the camera and recompose, while locking focus in.

FOCUS POINTS

For animals in general, and especially those hidden amid trees and leaves, a single, central focus point is always safer than the multiple points or tracking mode, where the sensor darts around the frame looking for moving objects. For herds of wildebeest that more or less remain static, choose a focal point and a wide depth of field to keep the entire scene in focus.

AI SERVO OR CONTINUOUS AUTOFOCUSING MODE

Servo or continuous tracking mode is especially useful for refocusing on an animal that's moving towards or away from us. Combined with the multiple focus point mode, some cameras can anticipate movement, and work well for tracking birds in flight where the sky provides a blank canvas and reduces the chances of focusing on the wrong element.

PANNING AND MOTION BLUR

Motion blur can add drama to the natural behaviour of animals. Keep the single focus point trained on the moving animal's face, and pan with it, experimenting with slower shutter speeds for more drag and blur in body and background.

CONTINUOUS BURST MODE

For freezing action, a series of images with a fast shutter speed will allow for a high-speed hunt to be captured, a bird in flight or one landing with wings fully expanded.

STABILISATION

From a stationary safari vehicle, a beanbag can provide a cushion for a long lens that's poked above the roof or through a window. On Zodiacs or moving vehicles, a monopod is a space-saving support, and a tripod is necessary for environmental shots, sunsets and sunrises.

AN EXPERT'S VIEW
HARRY SKEGGS

Harry Skeggs is a multiple award-winning wildlife photographer, working solely with camera in hand to get close to animals on their terms. Animal welfare and ethics underpin Harry's work, and he is proud to support Generation Tusk both as a founding member and by donating a percentage of sales to support conservation work across Africa. Harry works with leading names, from *National Geographic* to Nikon, and is represented by galleries worldwide. **skeggsphotography.com**

Are there particular types of wildlife or locations where you prefer to photograph?

I am particularly interested in animals that challenge me and can give the biggest impact in a piece. As a result, I tend to focus on predators and megafauna, as there is something so compelling about staring down a male lion in a photo or coming face to face with a cruising humpback whale. Working in close proximity to these animals is also exhilarating and I am always seeking to convey this sensation in my work.

What's the most important equipment when photographing wildlife?

Lenses are the absolutely critical element. I print on a large-scale format, ideally between 40–100", so a high-resolution camera is

a given; however, the optics need to be perfect. I lean towards relatively wide-angle primes, both because they are tack sharp, but also because it forces you to get close and allows you to capture the wider context of a shot, the habitat and skies. For this reason, I always prefer to shoot with a 35mm or 85mm where possible.

Is it possible to be a wildlife photographer and never leave your home country?

Absolutely! Great wildlife photography is so reliant on understanding your subject, its quirks and habits, as these will ultimately give enough clues to pre-empt a shot. Often this level of understanding means spending a lot of time with these animals so some of the best photographers are those who live alongside their subjects and see them daily. Photography is also about sharing your unique world view, not just adding more interesting subjects. A creative photo of a rabbit will always be more artistically compelling than a lion in the shade.

Does wildlife tourism have a positive impact on conservation?

It certainly has the ability to, when properly managed. The travel industry can be very lucrative for emerging countries and when this is used to support both the people and the environment through forward-thinking conservation policies then it is a real force for good. However, with money can come greed, and corruption in governments is all too common meaning these much-needed funds don't find their way to the places that need them. Tourism, where not through an ethical and conscious provider, can lead to overcrowding and mistreatment of animals, destroying the very resource that once drew the crowds. Travel with an eco-conscious provider, so your trips can be part of the answer, not the problem.

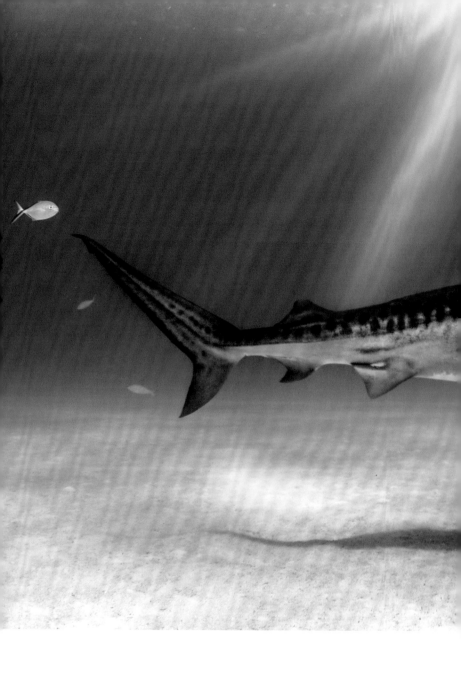

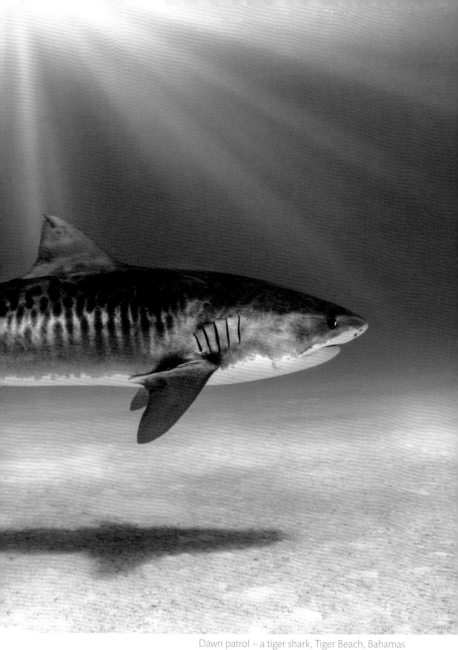

Dawn patrol – a tiger shark, Tiger Beach, Bahamas
DSLR, 17MM, 1/250 SEC, F8, ISO 400

Do you have any special considerations for photographing wildlife, especially regarding ethics?

Yes, this is hugely important for me and really the bedrock of my work. I am committed to showing the world as it should be, wild and free, so we work very hard at ensuring our subjects are at complete ease. We study their body language extensively, so we know when we have outstayed our welcome and give the animals the space they need. This means that when we are in their presence we are always on their terms. Often this means we can't get the shot we are looking for, but there is never a shot worth taking that puts any stress on an animal. The shot that you do eventually get is always the better for the wait. Wildlife photography should act as a window to the wild places left on our planet and there is never an excuse for manoeuvring animals, cramping them or distressing them in any way.

I am committed to showing the world as it should be, wild and free.

HARRY SKEGGS

Tooth and nail – lion, Okavango Delta, Botswana
DSLR, 600MM, 1/1600 SEC, F6.3, ISO 640

ASSIGNMENT 1
PHOTOGRAPH A LOCAL BIRD AS A PORTRAIT

- Pick a local bird species that can be located close to home.
- Visit the location where they can be found and observe their behaviour over several days or weeks, ascertaining when they are most active and accessible.
- Choose a good weather day and be out at the optimum time for the best available light.
- Be in position early with enough time to practise.
- Select an adequate lens and set the shutter speed to around 1/500 sec, dependent on activity and species. For birds in flight, think 1/1000 sec or more.
- Turn on image stabilisation in camera and lens if you have it.
- If using a wider lens for environmental portraits, pick out the best angle with little to obscure the view.
- Choose a single, central focus point and be ready to half depress the focus button before recomposing.
- Choose the one-shot mode if you know you'll get a fair crack at a stationary bird.
- For fast fliers like swifts or terns, employ the AI servo or continuous autofocusing mode if the background is clear.
- Take some test shots and check the histogram along with your shutter speed and ISO. If the image is too dark, increase the ISO.
- Take a variety of shots with different compositions and framing.

- Decide whether to defocus the background with a shallow depth of field, and prioritise the aperture for additional creative shots.
- If the animal looks like it's ready to fly, prioritise the shutter at 1/500 -1/1000 sec, or use continuous burst to freeze wings on take-off and landing, thereby getting feather detail.
- For a blurred background, pan with a moving bird, following the direction of flight, or use the multiple focus points if shooting against the sky.

REFLECTIONS

Photographing wildlife can be a bit hit and miss as there's nothing we can do to make an animal appear, and previsualising doesn't usually match up with live action. If you didn't manage to photograph the elusive bird you were after, hopefully you made the most of what else was around you.

Like people photography, we want images of an animal's face to be sharp and probably for the nearest eye to be in focus for single subjects. For animals in groups or in the environment, the overall composition and surrounding habitat becomes an important part of the scene, along with light and shade.

Choose your best three to five images to review:

- ☐ Is the subject well composed or does the image need cropping?
- ☐ Are the eyes in focus?
- ☐ Did you take a shot that includes the animal's environment?
- ☐ Is there something of the species' distinctive character, movement or behaviour within the image?
- ☐ Did you keep yourself safe, and ensure that the wildlife was free from any stress, disturbance or threat?

- ☑ Did you take a variety of images?
- ☑ Was the lens you used up to the job or were you too far away for even a good environmental shot?
- ☑ Did you have camera shake?
- ☑ Did you increase the ISO and prioritise the shutter?
- ☑ Did you manage to isolate the subject, and differentiate it from a fussy background?

Some species of bird will be tamer than others, sitting still on a nearby branch while you walk around for a better angle. Others, like hummingbirds, are wary of humans or constantly moving, so the realisation of your final shot is dependent on so many variables. With wildlife perhaps more than any other form of travel photography, a large amount of luck needs to be on your side. Success rates can be improved by regular trips, learning about a particular environment or specialising in a species, perhaps over decades or even a lifetime.

Superb starling, Serengeti National Park
DSLR, 200MM, 1/320 SEC, F5, ISO 200

ASSIGNMENT 2

PHOTOGRAPH A PORTFOLIO OF ANIMALS IN ACTION

- From urban foxes and forest deer to seals and wild ponies, do your research into the behaviour of the animals you want to photograph.
- A good wildlife sanctuary or nature reserve is a wonderful place to encounter groups of large or rare wildlife close to home.
- If you know of a local guide or photographer, follow them on social media or, even better, hire them for the day to guide you.
- Knowing what you do about characteristics and behaviour, write a shot list of six images that could work together, ranging from an establishing, wide shot to close-up detail and a vertical or two.
- Once in place, prioritise the shutter speed, single focus point and one shot or burst mode.
- Depending on the animal and how close you can get, think about changing angle. In places like the Galapagos Islands, you can get very near to wildlife. Drop low on the ground or shoot through grasses and flowers to recreate another creature's point of view.
- For general movement, use stabilisation and a fluid tripod head to keep the animal sharp.
- Aim to shoot a portfolio of images that tell a story, including of the landscape and habitat, any human interaction or relationships.
- Remember to pull wide and zoom in for detail.

GENERAL ADVICE

- Do your research on habitat and type of wildlife before travelling.
- Check the operator's credentials on animal welfare and sustainability.
- If travelling independently, hire a local guide.
- Don't use flash.
- Never do anything to put yourself or the wildlife in danger.
- Practise at home with slow-moving domestic cats, territorial robins or inquisitive urban foxes, and try out your settings.
- Work quickly to maximise the fleeting moments afforded you, then recompose for more interesting framing.

Hyrax in a tree
DSLR, 400MM, 1/1000 SEC, F5.6, ISO 640

- Prioritise the shutter and ISO.
- Use the the AI servo or autofocusing mode for moving animals.
- Aim to keep the eyes sharp.
- Try to control your excitement by breathing through your nose. Remain calm to avoid shake, though this will be difficult when faced with a baby elephant.
- Take a variety of images, including environmental and vertical.
- For safaris and most wild-animal photography, 300mm-plus lenses are recommended. Buy a teleconverter for long lenses you currently own or rent for special trips.
- Work with available light, keeping an eye out for breaks in cloud, the position of the setting sun, shadows and shade. Try to get the animal walking into your frame, or a shaft of light.
- Check for messy backgrounds or ones that engulf your subject.
- Pan using the same direction of movement, beginning with the animal at the edge of your frame.
- Use stabilisation and a fluid tripod head.
- Take waterproof rolltop bags for dusty, sandy and wet conditions.
- Clean the sensor regularly using a blower and any in-camera dust removal programme – and get a professional service on your return.

THREE PHOTOGRAPHERS TO FOLLOW
Marsel van Oosten @marselvanoosten
Cristine Mittermeier cristinamittermeier.com
Eric Sambol ericsambol.com

URBAN CULTURE AND STREET

FOCUS ON
EUROPE

From days out in our home countries to city breaks in iconic capitals like Paris and Amsterdam, photographing urban spaces is one of the most accessible forms of travel photography, and where most of us will cut our photographic teeth. I can still recall, as a teenager, being handed my dad's prized Agfa 35mm film camera in its brown leather case and asked to snap a picture of my mum and dad in Monaco. I didn't realise how wide the lens was, and we still laugh that I photographed my sister standing at the edge of the frame holding everyone's bags, thinking she was well out of shot. But oh, how I loved and coveted that camera, and maybe it's why I adore my compact Fujifilm X100 and its retro leather case – and why I don't want to upgrade it, ever.

< INTERIOR DETAIL Galleria Vittorio Emanuele II, Milan
< DSLR, 16MM, 1/200 SEC, F11, ISO 100

The camera makes you forget you're there. It's not like you are hiding but you forget, you are just looking so much.

ANNIE LEIBOVITZ

Less elitist than forms of photography that require expensive kit and even more expensive trips, street and urban culture can be shot anywhere and on anything, from a second-hand film camera to a smartphone. In fact, when photographing in busy places, the smaller we can go kit-wise, the better. New buildings with security guards will treat you as suspicious if you arrive with a tripod or lights, and you'll no doubt be asked to produce your photography permit. For professionals though, calling ahead to say you're coming reaps all kinds of rewards, from free entry to museums to 'backstage' access.

If shooting from the hip sounds like your thing, then hang out on your local streets and watch how a town morphs into life, from the quiet before rush hour to the crepuscular blues and violet skies as night falls. In bright sunlight or the middle of the day, using a polariser to shoot low and *contra luz* creates drama, and going inside to photograph interiors and public spaces is a good way to maximise those in-between, harsh daylight hours. After dark, work with light trails created by fast-moving traffic and photograph ant-sized city-dwellers at busy

crossroads from high vantage points – there's no right place or wrong time to take pictures in urban spaces. Even better, urban photography gives you permission to take it a bit slower. Sit outside a café in Seville and watch the world go by, have a coffee and a pastry in Florence while photographing from the comfort of your chair, panning with the nameless passers-by or creating an amorphous blur of movement. Sitting still has to be one of the best ways to go unnoticed, and is probably the only time, as a working travel photographer, you'll be able to take the weight off your feet and not feel a pang of guilt.

With towns and cities in close proximity, easy train and road travel across borders, and historic and cutting-edge architecture sitting cheek by jowl, Europe's a continent ripe for photographic exploration. And with people too preoccupied to much notice a photographer camped out on a bench, especially in the Instagram era of ubiquitous snapping, one can blend in quite effortlessly, even with a DSLR. Cities might be less friendly than villages, but that's an advantage for street photographers who don't necessarily want to engage, enjoying something of an invisibility cloak when lurking in the daytime shadows.

> There is one thing the photograph must contain,
> the humanity of the moment.
>
> ROBERT FRANK

Most of Europe's historic architecture has been painted or represented in photography over hundreds of years, but the first-time visitor can still do a lot that's different. While we're inundated with too-perfect Instagram top-down shots of food and urban hotspots, street photography proper has always documented the moment, demonstrating the world as it is, sometimes warts and all. And as artefacts, those snaps have become historical documents, giving us an invaluable record of the past.

The speed at which buildings have gone up in London over the past decade reveals just how much a skyline can change – even architecturally nothing remains the same. But more than any other form of travel photography, images from urban conurbations show a changing demographic and shifts in cultural mores – from street fashion and public displays of affection to demonstrations and protests, even insurgencies. And anyone who had the foresight to photograph during the Covid-19 pandemic will have images of dystopian empty streets –

Daguerreotypes taken by this vivid sunlight are glorious things. It is very nearly the same thing as carrying off a palace itself – every chip of stone and stain is there – and of course there can be no mistakes about proportion.

JOHN RUSKIN

A photograph isn't necessarily a lie, but nor is it the truth. It's more of a fleeting, subjective impression. What I like most about photography is the moment that you can't anticipate: you have to be constantly watching for it, ready to welcome the unexpected.

MARTINE FRANCK

like my student, Alix, who used 'post-apocalyptic' London as a film set during the UK's first lockdown in spring 2020.

What's more, in metropolitan spaces, you never quite know what's around the next corner. Just like the natural world, we need to be ready for what the urban jungle will throw at us. Notably, street and reportage demand a semblance of truth and reality, but that doesn't mean we can't get creative with our framing within the built environment. I won *Wanderlust* magazine's Travel Photo of the Year in 2011 by lying on the cobblestones in Sultanahmet (Istanbul, Turkey) and taking an image of the Hagia Sophia mosque, now a museum, reflected in a puddle (page 395). I pondered over whether to edit out the cigarette butt I hadn't noticed until later. I left it there, part of the scene of the life of a city where people love a smoke – creatively rendered in a reflection, but recognisably one of Europe's most beautifully distinctive historic and religious structures on the European side of the Bosphorus Strait.

With urban culture and street, the world, and how you choose to represent it, is quite definitely your oyster.

Waiting for the off, Athens
MIRRORLESS, 300MM, 1/60 SEC, F6.4, ISO 1000

THE
URBAN SCENE

CANDID | NATURAL | STREET | CREATIVE FRAMING

Urban photography is, by its very nature, a document of ordinary life, but it's very far from banal. Created in the moment, the human compositions are almost impossible to plan for. What we often do have to rely on, however, is a static backdrop of architecture or the continuous presence of moving traffic. With daytime shadows from people and tall buildings, often long and Expressionistic in form, there's a lot we can do with *chiaroscuro* and the **dynamic range** created by available light and the seasonally shifting sun. Imaginative framing is at the heart of most street photography, angling down on feet and pavement slabs or up to anonymous, silhouetted giants, backed by polarised blue skies – all of which can pose questions for the viewer through their ambiguity.

The 17th-century Rundetaarn Observatory, Copenhagen >>
DSLR, 16MM, 1/50 SEC, F2.8, ISO 200 >>

The whole point of taking pictures is so that you don't have to explain things with words.

ELLIOTT ERWITT

In a city like Athens, the focus is usually on its magnificent archaeology and architecture. From the Parthenon to the Acropolis, one cannot take a step without bumping into a Corinthian column or a marble statue. With good reason, it's a popular location that will always have a constant stream of visitors, so weaving in people alongside the backdrops can be fun.

On location, it's often when we've taken a pause from photographing the shot list that we glimpse something unexpectedly inspiring. Before heading out to see the Agora, I noticed shadows thrown by the columns of the museum's passageway creating a geometric pattern that looked like it was in monochrome. After a few minutes of waiting for the 'right' number of people to walk into the frame to make it work compositionally, one couple stood momentarily stock still in the very centre of the converging diagonals, with few other distracting limbs or shadows. As a spontaneous image it's become one of my favourites, in spite of and perhaps due to it looking unlike any of the typical Athens' images that flood picture libraries. Of course, I had to get the iconic shots too – after all, in travel, it's those recognisable sights that draw the viewer in. But it's often in the delicate balance between the familiar and the unusual that we create a fresh perspective on a well-loved destination.

Chiaroscuro of the Agora, Athens
MIRRORLESS, 14MM, 1/550 SEC, F5.6, ISO 200

Valletta after sunset, Malta
DSLR, 63MM, 1/125 SEC, F4, ISO 100

CITYSCAPES

SKYLINES | AERIALS | PANORAMAS | APERTURE PRIORITY

From romanticised depictions of dusk to the brutalism of modern concrete, capturing an entire urban skyline is one for every travel photographer's shot list, and often the perfect DPS opener for magazine features. Given that other buildings may obscure the view and you won't know the exact direction of light and shadows before arriving, it's not always going to be straightforward. Getting a high vantage point far enough away to take in an entire panorama is key, so research the best spots beforehand, with scope for a recce if possible, once there. By now you know how vital it is to factor in 'wrong weather' days or allow time to follow local leads or your own nose. Combining cocktail hour or dinner at a rooftop bar or restaurant is also a good way to gain entrance to a top spot – and you have somewhere nice to relax once you've called it a day.

This City now doth, like a garment wear
The beauty of the morning; silent, bare,
Ships, towers, domes, theatres and temples lie
Open unto the fields, and to the sky

WILLIAM WORDSWORTH

ARCHITECTURE

VERTICALS | CREATIVE ANGLES | TILT-SHIFT LENSES

The beauty of photographing architecture is that it stands proudly upright, still and invariably uncomplaining. One would think, therefore, that all images of iconic buildings would look more or less the same, and perhaps are a little uninspiring to shoot. Originality, of course, depends on angles, especially if there are limited vantage points. Like anything, good light and differing focal distances have an enormous impact on the composition. Serious architecture photographers will use a **tilt-shift** lens to straighten the verticals and keep the building in proportion. An all-round wide-angle travel lens copes well with the immensity of an impressive edifice, but it will also distort verticals like towers and turrets – often to dramatic effect.

Duomo detail, Milan
DSLR, 20MM, 1/30 SEC. F11, ISO 100

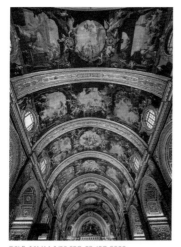

DSLR, 16MM, 1/30 SEC, F9, ISO 8000

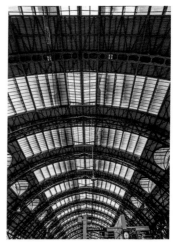

DSLR, 16MM, 1/125 SEC, F2.8, ISO 100

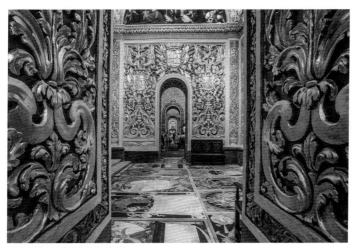

DSLR, 16MM, 1/125 SEC, F2.8, ISO 100

IT'S IN THE DETAIL

DETAIL IN CONTEXT | ABSTRACT PATTERNS | WIDE APERTURE

From brass door handles to church gargoyles, architectural details are plentiful in the built environment, and may even side track us from what we'd planned to photograph. We're also able to get as close as our lenses will allow, so the ease and creative possibilities make it quite an addictive practice. But for magazine travel features, abstract close-ups are not usually a photo editor's first choice. Though they are beautifully conceptual in fine art and creative work, it's often better to focus on the intricacies of the environment while keeping enough of the scene recognisable – for example, using a wide aperture to blur out passers-by while bringing the details of a wall or a painting into focus. Iznik tiles in Istanbul or trulli rooftops in Puglia are redolent of those locations, therefore providing detail and adding to the travel story.

Photography is truth.

JEAN-LUC GODARD

INTERIORS

SCALE | FRAMING PEOPLE | WIDE ANGLE

Photographing the interior of a building usually involves a combination of people and architecture. It's very rare on assignment to find a location completely devoid of visitors, even early in the morning, so make the most of that by including figures in the story. Framing people as a natural or staged part of the composition – looking at a painting or walking through a doorway – positions the viewer to perhaps see themselves there. Oftentimes it's the images with human interest that are more engaging than an empty room, and by keeping people as a small part of the scene you can also focus on the detail, especially in museums and ornate buildings.

St John's Co-Cathedral, Valletta, Malta
DSLR, 16MM, 1/40 SEC, F2.8, ISO 1000

Motion blur shoppers, Milan
DSLR, 16MM, 0.4 SEC, F22, ISO 200

Part of a large travel media delegation during Milan's EXPO in 2015, I was being guided around the city. A global centre for fashion, shopping was an integral part of our itinerary. Usually, these kind of tours allow for a quick food stop or an opportunistic gift purchase, but in Galleria Vittorio Emanuele II, I became entranced by the intricate iron and glass domed ceilings. Like other gallerias in London, Paris and Buenos Aires, this is a landmark building that just happens to have retail at its heart. Designed in the 19th century, it is the perfect combination of diffused natural light, tiled floors and a busy thoroughfare – all great for photographing people. As I crouched low to capture as much of the vaulted ceilings as possible, I began to see compositions of well-heeled Milanese passing over the intricate flooring. Without a tripod but wanting some motion blur, I balanced my camera on the tiles, tilted it up with a rolled-up scarf, and used a slow shutter and timer to try to avoid shake. I had a brief moment to capture a few frames before rushing to catch up with the rest of the group. I would have preferred to have stayed longer, but sometimes it's the failures or the 'almost' images that help us to do better next time, and perfect our craft.

GOING UNDERGROUND

MANUAL SETTINGS | STABILISATION | LOW LIGHT

Photography's always about the quality of light but, ironically, going underground can provide the ultimate conditions. Unlike the changing skies above ground, the constancy of artificially lit tourist attractions, like the cisterns in Istanbul or Seville, creates a stable environment for shooting manually. Underground structures typically require low-light equipment, so take a tripod if possible, or find somewhere to prop your camera. Train stations offer similar environments, with moving carriages and static people to compose around. The world over, there is beauty in the everyday, and train stations are decorated with art, colourful signage and statues – an interesting counterpoint to the gritty, urban decay of some dank underground tunnels; and a perfect frame for a shadowy figure to walk into.

Subterranean Royal Alcázar, Seville
DSLR, 35MM, 1/30 SEC, F2.8, ISO 2500

During another long meeting at the Milan EXPO, I felt a little trapped inside a building and kept looking through the window at the blue sky and train station opposite. Checking the clock, over and again, I was hoping for a break to at least be able to go outside. But as each rest period arrived, there was someone else to talk to, or a cup of coffee with my name on it. Nowadays, I usually never travel in groups, and this proved once more how frustrating it can be to not be able to follow one's instincts. Having had enough, I gambled that I could disappear for half an hour, without anyone really noticing, and hotfooted it out of there, camera in hand. The train station was more beautiful than I'd expected, and full of bustle and life. I took a few shots from outside and just within the entrance, where the light was spot on for capturing people and their long shadows.

But it was the travelators taking passengers down to the platforms where I spent most of my time. With vertical and diagonal lines converging on a distant arch, and the metal structure reflecting the yellow hue of interior lighting, conditions were perfect for some slowish shutter and slight motion blur. Without my tripod (I couldn't' have taken it without drawing attention to my escape plan) I simply rested the camera on a low wall overlooking the scene, kept the strap around my neck for safety and used the timer while breathing slowly for as little camera shake as possible.

Within minutes, I was back in the conference hall, with people none the wiser, much happier for my mini photo session and the chance to see a building that was not on the itinerary.

< Grand Central Station, Milan
< DSLR, 16MM, 0.3 SEC, F11, ISO 100

NIGHT SCENES

LIGHT TRAILS | LONG EXPOSURES | STABILISATION

The thrill of the city is that anything can happen at any time, but at night things become even more dynamic. Stabilisation is necessary, especially for capturing light trails from traffic or reflections in water. Just after sunset, before darkness descends, is when lights twinkle on in buildings and the skies encompass a myriad of blues, pinks and lilacs. And when it becomes dark in winter, you won't need to stay out late to get inky night scenes. In fact, you'll probably be done and dusted before anyone's had dinner – a good time to fit photography in when travelling with a friend or partner. And in the wee small hours there's a different tribe of humans on the streets altogether and a completely other vibe, so photographing counterculture or the music scene might add another dimension to your travel storytelling.

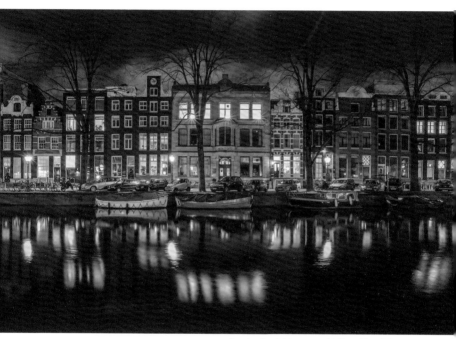

Amsterdam's Herengracht Canal by night
DSLR, 16MM, 25 SEC, F11, ISO 800

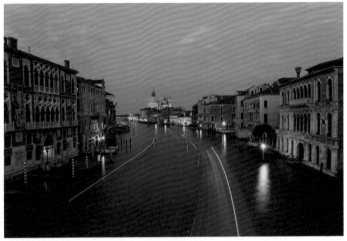

Grand Canal, Venice by night
DSLR, 23MM, 25 SEC, F22, ISO 200

Venice *vaporetto* light trail
DSLR, 16MM, 30 SEC, F22, ISO 200

I'll fully admit that in Venice I wanted to capture those iconic images that we've all seen in paintings by Canaletto, countless travel programmes and even feature films. Some photographers will say they only ever shoot original compositions, but I found in Venice there's a reason for the popularity of *that* view of the Grand Canal. No, this time, it's not down to a lack of inspiration or vision, but mostly because the Rialto Bridge provides the perfect view of Venice at sunset, with the canal wending off into the distant lagoon, flanked by subtly hued narrow buildings.

And many other sites invite late afternoon long exposures with ND filters – from lesser-seen locations to the well-represented gondolas at St Mark's Square. Sauntering back to my hotel, away from the iconic centre, I stopped wherever I found an interesting canalside composition. The sky had darkened enough to shoot the light trails from vaporettos, and I kept the tripod as low and as close to the water's edge as possible – continuing with 30-second exposures even when some lovely young Venetians gestured that it might be fun to push me in. At least I think it was a joke. Ah, those cheeky Italians.

THE FUNDAMENTALS

REPORTAGE AND STREET KIT

Compact or mirrorless cameras work well for street photography, allowing for handheld images. The photographer has the chance to capture more natural behaviour, by blending in unobtrusively.

FOCAL LENGTH

Wide enough to show the scene but allowing the photographer to use their feet to move in for close-ups, 35mm was the old-school film focal length beloved by the originators of the street style – and continues to be a good choice for us now.

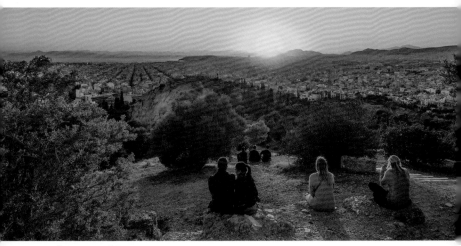

Sunset over Athens
MIRRORLESS, 14MM, 1/160 SEC, F8, ISO 200

MONOCHROME EDITS

Whether from the dynamic range of light and shade caused by urban shadows, black-and-white photos are the image of choice for much street and urban reportage. Shoot in RAW and desaturate when you edit, or choose the camera's black-and-white display to see what the image will appear like after processing.

SHOOTING FROM THE HIP

Many new cameras have LCD screens that can be angled away from the camera body. Instead of looking through the viewfinder, you can shoot from the hip but still see the composition and plan your shot. Cameras like the Fujifilm mirrorless system have a Bluetooth app which provides the option to place your camera on a table, face away with your phone but still see the scene that's being photographed. Similarly, Bluetooth lenses for smartphones enable you to point the lens in a different direction to where you're looking – perfect for candid, discreet street photography.

SHOOTING IN MANUAL

With the choice to shift between aperture and shutter priority for sharp buildings or light trails, photographing street and urban scenes provides the perfect opportunity to shoot in manual. As you angle up or down, you'll need to check the exposure meter. A very small aperture and a polarising or ND filter during daytime will allow for slightly longer exposures for subtle human movement, especially if the camera is rested on a table or prop. At night, increase the exposure time for light trails, using a tripod and keeping the ISO as low as possible and the aperture wide to reduce noise.

AN EXPERT'S VIEW
POLLY
RUSYN

Polly Rusyn is a freelance photographer and Official Fujifilm X-Photographer. Aside from commercial photography work, Polly runs street photography workshops in Europe with The Photo Weekender. Polly's work has been exhibited worldwide, and published internationally, and she has also spoken about street photography at a number of events, including at the National Geographic Traveller Masterclasses in London. **pollyrusyn.com**

What makes street and reportage different to other forms of people photography, and why do you find it so interesting?

Street photography is candid and unstaged – the photographer simply observes real people behaving in authentic ways. I see the world as a moving jigsaw, and there are pictures everywhere. My job as a street photographer is to make the pieces fit! People form part of the overall whole so, in my mind, they are part of the 'life' that is happening in front of me and not necessarily the sole reason for the photo. The goal is a well-composed image with great light and interesting content – the holy grail.

I find that for me the process of creating the final image is of equal importance to the image itself. I love that I can lose myself when I am

making photographs. It really is a form of meditation, plus I get to walk and explore and travel! It grounds me, and it gives me joy.

How do you decide where and what to photograph?

I like to head to any location that attracts people; and the people I like to photograph are those that have a strong 'look' (clothing, hair or accessories) which makes them stand out. I also look for people who are animated – moving, gesticulating or doing something, although more static, less 'interesting' subjects are fine for when I'm working with silhouettes and shadows.

Do you ever take a photograph first, and ask for permission later?

I always take a photograph first, and never ask permission! As a street photographer I sometimes spend time in one spot with a scene in mind and wait for a human element, so I could photograph twenty people in ten minutes. If I checked every photo and ran after every person to explain what I was doing, I would spend very little time actually making pictures! People will always act differently if they know they are being photographed, even if the photographer asks them to carry on as if they weren't there.

> I love that I can lose myself when I am making
> photographs. It really is a form of meditation,
> plus I get to walk and explore and travel!
> It grounds me, and it gives me joy.
>
> POLLY RUSYN

Cheerleaders in Rome, Italy
MIRRORLESS, 27MM, 1/500 SEC, F5.6, ISO 1600

Horsemen in Jerez de la Frontera, Spain
MIRRORLESS, 27MM 1/1000 SEC, F14, ISO 800

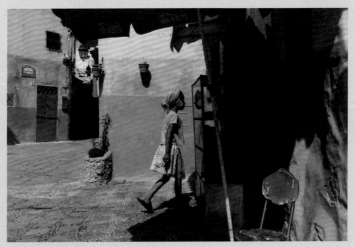

Young girl in Chefchaouen, Morocco
MIRRORLESS, 23MM, 1/1000 SEC, F16, ISO 1250

218

Do you have any special considerations when photographing in specific overseas locations, especially where people and buildings are concerned?

I respect privacy laws, and if they are very strict then I focus on anonymous subjects – this could mean photographing only visible 'fragments' of people (partly obscured by shade, random limbs, faces hidden etc), shadows, silhouettes, people as part of crowds etc. I avoid any government or military buildings, but most of the architecture I photograph around is designed to attract tourists. Also, with regards to people, I'm guided by my personal ethics in that I won't share pictures of people that make them look bad, or possibly incriminate them in some way if they are recognisable. Basically, I believe in being kind to the people who find themselves in my pictures!

What would be your advice to an inexperienced photographer who wants to photograph urban environments or street scenes?

Start by looking for interesting light, geometric shapes or colourful backgrounds. Figure out the best angle and point of view by trying out different ones, not worrying about including any human element until you get something that looks good without. Then plant yourself and be patient, and wait for one of more people to enter the scene. This is known as 'fishing' in street photography, and is a great way for beginners to get started making images in an urban environment. My other bit of advice would be to join me on a workshop!

ASSIGNMENT 1
PHOTOGRAPH
A LOCAL STREET SCENE

- Find an urban locale where there's a mix of interesting architecture, outdoor cafés or office buildings with regular footfall.
- Do a recce to see where the light and shadows fall, and choose a specific location.
- Write out a shot list that plots either a morning or afternoon shoot.
- In your first spot, wait in location and watch for any action.
- Find a composition and wait for people to walk into the frame.
- Prioritise the shutter and decide whether you want blur or sharp focus. Vary this once you have taken a few images.
- Try motion tracking and pan for movement.
- Take a number of images, with single figures, groups and juxtapositions in size and shape.
- If you have a polarising filter, try photographing from a lower angle with more sky.
- Check the histogram and try to shoot in manual, setting your aperture to about f5.6 and watching your exposure meter for the correct shutter speed. Increase the ISO if necessary.
- Move to another nearby position, and see what changing position does to the framing, light and atmosphere.
- Try shooting from the hip if you have a tilting, angled display.
- If you have a longer lens and want to get higher or further away, zoom in or shoot top-down from a walkway or balcony.

- Take a food break and put the camera on a table, finding a good angle to shoot from while you sip your macchiato.

REFLECTIONS

By now, you'll probably be a confident photographer, able to move between aperture and shutter priority with ease. If you've just begun to work in manual, however, you may feel that you're less sure of yourself. Urban photography is probably the best time to play with your settings, as there are ample opportunities to experiment and you're unlikely to miss a once-in-a-lifetime image.

Depending on your choice of image style, framing is usually key for street, with abstract or conceptual cropping, and perhaps wider angles for more 'traditional' urban architectural backdrops.

Choose your best three to five images to review:

- ☐ Is the framing interesting?
- ☐ Did you angle the camera in a way that's different to your usual travel imagery?
- ☐ Is there interplay between light and shade?
- ☐ Is there a mix of people and architecture?
- ☐ Were you in position early or did you do a recce?
- ☐ Did you wait in position long enough for a variety of compositions to appear?
- ☐ Did you follow a scene, or find someone interesting to focus on?
- ☐ Did you work in manual?
- ☐ What kind of focal length did you use, and was it in one shot or servo mode?
- ☐ Did you end up with better images than you'd envisaged when planning the shoot?

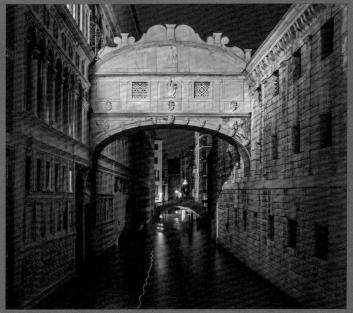

Bridge of Sighs, Venice after dark
DSLR, 24MM, 30 SEC, F10, ISO 200

What can sometimes seem most interesting to us is not the photographer's intended subject but something else he or she, perhaps unwittingly, included in the frame. It is these incidental details that lend street photographs their strong flavour of authenticity.

MIKE SEABORNE

ASSIGNMENT 2
PHOTOGRAPH AN URBAN SCENE AT NIGHT

- Plan ahead and have a tripod alongside your usual kit. Prop the camera up somewhere safe if you don't have stabilisation.
- Choose a spot and a time where you know you can shoot something distinctive – light trails from vehicles or buildings lit up against the night sky.
- Get in position early and use manual settings to practise. Take note of light sources and check exposure times.
- Don't increase the ISO too much.
- For reflections of buildings in canals and rivers, set up directly on the opposite bank, then move to another spot, perhaps the centre of a bridge for a different perspective.
- Twilight is great for light trails, and the aperture can be narrow enough for background detail.
- Take a series of long or short exposures until you run out of light, adjusting the shutter for longer exposures as it gets darker.
- High vantage points over traffic intersections work well after dark, and ND filters allow you to shoot light trails before sunset.

GENERAL ADVICE

- Organise your day to cover key locations. Plan carefully in order to get the best light and activity, and consider travel time.
- Use a small camera set-up to blend in if you want to capture people acting naturally.
- Plan to be inside in the harshest light of day, and use the time for interior images.
- Underground stations provide a dependable background of static and regular moving humans and trains, with constant light conditions in which to practise.

Amsterdam light trails
DSLR, 16MM, 30 SEC, F10, ISO 320

- Photograph hand held for street or reportage, and experiment with shooting from the hip.
- For anonymous passers-by, you don't usually need to ask for permission, especially if you want to capture natural scenes.
- Have a light tripod to use outside for long exposures of water or night photography.
- Ensure you're not on private property or you may be asked to provide a property release form if selling to picture libraries.
- If you see someone you particularly like the look of, ask permission then direct them into your previsualised scene.
- Using flash outside in daylight creates dramatic people shots.
- Practise shooting in manual as you have the time to prepare for different setups and effects.
- Alternate between sharp and motion blurred images, aiming to always keep something of the scene in focus.
- Look for compositional patterns and a relationship between people and their surroundings.
- Don't be afraid to use canted angles, tilt the lens or generally work in unexpected ways.
- Get low, lose the horizon and shoot unique frames.
- Document a range of scenes, from bustling, busy streets and quiet nights, to urban decay and shiny new skyscrapers.

THREE PHOTOGRAPHERS TO FOLLOW
Martin Parr martinparr.com
Clarissa Bonet clarissabonet.com
Nige Levanterman levanterman.photography

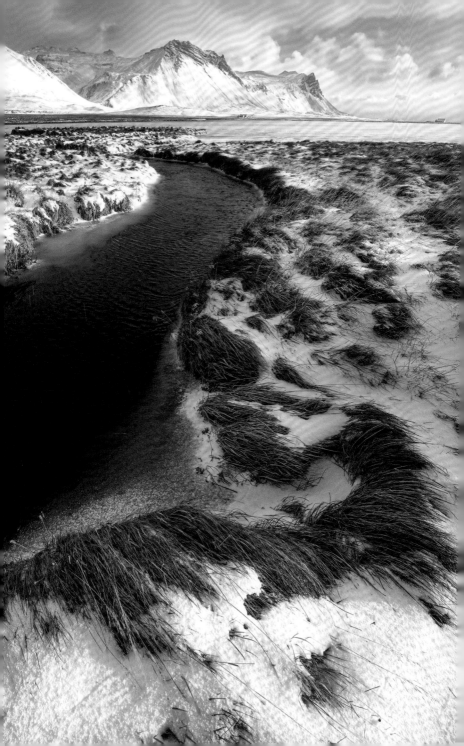

ACTION AND ADVENTURE

THE ARCTIC AND HIGH NORTH

When we think of photographic adventure – from the thrills and spills of high-energy activities like skiing or mountaineering to documenting remote expeditions – the northerly realms are what immediately spring to mind. And given the stark beauty of the backdrop to these adventures, it's hard not to become mesmerised by the notion of 'travelling north'. A place of snowy dominions and extreme cold, the north is resonant of big, icy tundra, wolves and the magical aurora borealis. And even if we're not about to embark on a solo trek to the Pole in Sir Ranulph Fiennes' style, heading due north still feels like we're off on a major expedition. Every travel photographer who's ever had their hair flecked with hoar frost, or even frozen solid, will have posted an Amundsenesque photo on their Instagram profile – perhaps just before sidling back into a warm cabin for a hot chocolate laced with a nip of something stronger.

< VERTICAL LANDSCAPE Snowy realms, Snæfellsnes, Iceland
< DSLR, 16MM, 1/125 SEC, F13, ISO 100

227

In this vast amphitheatre, walled in by mountains
of snow, here and there penetrated by the peaked
summits of their aiguilles, reigns an eternal winter,
the accumulated snows of many ages,
the wreck and run of rocks, and all the
magnificent personification of dread desolation . . .
JOHN MURRAY

I'm no mountaineer, yet I've had my share of intrepid adventures, most of which happened well before I started working as a travel photographer. In many ways I'm glad I wasn't focused solely on documenting the event when I dived on the Great Barrier Reef, climbed volcanic peaks in Chile, skied mogul fields in Switzerland and donned crampons to climb over, and under, glaciers in Argentina. Part of what led me to becoming a photographer in the first place was my lust for travel and the myriad possibilities for hiking, wild camping and jumping off cliffs with paraglide instructors – and stopping frequently to record images kind of gets in the way of the fun.

Obviously, I prioritise the work now, choosing not to dive with whale sharks if I need to be on deck to document the story of others doing just that – but it's still a struggle not to want to be in the thick of it. Hang-gliding and landing on a beach in Rio de Janeiro was an intoxicating, spur-of-the-moment thing – my Birkenstocks were

taped to my feet, and the hem of a floaty long skirt tied in a knot. Jumping into unplanned adventure is made more difficult by the kit we're carrying to do our job. Yet there is a balance to be had – through the right, compact equipment and careful planning – so there's time to participate as well as observe. Get the shots, then plunge in and become part of the action whenever you feel the urge.

Of course, the high north has a lot more to offer than just icy tundra and action. With abundant wildlife like the reindeer in Rovaniemi or more elusive narwhal off Greenland and Canada, going north, particularly in winter, is a dream for photographers and travellers alike. In summer too, when ships carve their way through the melting pack ice, Norwegian Svalbard and the seas around the Arctic Circle are the perfect place to spot fulmar, eider duck and walrus, not to mention the most majestic northerly apex predator of them all, the iconic polar bear. With an abundance of migrating birds and flowering plants and berries, the high north in summer is another world entirely.

And the islands and archipelagos outside the Arctic Circle are no less impressive than those within parallel 66.5 degrees north. Iceland and its frozen waterfalls and ice caves are easily reached via its ring road – a boon for the equipment-laden photographer – while the remote and windswept Faroe and Shetland islands have some of those lush yet rugged landscapes redolent of the ancient Icelandic Sagas – or the 21st-century's *Game of Thrones*. What's more, the north is more accessible than a great deal of its polar opposite down south, largely owing to the number of inhabited countries on the edge of the Arctic Circle. Don't get me wrong; flying to Oslo, then on to Longyearbyen, and overnighting before joining a ship to sail the Arctic Ocean for ten days is an adventure in itself, but there are many alternative land-based ways to see the Arctic and partake in exciting photographic adventures.

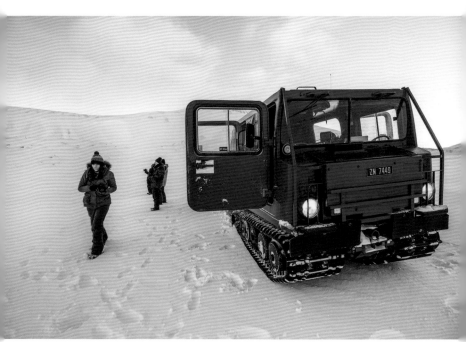

On Longyear Glacier, Svalbard
DSLR, 16MM, 1/40 SEC, F6.3, ISO 200

Finnmark is a vast territory, bordered by the sea to
the west and the north, and all the way to the east
with great fjords, while Norway lies to the south
of it... there are mountain settlements in many
parts, some in valleys and others by the lakes.

THE SAGAS OF ICELANDERS

Many travellers first encounter the north by taking cruises along
the Norwegian coast, or setting down in Tromsø or Kirkenes in their
quest to see the northern lights. And if the green flashes are not visible
through cloud or poor conditions, there are many additional attractions.
Greenland and Lofoten are favourite locations to photograph brightly
coloured timber-framed houses on the edge of pure, ice-strewn
wilderness. Land-based itineraries in ice hotels or cabins in Canada
can offer a similarly exhilarating experience, with adventures in warmer
seasons that include camping, hiking and kayaking. Glass domes or
treehouses in dark-sky reserves like Sweden's Abisko National Park
make star gazing more accessible, with respite and shelter from the often
extreme cold. But, quite understandably, it's the inner Arctic Circle that
is the magnet and pinnacle for most. Keen to circumnavigate Svalbard
or sail Alaska's inside passage or the Russian Arctic, we may not all
reach the magnetic North Pole – let's face it, it's a massive expense

to even try – but a shorter expedition is worth the outlay for those with the means and the dreams of high-Arctic adventure. Once aboard, you'll have a place to recharge batteries (yours and your camera's), store a hefty lens or two if here for the bears and birds, and be guided and advised by some of the world's leading scientists. On-board talks will give you the heads-up about what's to come, and usually there'll be a professional photographer either running workshops or taking guests out on Zodiacs and walking trails. I've been guiding over the past few years, and the people who join me are invariably wide-eyed and ecstatic about finally making it to one of their dream destinations. Whether it's Iceland, Patagonia or the Arctic, I have immense gratitude for the opportunities I've had to return on assignment or work for an expedition travel company. Nice work if you can get it.

Not many of us have the skills, or perhaps even the desire, to abseil with photography kit down a mountainside or bivouac at altitude. But even if we can't all be Jimmy Chin filming Alex Honnold freeclimbing El Capitan, a guided 'soft' adventure in mountainous or frozen terrain can still provide the dramatic backdrop to action photography. The main drawback is that we'll want to pack each single piece of equipment we own to record these life-changing encounters amid the pristine, natural terrain. And the really dangerous part of it all? You might just become addicted to the very notion of 'north'. I know I did.

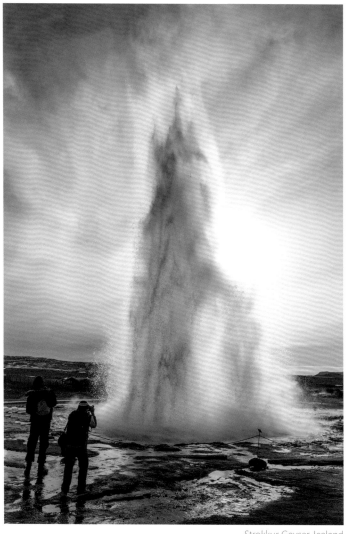

Strokkur Geyser, Iceland
DSLR, 30MM, 1/4000 SEC, F8, ISO 400

GETTING SPORTY

SPORTS & ACTION | HIGH SPEED | GIMBALS & DRONES

The cold conditions of the wintry north offer a myriad of photographic opportunities, from capturing a cross-country snowmobile adventure to Nordic skiing. If you're documenting activity, it's obvious you'll need to be on the move too, either with a helmet-mounted GoPro for video or possibly a drone or handheld gimbal. It's difficult to compose still frames when in constant motion, so use a fast lens, burst mode and a speedy shutter whenever there's action in the offing. Check the white balance and use filters for glare under sun-filled skies. The best and most stable photo opportunities are often during moments of transition and relative stillness – before the skidoo teams return or as skiers stop on a sixpence in a flurry of snow at the foot of a slope. Get low, think about best vantage points, and ask to travel at the head of convoys, jumping down to document action from a momentary position of stability.

< Snowmobile safari, Finland
< DSLR, 24MM, 1/500 SEC, F9, ISO 500

235

Having enjoyed plenty of alpine and icy adventures during my time in South America, I soon began to dream of the north. I'd even got to pet a couple of husky puppies at a kennel in Ushuaia, and the idea of an Arctic escapade would not quit my consciousness. The moment I returned to the northern hemisphere I had plans to do three things: see the northern lights, photograph polar bears in the wild and take a dog-sled safari somewhere in the subarctic.

A trip to northern Finland enabled me to tick off two of those wishes. And even better, I could do most of it from a snowbound adventure hub near Syöte National Park, where saunas, log fires in outdoor cabins and warming dishes were the counterpoint to Nordic skiing, icy plunge pools and snowshoe trekking (much more arduous than it looks). And an overnight dog-sledding safari meant I would get to run my own team of hounds.

After the initial orientation and practice with the circus-style balancing act that is necessarily part of steering a sleigh, we set off on our adventure. I attempted to attach my mirrorless camera to the front of the sledge via a bracket, but realised my dogs were going too fast for that to be a successful option. It dawned on me then that the effusive and generous owner had bestowed on me the honour of an extra dog – but it meant hurtling around corners at an impossible pace for filming. I even managed to head-plant in a snow drift while my camera stayed mounted on the frame, and the dogs raced off into the distance! With the camera still rolling, the sound of my yelps as I was unceremoniously ejected at the chicane still makes me chuckle. >>

Let sleeping dogs lie >
DSLR, 35MM, 1/400 SEC, F9, ISO 100 >

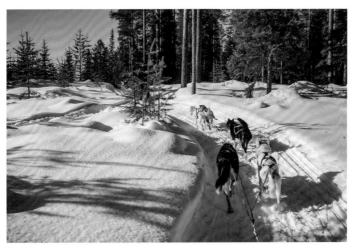

Sledding in Finland
DSLR, 24MM, 1/1000 SEC, F11, ISO 1000

Finnish safari lunch
DSLR, 16MM, 1/50 SEC, F5.6, ISO 100

But once we hooked my extra dog on to the guide's harness, I found that things slowed down enough for me to keep the sled on two blades at each bend and, more importantly, take the odd moving shot. Yet it was the moments when we stopped to make a fire, sitting on compacted snow with hides thrown over for waterproofing, or put the dogs in their kennels at night after a good feed that better photography opportunities arose. Participating in a hair-raising activity is a delight but makes documenting the scene challenging. Planning for the quiet moments between thrills will allow you to enjoy the ride without compromising your equipment, safety or the quality of your images. If high-octane adventure photography is your thing, it's likely that you'll need to take a backseat from the activity itself, or travel in tandem alongside it, with someone else doing the driving.

WILDLIFE

LONG LENS | FAST SHUTTER | MOTION TRACKING

Even more so than on other types of safari, ship-based Arctic wildlife photography involves spotting animals at a great distance (you're unlikely to get as close as say in Africa or even Antarctica). Many photographers will hire 600mm prime lenses for Arctic adventures, camping out on decks with tripods, enormous lens hoods and polarising filters to cut out glare – especially helpful when picking out camouflaged bears and foxes. As animals can appear at any side of the ship though, you'll still need to be ready to move, and on Zodiacs it won't be possible to use a tripod so pack a more manageable set-up and a shorter lens for all eventualities. Track puffins in flight using the pristine landscape as your canvas – no need to defocus the glorious backdrop of granite rockface, ice floes and 'bergs!

Reindeer and snowmobile, Svalbard
DSLR, 200MM, 1/80 SEC, F2.8, ISO 3200

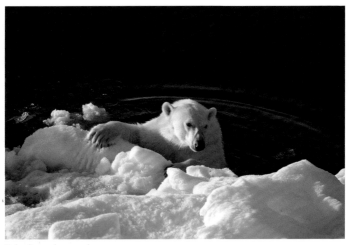

Polar bear claw marks
DSLR, 400MM, 1/800 SEC, F5.6, ISO 400

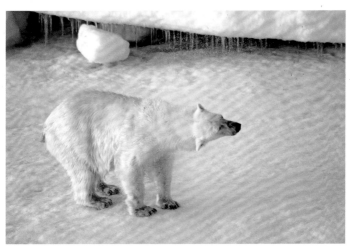

Shaking off water
DSLR, 400MM, 1/800 SEC, F5.6, ISO 400

Like most people, I'd longed to see polar bears in the Arctic, but it's not the kind of trip you just fall into. I made the decision to join a specialist photography sailing, where the route was open to change and always geared towards getting the very best images. I spent much of the downtime on that trip on the viewing deck, eyes trained on the distant horizon; with constant daylight and scenes of great beauty all around, I was reluctant to tear myself away until sleep forced itself on me for an intense few hours each night.

Vast swathes of pack ice were buffeted and gave way as our steel-hardened hull forced its way north. Many pairs of eyes had been scouting the surrounds, but by 11.30pm it was just me, the Australian expedition leader, Woody, and the trusty but mostly silent Russian crew keeping vigil. I took one last look through the ship's powerful telescope, deciding it was probably time for me to retire too. 'He's still out there you know.' Woody was referring to the bear we'd seen strolling for hours in the distant periphery of the ship.

I looked again and it took some time before I homed in on him in the stratified layers of ice, sea and snow. Blues and whites vied for supremacy in the vast landscape while the midnight sun covered all with a sheen of divine light. But there he was, slightly yellow and sun-warmed against the stark, cold background. There's a definite knack to picking *Ursus maritimus* out amid the tundra, especially once you can distinguish between the shades of white. >>

Serenity, silence and my ruminations were suddenly jolted aside when another guide appeared shouting 'He's hunting!'. And while he raced to grab camera gear, I watched alone through the telescope as a small, fat seal sat quietly, oblivious to the mass of creamy white fur stealthily approaching. As he swam silently and spy-hopped to get a brief glimpse of his prey, it took a full 20 minutes before the bear made a hurried dash towards dinner. But the slippery thing was too quick, and plopped heavily down into his swim hole, lost forever as far as the ravenous bear was concerned. It was sad thing to witness, especially as so many of the bears we'd seen had been thin or even emaciated.

It's now though that the real event begins. His appetite clearly whetted by the thought of seal fat, the bear turns his nose to the only other blubber in the vicinity. Us. And slowly, stealthily, he sniffs, swims, trots, paddles, hauls himself up on to floe after floe, smells the air with his protruding black tongue and walks until his twitching nose is almost touching our hull. Watching and clicking now through my camera, I realise I have been joined by the entire passenger list bar one; a man who could not be roused from his dreaming and who, to this day, will rue the night he continued to snooze.

It was a full hour since I'd started watching the great sea bear through the scope, and as he finally swam off on his way, I surprised myself by silently crying proper fat, hot tears. It felt like a divine experience, though I covered the evidence of my streaming eyes with excuses of tiredness and the biting air. I needn't have worried though. Woody's eyes were glistening too. Must have definitely been the chill – he's a tough Aussie, after all.

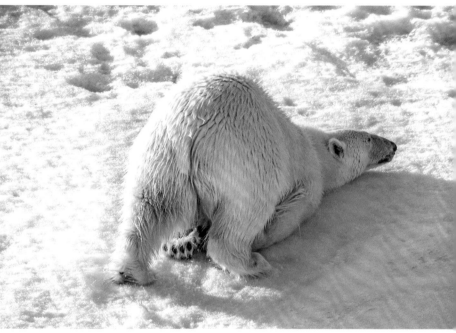

Getting dry
DSLR, 400MM, 1/800 SEC, F5.6, ISO 400

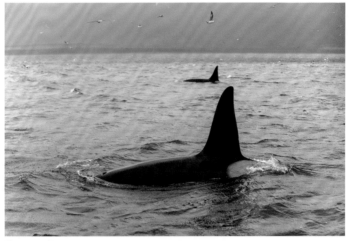

Orca patrol
DSLR, 70MM, 1/500 SEC, F3.2, ISO 400

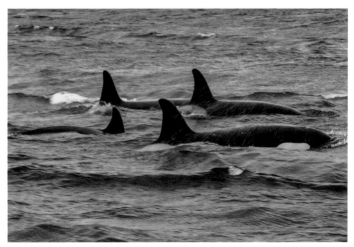

Orca pod
DSLR, 200MM, 1/500 SEC, F11, ISO 400

A week-long sojourn in the southwest of Iceland combined the opportunity to observe wildlife, listen to experts and see some of the lesser-known landscapes of the Snæfellsnes Peninsula. This cetacean-focused 'whale fest' had come about because shoals of herring had rather decided they liked the look of the fjords in Grundarfjörður. Eric Hoyt, Senior Research Fellow at the Whale and Dolphin Conservation (WDC), accompanied us and, with other cetacean specialists, provided regular lectures either in the evenings, or during the day when the weather was too stormy to head out on boats.

And the only reason any of us were there in the first place was because of one man. 'Big fish coming! Big fish coming!' shouted a lone voice on Iceland's west coast. Four years earlier Gisli Olafson had stood in exactly the same spot as pods of orca converged on his local fjord, following shoals of herring which had come to overwinter in the sheltered waters. After a second year of visits by the same extended orca families, he'd invested heavily, refurbishing a fishing vessel in order to take international passengers on day tours, despite hoots of derision >>

When I stood I thought I glimpsed my own desire. The landscape and the animals were like something found at the edge of a dream.

BARRY LOPEZ

from fellow Icelanders. 'Nobody watches whales in Iceland's west in winter!' So it was that he'd prayed to the Viking sea gods that the wild things would return, biting his salty fingernails down to stubs and watching the still empty horizon as late as January. And as any cetacean expert will tell you, there's no real guarantee with wildlife. But a horde of paying guests were coming. And soon.

Thankfully, the orcas had returned, much to Gisli's relief and our delight. In fact, they were here in numbers, and visible from our guesthouse window feeding on herring and surrounded by attendant sea birds – we were even photographing them with wide-angle lenses at fairly close range. But in the years after my trip they returned intermittently, seeming to have found better feeding grounds elsewhere, then reappearing just as suddenly the next season – perhaps blown in like the changing wind, or on the tail drift of cold water channels that carried the fickle shoals of bait, turning hither and thither like a silvery mass of fluid metal.

With our accommodation so close to the fjord and in the shadow of the distinctive and beautiful peak, Kirkjufell, we had been perfectly placed to photograph the aurora borealis too. But it was one of the few times I haven't seen the lights in Iceland in winter, and I remember us all staying up late on successive nights, faces pressed to the windows and eyes to the heavens, desperate for a hint of green in the dark sky. Our hopes had gradually diminished as the nights went by, but the trip itself was still a roaring success. Organising a range of activities will always mitigate some of the disappointment – and if there's one thing we know we should plan for, it's the unpredictability of Mother Nature.

Breathing out >
DSLR, 75MM, 1/500 SEC, F4.5, ISO 400 >

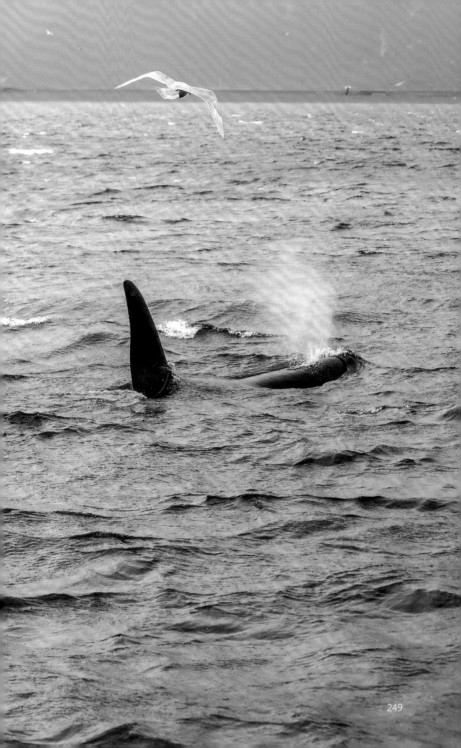

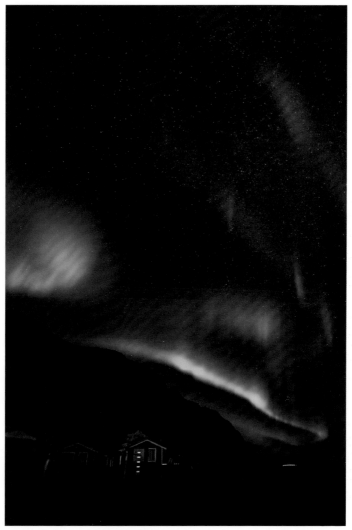

Northern lights over Hali, Iceland
DSLR, 16MM, 6 SEC, F2.8, ISO 1600

PHOTOGRAPHING AURORAS

WIDE ANGLE & APERTURE | LONG EXPOSURE | STABILISATION | SHUTTER RELEASE

Excellent stabilisation, fast wide-angle lenses and a shutter release or timer are required for auroras and other astrophotography. The main thing to bear in mind is the length of the exposure – both for the image and the photographer. Longer exposures allow you to include the movement of the lights, but with very dramatic activity you may opt for a shorter shutter time. Anything from a few to 30 seconds will record something of the colours and shapes, but to keep stars pinprick sharp the aperture should be wide, the ISO as high as your camera can cope with and the exposure time as short as possible. Given that aurora activity is often late at night too, you'll need to be properly kitted out in warm layers to withstand the wait – with a head torch and safety measures in place.

Combining aurora chasing on longer trips with other activities is a good way to travel, with more chances for clear weather – and plenty of other photographic options if they don't appear. I've seen the lights on nights in Finland after the day's skiing or snowmobile activities were done, heading out away from our building and getting close to hypothermic with a lovely aurora addict who'd taken a job in a hotel kitchen for the season just to photograph them. Tina's Finnish genes seemed to have protected her from getting frostbite as we trudged through snow drifts and waited things out for three or four nights in a row, often at more than -15°C.

There are many small tourism-friendly communities with such little light pollution that strong aurora displays can be seen from outside hotel windows. Location is everything with astrophotography, and it's why the best northern lights images you'll ever see are taken by those who live in dark-sky regions. Most disappointed travellers who have failed to see auroras generally tell me they only had two or three nights in which to try. Booking a longer trip, researching a place to stay where you can simply walk out at night and planning for daytime adventures will take some of the pressure off, and create more opportunities for great photos, whatever transpires.

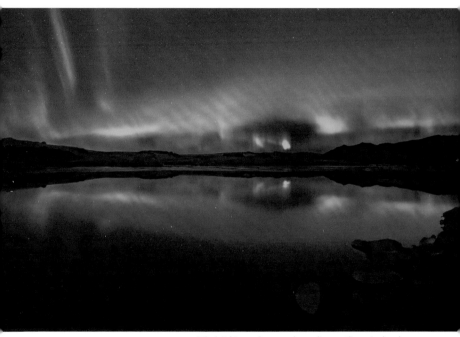

Jökulsárlón and aurora borealis, southern Iceland
DSLR, 16MM, 13 SEC, F2.8, ISO 1600

Stars and northern lights, southern Iceland >>
DSLR, 24MM, 15 SEC, F1.4, ISO 800 >>

One of the things I love about astronomy
and in fact about all of science is that the more
you know about the thing you're looking at,
the more wonderful and fascinating it is . . .
light travelling at 300,000 kilometres per second
took 430 years to journey from Polaris to your eye.

PROFESSOR BRIAN COX

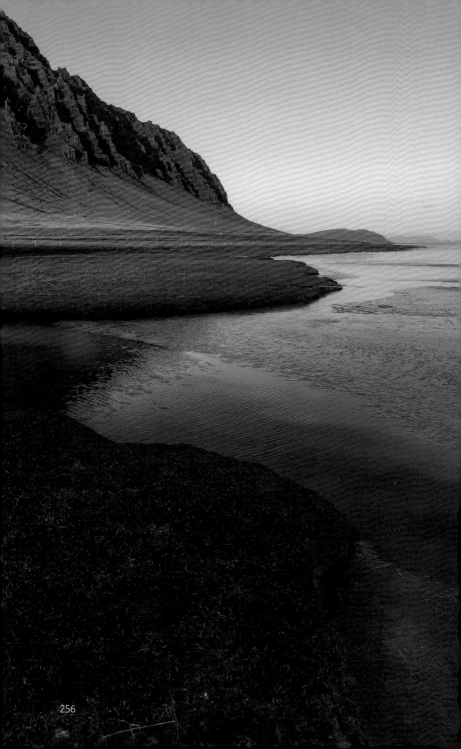

EPIC LANDSCAPES

WHITE BALANCE | NARROW APERTURE | COMPOSITION | EXPOSURE

Depending on the season, if photographing in the high north you'll be met by vistas such as permafrost, rolling green fields, waterfalls and mountainous terrain. The usual landscape rules apply – a good composition, small aperture and perfect exposure to avoid clipping highlights in the sky. And though a snow-covered domain can be pleasing to the eye, it adds another layer of difficulty, from finding foreground action and picking out key details to ensuring the white balance is accurate. It's easier with the heavenly, soft light of summer when the midnight sun hovers along the horizon, bestowing a divine sheen on everything. If aboard a ship, don't forget to take action shots of the hull moving through pack ice, and walk around on decks for different perspectives, looking ahead to steal a march on constantly shifting compositions.

< Frozen lagoon, Iceland
< DSLR, 24MM, 1/80 SEC, F6.3, ISO 100

Sunrise on frozen water, southeast Iceland >>
DSLR, 35MM, 1/60 SEC, F11, ISO 160 >>

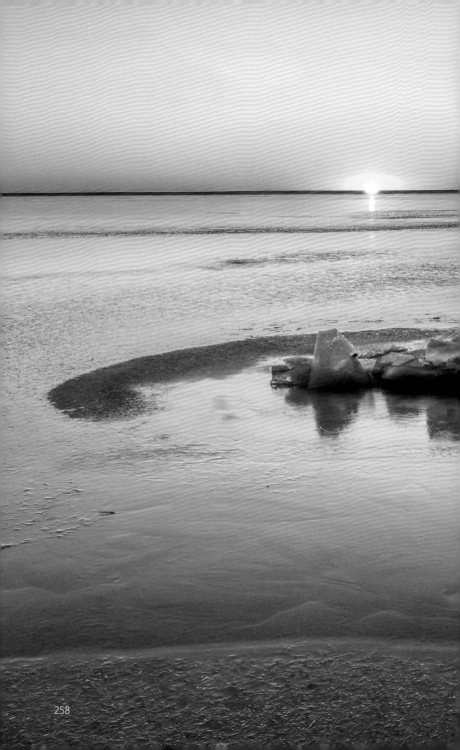

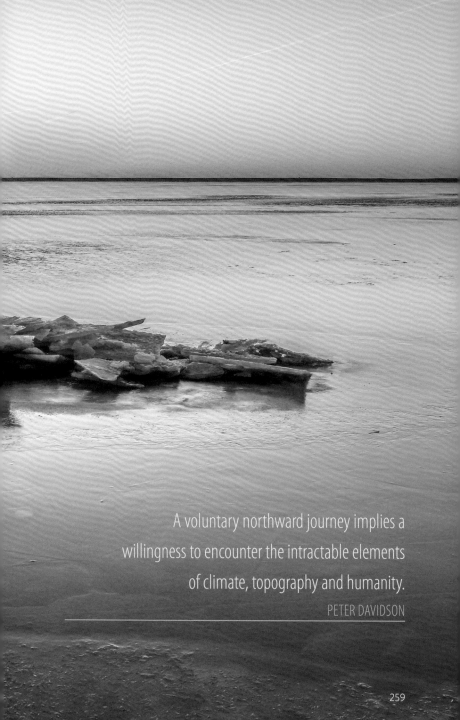

A voluntary northward journey implies a
willingness to encounter the intractable elements
of climate, topography and humanity.

PETER DAVIDSON

THE UNDERWORLD

LOW LIGHT | WHITE BALANCE | ISO | STABILISATION

Though the world of the north glares bright by day, going underground requires your low-light photography skills and kit. Dropping down in snowholes to walk underneath glaciers with professional guides, it will often only be artificial light that helps you to see your way. Stabilisation and wide, low-light lenses are essential, but you'll still need long exposures and a high ISO. Reduce noise by using head torches or taking additional, continuous lighting where possible – cave photographers create beautiful effects through the careful placement of light. If it's an unexpected part of your trip though, ask fellow travellers to help backlight a scene with headlamps, and have one model for focal interest. Use your timer or shutter release as you would at night, shooting in manual mode.

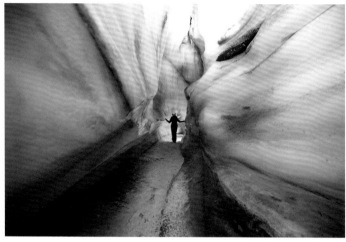

Under Longyear Glacier, Svalbard
DSLR, 16MM, 1/40 SEC, F4.5, ISO 12800

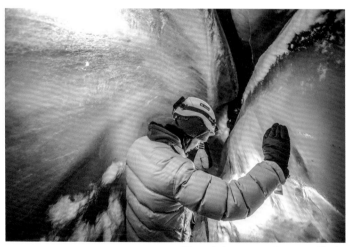

Through the crevasse, Longyear Glacier
DSLR, 16MM, 1/30 SEC, F2.8, ISO 12800

THE FUNDAMENTALS

WHITE BALANCE, EXPOSURE AND SNOW

When working in snow and ice, you might need to adjust the white balance and check your exposure meter. On arrival, you could take a greyscale image, or simply shoot in RAW and adjust the whites and greys later. Always check the histogram, and for landscape imagery use graduated ND filters to differentiate daytime skies, with stronger NDs to blur the flow of waterfalls.

PHOTOGRAPHING ACTION AND SPORT

A fast zoom or wide-angle prime lens can work well in rapidly changing situations, and – if participating yourself – consider using gimbals

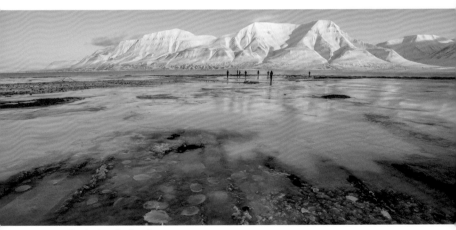

On the ice, Svalbard
DSLR, 16MM, 1/80 SEC, F11, ISO 100

or a helmet-mounted GoPro. Underwater housing for small cameras means you can shoot a little below-the-surface action too, and drones for aerial coverage are becoming lighter and more affordable every year.

WILDLIFE ON THE MOVE

You'll probably be photographing handheld from moving Zodiacs or ships, so remember the shutter speed for different focal lengths (see page 423) and keep the focus point either as one shot or in burst mode, depending on activity. Use the motion-tracking options or blur the background with birds in flight, aiming to keep eyes and faces in focus.

AURORA PHOTOGRAPHY

As any aurora photographer will tell you, the beauty of the northern lights will be further enhanced in the digital darkroom, however faint the greens are to the naked eye. You may be lucky enough to see vibrant aurora crowns and dramatic activity, with purples and sometimes reds joining the dancing greens. Set up the camera in advance, have tape to keep dials in place, a head torch for safety in the dark and shoot in RAW.

EXTREME CONDITIONS AND EQUIPMENT

A spare camera body is always a good backup plan for extreme conditions and remote trips. Batteries will die in the cold, so have extra and keep them somewhere warm when out in the field, like an inside pocket. Condensation can also pose problems, so take care when moving between cold outdoor situations and warmer interiors – remove cameras from plastic bags and allow lenses and bodies to air naturally in dry conditions.

AN EXPERT'S VIEW
PAUL
ZIZKA

© DAVE BROSHA

Paul Zizka is an award-winning mountain landscape and adventure photographer based in Banff, Canada. A prolific adventurer, Paul's journey to capture the 'under-documented' has taken him to all seven continents, as well as to each of Canada's provinces and territories. He is frequently published in some of North America's top magazines and has numerous coffee-table photography books. A passionate teacher, he hosts workshops all over the world, as well as an online community for photographers, through his company, OFFBEAT. Paul enjoys life in the mountains and exploring the world with his wife Meghan and their two daughters. **zizka.ca @PaulZizkaPhoto**

What's your process to capture those 'wow' images so prevalent in your work?

My process is two-fold. The first type of image involves more spontaneity where I roughly try to align a variety of ingredients in a way that I know can lead to something good, perhaps great. So, for example, I might go to a location that I know to be photogenic at a time of day that I know is conducive to having good light. In this case, I'm just trying to stack the odds on my side, but I don't really know what shot I'm after. The other approach involves a lot more

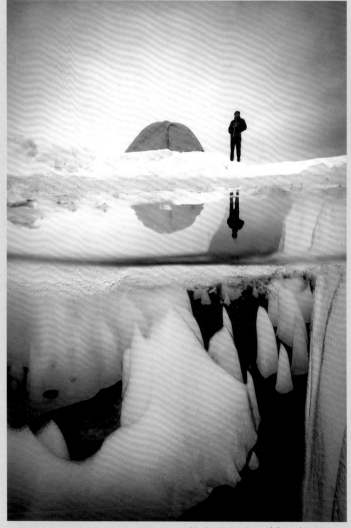

Underwater view of Greenland icecap
DSLR, 16MM, 1/1000 SEC, F16, ISO 1600

Athabasca Glacier, Jasper National Park, Canada >>
DSLR, 15MM, 8 SEC, F2.8, ISO 1600 >>

265

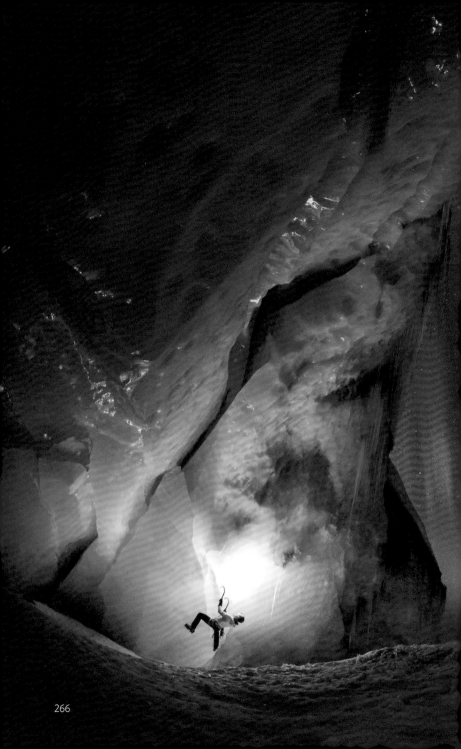

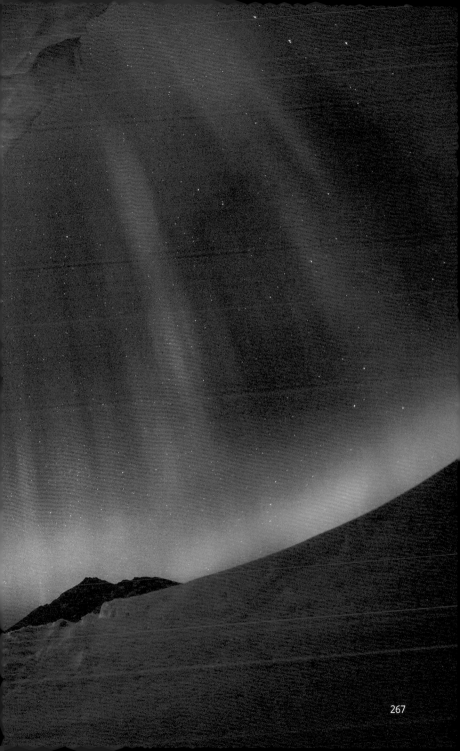

pre-visualisation in which I'm coming up with very specific images, almost down to the composition. For example, I may want the Milky Way in a certain spot with a reflection in a certain lake. And then I need a model in the shot who's got a specific skill set. Then the goal is to make all those factors align at one single moment in time. Often, I'll hop between these two different types of image. I find that this keeps me improving as a photographer and also keeps me excited.

Does photographing adventure require specialist equipment, and is there anything you couldn't do without?
Different activities or environments require specific gear, but in terms of what I couldn't do without in a more general sense, the first item is a head torch. Sometimes the day gets longer than expected and you need it for safety reasons or to get back to your car in the dark. But a head torch also works as accessory lighting and can come in very handy.

I also like to carry a satellite device so that I can remain connected, no matter what happens. I can use it to call for help, to tell my wife I'll be late, or to make plans with another photographer when I'm out of cell range.

In terms of camera gear, my workhorse has always been my wide-angle zoom (currently the 15–35 f2.8 Canon RF lens). I shoot probably 80% of my shots with a wide-angle lens. The one I use is trusted, durable, portable and versatile. It is one piece of glass I can confidently take into the backcountry, for instance, and know I can shoot various scenes with, whether landscape, astro or adventure.

Do you have any advice for dark sky photographers just starting out?
My biggest advice is to commit the time and stick with it. Also, set realistic expectations for yourself. A lot of people fall out of love with

astrophotography because they expect the same volume of output that they'll get when they shoot in the daytime. It's a difficult genre of photography and so you have to be easy on yourself.

One last important thing I would add is to find someone to photograph with. I think a lot of people stop astrophotography before they reach their peak within the genre because it's easy to find excuses not to be out in the dark, perhaps in the cold, or giving up on precious sleep. If you're committed to going out with somebody else who, ideally, has the same level of interest and experience, then you're way less likely to bail on your astro outings.

> Astrophotography is a genre that is frustrating at first; a lot of people give up too early. But once you've mastered the technical aspects, and the technical matters have become second nature, then it becomes addictive.
>
> PAUL ZIZKA

ASSIGNMENT 1
PHOTOGRAPH
THE NIGHT SKY

- Find a safe location, unpolluted by light, with good options for night sky compositions.
- Ensure you have adequate warm weather gear and ideally someone to photograph with. If not, plan to check in and let a friend know your movements.
- Plan for a clear, star-filled night; be in place before it gets dark.
- Have a tripod and a fast wide-angle zoom or prime lens.
- Before dark, find a composition where there's something to focus on – a tree, a row of rooftops in the distance or the person who came with you. Don't choose something too close or the stars will be blurry – you're aiming at something like infinity for the heavens.
- Fix the focus point on your distant subject, then turn the lens to manual focus, locking or taping it down.
- Using the manual camera settings, turn your aperture to around f2.8–4.0, and set the shutter speed by consulting your exposure meter. Turn up the ISO as necessary.
- Activate the timer or use a cable or remote shutter release.
- Take several images as the sky begins to darken and more stars appear, increasing the length of the exposure.
- You can turn on the camera's internal noise reduction, but this will double the exposure time (not great for sometimes fleeting auroras, but ok with stars if you're not in a hurry).

- If you can, check a test image and histogram on your screen – if it's obviously too light or dark, adjust the ISO or exposure time accordingly. Ideally, know how to change settings in the dark with minimal movement of the camera's positioning.
- Use shorter and longer exposures, from a few to 30 seconds.
- Advanced photographers may want to try some light trails, pointing the camera towards Polaris or the south celestial pole, using an intervalometer that triggers the camera to take a series of photos at regular intervals over a set period. Stack these in processing software to demonstrate circular arcs and the earth's rotation.

REFLECTIONS

Getting used to working in cold, dark conditions is good training for what it will feel like when photographing the northern lights. But as each camera, lens and sensor will have a unique threshold for noise and an optimum ISO, it's important to get a feel for how the images will look once edited. Put them through your processing software and use brightness, contrast, clarity, highlights and shadow sliders to see if the image can be really brought to life. See *Chapter 11* for editing tips.

Choose your best three to five images to review:

☐ Is the composition interesting?

☐ Are the stars visible?

☐ Did you manage to keep the camera steady on the tripod, or is there obvious blur from camera shake?

☐ Are the stars quite sharp, or more like miniature blobs?

☐ Did you vary the exposure time?

☐ Is the main subject in focus?

☐ How high did you turn the ISO, and did it create too much noise?

- Were you cold or uncomfortable during the shoot?
- Did your batteries hold up in the conditions?
- What was your camera's optimum ISO, aperture and shutter combination for sharp stars and minimal noise? Record what worked best on this particular shoot.

Surprisingly, in the high north you'll probably spend more time in extreme cold weather than you might in Antarctica, given the emphasis on aurora chasing and other land-based exploits. No matter how well prepared you are, on intense, cold night shoots you will find it harder to concentrate and focus on your photography. Knowing your camera inside out and being prepared with a torch, plus good warm and windproof gear will make astrophotography less about the conditions, and more about the images.

As far as personal kit goes, I'd say that for the outdoors a good pair of shoes makes all the difference. Never, and I mean never, travel – as a professional or an amateur – without having tried your shoes out. Without the proper footwear your trip, and your work, can be a disaster.
PAOLO PETRIGNANI

ASSIGNMENT 2
PHOTOGRAPH PEOPLE IN ACTION

- If there's a local skate park or mountain bike trail, do a recce to check out activity on a busy day. If you live near a beach or lake, kite surfers and water skiers make great, fast-moving action subjects.
- Think about the story that you want to tell or be spontaneous and see how the action unfolds, figuring out a narrative angle as you go.
- Work out whether you'll be static, documenting from a beach or riverbank, or moving yourself on a boat or other vehicle.
- Check the direction of light and find the best vantage points.
- Choose your camera and lens accordingly – a wide or long zoom depending on your position.
- Use the lens hood to reduce glare and a ND filter if necessary.
- Prioritise shutter speed, and adjust it after taking some test shots, aiming for frozen action.
- Look for relationships between people; synchronised movement, jumps and high-octane moments.
- If you have lighting, are close enough and it won't be a problem for the subject, use flash and get down – the lower you are, the more dramatic any leaps and somersaults above you.
- Don't forget the people watching as well as those participating – include reaction shots and adrenalin-fuelled moments.
- Get as close as you can to create an immersive feeling for the viewer.

GENERAL ADVICE

- The far north offers a range of photographic possibilities, so decide on your priorities before packing your kit, especially if you'll be involved in activities yourself.
- Use a long lens for wildlife photography, but remember you'll often need to hold it, so make sure it's physically the right kit for you.
- Remember to keep the shutter fast for activity.
- Have a light or compact system for rapid action on the move, and consider underwater housing if planning to submerge it for some of the story.

The frozen Arctic Ocean
DSLR, 16MM, 1/40 SEC, F11, ISO 500

- Keep filters at hand for daytime glare and use your lens hood.
- A sturdy but light tripod is vital, but in extreme sub-zero temperatures, even the fittings on the best carbon-fibre stabilisation can shrink and behave badly.
- Don't forget to capture a range of images and focal lengths – it can be tempting to only zoom in on wildlife if you do have a very long lens, especially a rented one you want to get your money's worth out of!
- Stay alert. Animals can appear at any moment, especially in the ocean, so you'll need to keep moving.
- For 'wow' images that grace magazine covers and win awards, make sure you take your time and recce the locations.
- With northern lights photography you'll need a wide-angle and low-light-capable lens, as well as good stabilisation and a cable or remote shutter release.
- Waterproof clothing, base layers and decent footwear will keep you comfortable, mobile and able to stay outside for longer.
- Remember to balance work with the incredible experience of being in the magnetic north. It isn't *always* about the photography – though 99% of the time it will be.

THREE PHOTOGRAPHERS TO FOLLOW
Paul Nicklen paulnicklen.com
Simona Buratti beyondthelands.com
Martin Hartley @martinrhartley

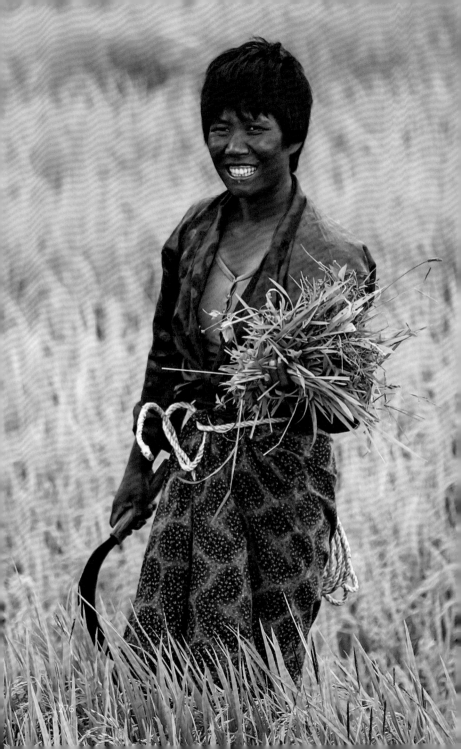

FOOD AND MARKETS

FOCUS ON
ASIA

Food has always been so intertwined with our experience of travel that it goes hand in hand with imagery of cities and culture. In the wider story of a journey, our photographs of restaurants and cafés create atmosphere and colour, and add to the bigger picture of a destination. But food can also be a subject in itself, taking in everything from farm to fork in photo stories that encompass sustainability, environment and taste. There's no limit to the points of view and storytelling angles, and photographic food spreads are a regular feature in the specialist and general travel pages of newspapers and magazines.

In the last decade or so, nutrition has also become one of the most ubiquitous forms of social-media imagery, with bloggers and 'grammers posting luscious pictures of everything from their brunch to green smoothies and cocktail hour. It may be no coincidence that we call it an Instagram feed – so moreish are the photos we scroll through,

< IN THE FIELD Bhutan rice field woman
< DSLR, 200MM, 1/250 SEC, F5.6, ISO 640

Taking pictures is like tiptoeing into the kitchen late at night and stealing Oreo cookies.
DIANE ARBUS

like a sugar addiction that can never be sated. And given that restaurants and interior designers have prepared a dish and décor to look its best, with guests often dressed to the nines, it makes sense that food photography often incorporates all that is fashionable and aspirational. What's more, it can very easily be shot on a phone and posted within seconds, while you sip what's left of your mojito.

Seriously stylish food and travel photographers understand the importance of backdrops and lighting, often transporting an off-camera continuous LED light, reflectors or flash systems to create a mini studio. Wipe-clean table coverings are easily packed into a suitcase or camera bag, and can recreate the look of farmhouse oak tables or pure granite for clean, well-composed top-down or flat lay images. Crop in close and you could be anywhere.

Like many good ideas, the high-angle food photo has become something of a cliché. But there's a reason it's so popular. Having a God's eye view of the scene and every detail of a bounteous spread, we're being offered a seat at the top table. It's as pleasing to the eye as any still life painting from an Old Master of the Dutch Golden Age. Those artists were influenced by one another too, reproducing a

table of objects from wine and fruit to flowers, symbolising life and ephemerality, using colour and tone to create captivating scenes. Working from a picture that inspires doesn't simply signal a lack of creativity – we can learn techniques from what others have created, just like those painters before us.

Hotel rooms and empty lobbies can also work nicely as impromptu studios when on the road, removing fussy backgrounds and providing controlled conditions. Wooden tabletops are a simple, fuss-free backdrop for still life – think a single lemon that needs foregrounding in pure, macro-style close-up. I once spent quite some time unsuccessfully trying to capture a single, orange Ottoman tulip I'd been given while photographing flower culture in the Netherlands – after giving up, I popped into a hotel restaurant bathroom and the black marble interior instantly provided the perfect surface.

To me, photography is an art of observation.
It's about finding something interesting in
an ordinary place… I've found it has little to do
with the things you see and everything
to do with the way you see them.

ELLIOTT ERWITT

More traditional and rustic though is the 'real' food scene – the floating markets and hawkers in Thailand or roadside coconut sellers the tropical world over. And who can resist the sensory experience of a bakery on the Black Sea coast, or the aroma of chicken rice or satay skewers by the waterside in Singapore's Clarke Quay? With rows of *medialunas* on pastry shelves in Buenos Aires and viennoiserie in Paris and Austria, these flaky, golden delights are eaten on the go, sold alongside photogenic arrays of colourful macaroons or sweet delicacies. Food can give us a bit of drama too – once the baking smells

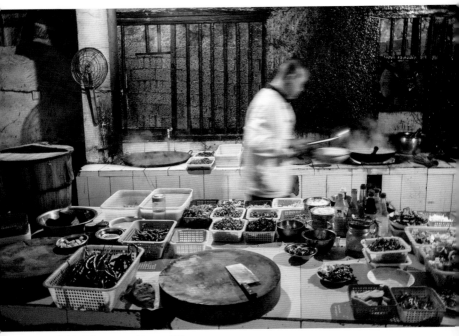

Behind the scenes, Hunan, China
DSLR, 24MM, 1/20 SEC, F2, ISO 800

have drawn us in, we stand mesmerised by dough bases being thrown in dazzling displays of self-confidence over the floury heads of pizza makers. And the pranks played by ice-cream sellers in Turkey, whipping frozen treats away from smiling customers in a magically deft display of virtuosity, leave everyone in high spirits, even before they've had their sugar rush. And it's all there to be consumed by us in pixels.

And remember, even working photographers need to eat at some point, so combining at least one good meal as part of your itinerary can kill two birds with one stone. Once seated in a restaurant it's much easier to fly under the radar and take atmospheric images of the interior – after you've checked with the manager, of course. But these days, thanks to Instagram, photographing your plate no longer seems rude or out of place – though many might argue it is still poor table etiquette!

Whatever your own food predilections, it's clear that there will be ample opportunities to visit markets, street-food vendors or high-end restaurants. And no matter the type of trip, it might just be the only time that travelling with others doesn't compromise anyone's happiness. Instead of eschewing those dining experiences to prioritise the sunset, you can multitask, indulging in a glass of something while photographing the scene, amid the other beautiful people enjoying it. Of course, there comes a point when you need to put your camera down and just tuck in – it's probably the best part of shooting a food story, even if you do have to delay gratification to first capture those mouth-watering shots.

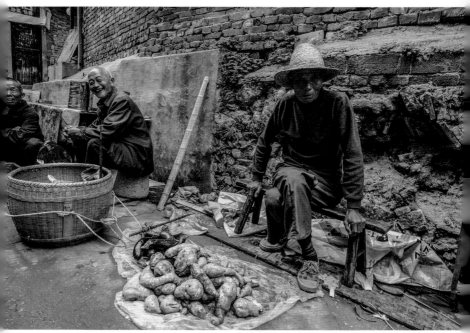

Hutong street vendor, Liuyang, China
DSLR, 24MM, 1/25 SEC, F5, ISO 250

MARKETS AND STREET FOOD

ENVIRONMENTAL | ACTION | REPORTAGE | CLOSE-UPS

Arrive at food markets well before breakfast to catch the early deliveries of fresh produce, watching the scenes unfold as shoppers appear. Food festivals can be a riot of colour, and the activity around street stalls, from funky aluminium retro vans to rustic roadside shacks and street vendors will draw on your people and reportage skills. Bring flavour and atmosphere to your storytelling by documenting the scene. Fill the frame with produce and capture the interactions between seller and customer, as they hand over goods or lovingly devour a delicious morsel with their eyes – try to avoid unflattering chewing shots! Remember to engage with your subjects and get their tacit agreement, even if you're only going to focus on their wares.

RESTAURANTS AND CAFÉS

PORTRAITS | AVAILABLE LIGHTING | FLAT LAY

Depending on the destination, restaurant photography can range from a three-star Michelin, fine-dining experience, to a table and plastic chairs set up by a roadside café. Whatever the décor, there will always be a server, very likely other diners and most definitely a plate or cup of something tasty. Use a variety of angles, from top-down to posed portraits and open up the aperture. Decide whether to focus on the food or the human behind it: blurring the background, as we know, is so helpful in crowded places. Creatively anonymise the figure sitting opposite you or frame your waiter through a steaming bowl of noodles as they set down the plate. Increase the shutter speed or ISO to freeze movement, and remember not to shoot unflattering chewing or open mouths.

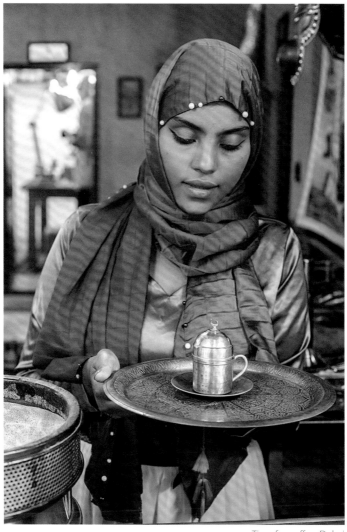

Time for coffee, Dubai
DSLR, 50MM, 1/50 SEC, F4.5, ISO 640

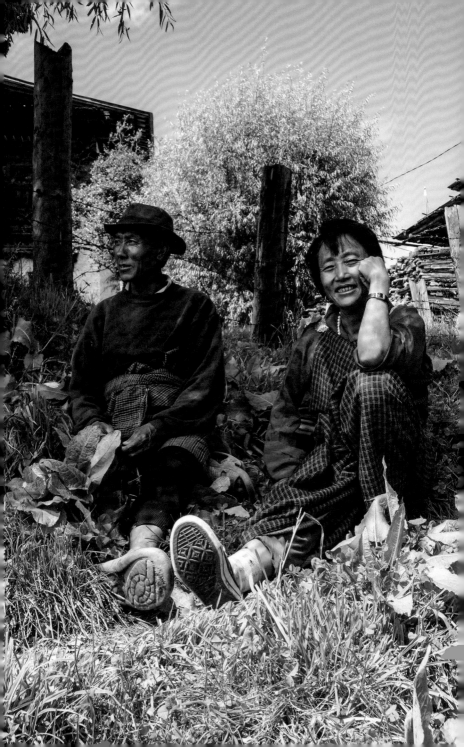

IN THE FIELD

LANDSCAPES | ENVIRONMENTAL | SCALE

From farm to plate and orchards to tea plantations, stories of food grown and harvested provide a glimpse of the provenance of what we eat. Terraced rice paddies and salt flats can also furnish us with the most stunning backdrops, employing our landscape and people skills, hopefully in optimal light. From the farmer to the restaurant, charting the progression of a particular foodstuff means finding its origin in the soil. Combine a variety of elements, taking mid shots of growers with a handful of potatoes or catching them resting, soil-covered and cold-nipped fingers clasped around a steaming mug of Darjeeling. Panoramas of ploughed fields or far-off diggers working the soil, alongside rattan baskets filled with green abundance can effectively contrast elements of scale and also work as single images.

< A break from work, Bhutan
< DSLR, 24MM, 1/200 SEC, F9, ISO 400

287

I might be biased given my cultural heritage, but all my journeys in Turkey – northeast to the Black Sea or southwest to the Aegean via the centrally located Göreme and Konya – have always resulted in some of the most magnificent food experiences.

On a trekking week in Cappadocia I managed to lose the group by lagging behind to take pictures – nothing new there. Finding myself lost in a small village, I was suddenly scooped up by two young women who began to show me around the hilly terrain, steering me towards a secret garden where I found a group of seated women making cheese-filled flatbread.

I introduced myself in very basic Turkish, and they visibly brightened, recognising the 'Heavenly Light' meaning of my Turkish name – always confusing to explain at home in the UK, but an absolute boon when travelling in Arabic- and Turkish-speaking countries. These are locations where I feel very much at home, despite not knowing more than a few phrases of my father's language – something I always regret not learning more of, though most of us veer naturally towards our mother tongue.

I don't think the guide had realised I was missing and, when he eventually came back to find me, I was very happy that I'd got to spend an hour lost in the fabulously fecund hills of the Ihlara valley, eating freshly made *gözleme*, still warm from the hotplate. The next day we took another route, and were handed walnuts and fruits straight from the tree later eating river trout with salad dressed in pomegranate molasses at an over-the-water restaurant terrace by the Melendiz River.

Making bread, Turkey >
MIRRORLESS, 14MM, 1/60 SEC, F3.2, ISO 1000 >

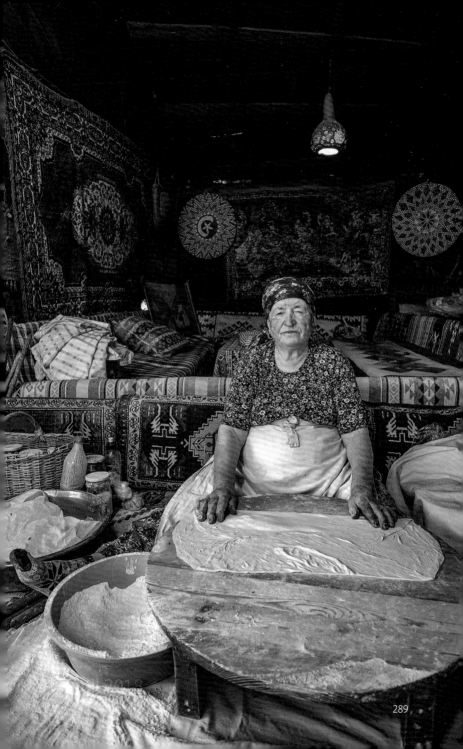

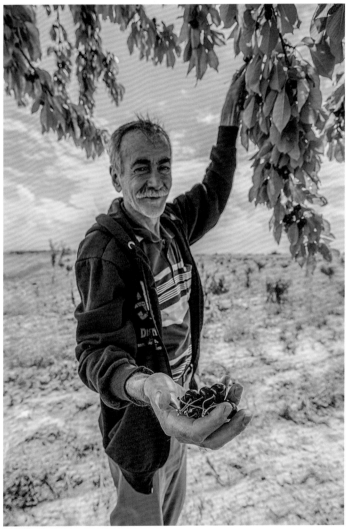

Cherry orchard, Denizli, Turkey
DSLR, 16MM, 1/640 SEC, F5, ISO 100

On another trip in Pamukkale during Ramadan, I managed to perfectly time my return after sunset shoots with the breaking of the fast by the hotel owner's family. Despite having their own small restaurant, they still insisted that I join them every evening as their guest. What's more, the manager's father-in-law drove me out to visit nearby sites, stopping at his smallholding and at a cherrry orchard near Denizli, where pickers jumped the fence to deliver freshly harvested fruit, some of it still attached to a branch.

Being local, speaking the language or returning to a familiar place will nearly always open the door to a secret garden.

It's one thing to make a picture
of what a person looks like,
it's another thing to make
a portrait of who they are.
PAUL CAPONIGRO

IT'S IN THE DETAIL

SHALLOW DEPTH OF FIELD | TEXTURE | DYNAMIC RANGE

A pair of hands holding palms full of coffee beans with a blurred figure behind them, shot through a wide aperture, may be something of a cliché in food magazines, but it's because it's such a powerfully evocative shot – the viewer wants to grab the glistening bounty. Playing with the range of light and shadow adds interest, using available, natural illumination or additional off-camera lighting to bounce a gleam on dewy, market-ready melons or freshly cut pomegranates. The skin of a citrus in macro close-up or a crinkled shell on a nut provides texture, alongside a varied colour palette or atmospheric tone.

DSLR, 50MM, 1/40 SEC, F1.4, ISO 1600

DSLR, 400MM, 1/500 SEC, F8, ISO 125

DSLR, 50MM, 1/40 SEC, F4.5, ISO 1600

DSLR, 300MM, 1/500 SEC, F5.6, ISO 100

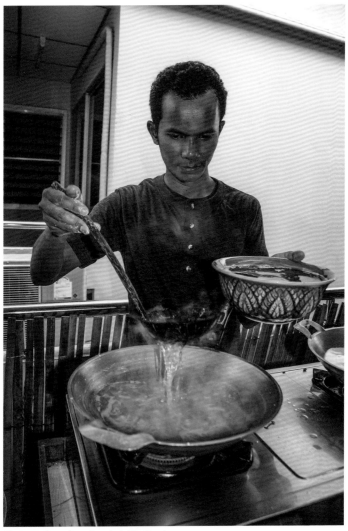

Silom cookery class, Bangkok, Thailand
DSLR, 17MM, 1/60 SEC, F4, ISO 400

CHEFS AND FOOD MAKERS

CONTEXT | ACTION | DETAIL | ATMOSPHERE

One of the best ways to discover a country is to join a cookery class. Joining in is fun, but makes getting the photographs more challenging. If you can get a friend to go along or observe from the sidelines, you're sure to get some great behind-the-scenes shots. Ask chefs if you can enter their kitchens, or at least stand at the periphery, shooting the hubbub and meticulous chaos that often ensues. Some high-end kitchens are open-plan, and it's fun to watch the camaraderie and finely tuned orchestrations, possibly shooting through a haze of heat and following the journey of the plate from hob to table, with tight shots of pots and pans on the boil. Sommeliers, vintners and craft-ale makers also make interesting subjects, as do whisky distillers or cheesemakers, with their workshops full of stainless-steel vats and cheese roundels in pleasing rows.

STORYTELLING

PROVENANCE | FARM TO PLATE | REPORTAGE | VARIETY OF SHOTS

It's likely you'll chance upon an abundance of food photo opportunities on any trip. However, to get under the skin of a winemaker's story, research and planning is vital. Even if the trip's not centred around food, looking into national dishes and drinks, or the proximity of vineyards or terraced salt flats, will give you an idea of how to fit a story into your itinerary. If you do chance upon a scene, having planned to allow leeway to search for inspiration, exploring the backstory (and, more importantly, getting names and details for caption writing and introductory text) will lead to a more rounded set of images. And if you can revisit, then make contacts and get preliminary images to pitch your unique angle to magazines for paid commissions and a return trip.

Tea at the monastery, Bumthang, Bhutan >
DSLR, 85MM, 1/125 SEC, F7.1, ISO 400 >

297

MIRRORLESS, 14MM, 1/2000 SEC, F3.2, ISO 200

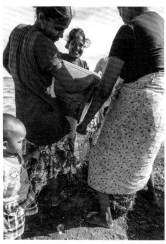

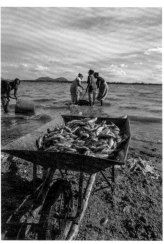

MIRRORLESS, 14MM, 1/150 SEC, F8, ISO 200

MIRRORLESS, 14MM, 1/680 SEC, F8, ISO 200

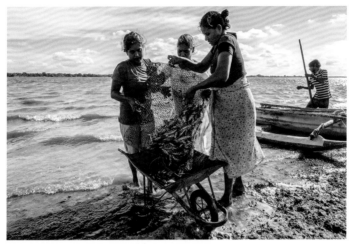

MIRRORLESS, 14MM, 1/220 SEC, F8, ISO 200

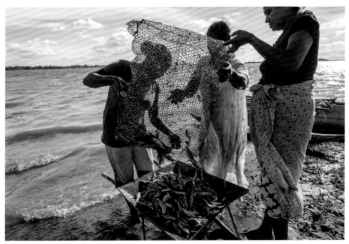

MIRRORLESS, 14MM, 1/320 SEC, F8, ISO 200

Everywhere we ventured, whether inland or along the coast, fishing seemed to be on the menu. On the way to the east coast, we set down in the centre, near the ancient capital of Anuradhapura. An invitation to visit a nearby lakeside village manifested into one of those lucky occasions when a photographer's dreams come true. >>

Nothing about food photography is different
to any kind of travel, reportage or culture
photography. A picture is a picture is a picture.
All photography is about the photographer:
a photo captures the photographer's mood as she's
looking at this scenario in front of her, whether it's
a matador, a fishing boat, a bowl of ramen,
or a sunset over a vineyard.

MARK PARREN TAYLOR

Spending the entire day there with a community of intergenerational family groups, we were invited to hang out on the beach, play cricket and drink tea. As there was no rush about things, I was able to engage fully with my hosts, as well as keep one eye on a scene that was unfolding by the lakeshore. As the afternoon wore on, more and more people appeared with small boats and fishing paraphernalia. It was mostly the husbands and sons out on the water in thin wooden structures, while the women used wire nets and wheelbarrows to haul in the catch, sorting it later to share among the families, all the while surrounded by their infant children.

The fact that I was being hosted by a Sri Lankan family who introduced me to their friends meant I was able to chat with them and capture a series of natural images. I'd been there for so long they saw me simply as one of the crowd.

Professional photographers often work on the ground with fixers, who act pretty much as hosts —making introductions, smoothing the way and translating if necessary. If you can't avail yourself of that level of help just yet, then do the next best thing and forego large hotels in favour of homestays, where getting to know a local will open up a whole new world to you. And for people to really let you in, it just takes a little bit of time and for you to return their hospitality with a generous heart.

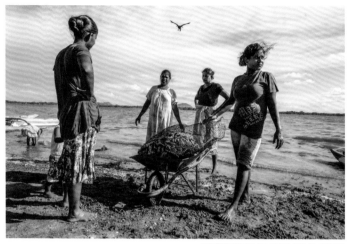

MIRRORLESS, 14MM, 1/1000 SEC, F8, ISO 200

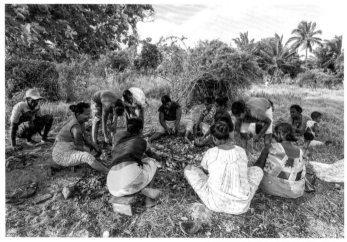

MIRRORLESS, 14MM, 1/60 SEC, F8, ISO 250

303

THE FUNDAMENTALS

WHITE BALANCE

When photographing in bars, restaurants and covered markets, you'll often find yourself working in fluorescent, tungsten or low-light conditions. Select the appropriate white balance setting for incandescent lighting, checking the colour temperature of test shots to see if they match with what your eye can see. Digital processing will allow for the WB to be tweaked if you photograph in RAW, but it's better to get the shot as it was in camera, at least for reference when you colour grade or edit. See *Chapter 11* for more on editing.

USING NATURAL LIGHT

Consider the direction of light and try to place your subject in a good setting. In restaurants, daylight diffused through curtains will have the same flattering effect as a softbox. If you are sitting outside, then aim for a table in full sunlight or shade, and adjust your settings – it's difficult to expose for both light and shadow, and if food is your focus, you'll want it all to be equally visible. Look for natural environmental shots that are well lit, and landscape images, from tea fields to vineyards, will always be better in the hues of morning or late afternoon.

USING FLASH

Given so much food photography is executed indoors, often in low light, flash can be helpful. Of course, it depends on your surroundings and whether using additional lighting will offend other diners or the restaurateur. Try not to use direct on-camera flash systems or you'll

probably have a flat, overly lit image. Use reflectors and bounce light off walls and ceilings, sitting near natural light sources. Off-camera flash systems or continuous lighting can be used as directional light at a more flattering angle, and a small tripod or bracket can hold it in place. Only use flash if increasing the ISO goes beyond the camera's noise threshold.

STUDIO LIGHTING

Trying to emulate magazine food stylists at home means using a lighting system that provides both directional, fill and backlighting to remove unwanted shadows. This three-point lighting is used by cinematographers in the film industry, and can add texture as well as a bit of glamour. Not easy to do on the road, practise at home by making a walled cardboard studio or using a plain wall as background. Portable, collapsible studio light tents are worth purchasing if you plan to focus on studio-style imagery, with smaller plastic light boxes a good option for when travelling.

FOCAL POINT

There'll often be times when you're faced with a chef or server holding a plate of food in front of you. You'll need to decide quickly whether to focus on the food or the person's face – hopefully they'll allow you time to do both. But if the person's important and you have limited time, keep the aperture narrow and avoid the use of creative blur, unless it's a close-up of hands. Losing an important subject's face in favour of a bowl of soup doesn't always work for storytelling. To get the whole scene in focus, take a few steps back, use a different lens or ask the subject to hold the tray closer to them – or perhaps move position for a better angle on things.

APERTURE PRIORITY

When needing to blur out a messy background or protect the privacy of diners, a wide-open aperture can both add focus to dishes and creatively defocus the background. Too wide and you'll only have a small part of the plate in focus, but this can also work if you intentionally want to home in on the froth on a craft ale. Aim to keep most of the food sharp by staying a level distance from the elements on the plate – either by shooting straight on or top down.

STYLING AND PROPS

Even if you're not going to style things out, think about how the table looks before you begin to photograph in a café or restaurant. The angle of a fork can ruin the composition, as can a wayward ashtray or gravy spill. Set the scene on a terrazzo, with a folded newspaper, pair of sunglasses and a full cup of cappuccino, and bring your street skills to the fore with blurred passers-by or moving vehicles.

Turkish coffee
MIRRORLESS, 14MM, 1/320 SEC, F2.8, ISO 200

MOVEMENT, SPLASHES, DETAIL

There's a whole photographic genre that works with oil on water and colour explosions – with kits for those keen to specialise in splash-drop photographs. While not general travel fare, it is fun to play with camera settings, working out how off-camera-synchronised flash guns can pick out water being poured from a jug or backlit champagne bubbles. Playing around will give you the confidence to try things out when travelling, or simply be inventive.

COMPOSITION AND ANGLES

Like all other types of photography, original composition is key, yet for recent magazine and Instagram food photography, there's a recognisable style that's currently in vogue. Whether you work with this flat lay trend or against it, dress your set and move things around, depending on the focal length of your lens and camera set up. Three diagonally placed objects, with one or two off-centre or half out of the frame work well, but there are a myriad of patterns to play with. Be creative and look for fresh ways of depicting the scene.

Fill the frame with telling details:
local patterns on fabric,
plates in typical colours,
a glimpse of embossed silverware.

KAROLINA WIERCIGROCH

AN EXPERT'S VIEW
MARK
PARREN TAYLOR

Mark Parren Taylor has been an editorial photographer for almost twenty years, published in magazines and books in Europe, the US, Australia, Japan, Hong Kong and East Asia. He didn't go to university or have any contacts in publishing or photography. Knowing nothing about the business of taking photographs, he simply saved up for a year, quit the day job and went off for a month taking pictures. 'They were mostly useless, except a batch that I managed to make into a story which I showed samples of to *Geographical* magazine, who published it the next issue.' These days, his work graces the pages of *National Geographic Traveller*, *Food and Travel* and some *Condé Nast* titles, among others. **mptphoto.com @mark_parren_t**

What kind of research do you undertake before travelling to a photographic destination?
I want to know a place inside out. I will plan meticulously where I need to go – the shorter the visit, the more exacting the plan. However, I will need to factor in some wandering time – to grab the light and people and moments you can only find when you're walking the streets. Information I need before I go includes when timetabled events are occurring, the top ten best restaurants and bars; if there are street

During a tour around Sri Lanka, I was fortunate enough to have been able to arrange a series of homestays. And at nearly every location on the tear-shaped island we were met by great subject matter for food photography. A local cook on the east coast near Trincomalee taught me to make sambol from scratch, while the tea manufacturers in and around Kandy invited us to see the fields and production processes, as well as partake in a tasting that, of course, resulted in the purchase of many different varieties. I admit it. Tea is my drug.

But it was the fishing communities there that have most stayed with me. Initially I chanced upon a group of fisherfolk fixing their nets after bringing in the morning's catch by the sea in Negombo. I'd only just landed in Colombo, so wasn't fully ready to make the most of the opportunity. Occasionally, you happen upon great scenes when tired or under duress – those 'might-have-been' moments always remain with us and can be very frustrating. I needn't have worried this time though. >>

markets, festivals and religious events. I will also check social media to find the latest posts from city folk in the know.

Do you have any kit or lenses that are specific to your work as a food and travel photographer?
I use an old 50mm f1.4 for almost everything, from food and landscape to portraits and street. Everything else (apart from a camera, of course) I can manage without.

What's the most important technical aspect for you to get right when photographing food?
It must look as if it's all seen by the same eye: some photographers snap 'loosely' on the street, then use rigid tripods and wide or long lenses for landscapes, then spend time the next day dressing food portraiture shots and getting the light just right. And in the end, to me, it can all look very disjointed. All shots – food, people, cityscapes, candids – must be approached the same way. Food photography, in particular, can be the victim of too much fiddling.

What are you looking for aesthetically in the final images?
I work with stories and sequences of shots. I never intend to make a standalone pic. One shot is just one moment on a trip that is made up of 8– 10,000 clicks. If I've allowed myself to become totally immersed in my subject for those three or so days then it should all fall into place.

How do you decide which images to select for a photo story?
I start to know what the final selection will be from the first day of the shoot. This is when the mood of the place, the people I'm meeting, the light and weather all become known quantities. As I take each shot,

Morning sunlight at a Nakasendo Way teahouse, Nagano prefecture, Japan >>
DSLR, 24MM, 1/100 SEC, F2.5, ISO 280 >>

Don't just be a good traveller, be a good person – too many photographers have reputations for being rude and egotistical.

MARK PARREN TAYLOR

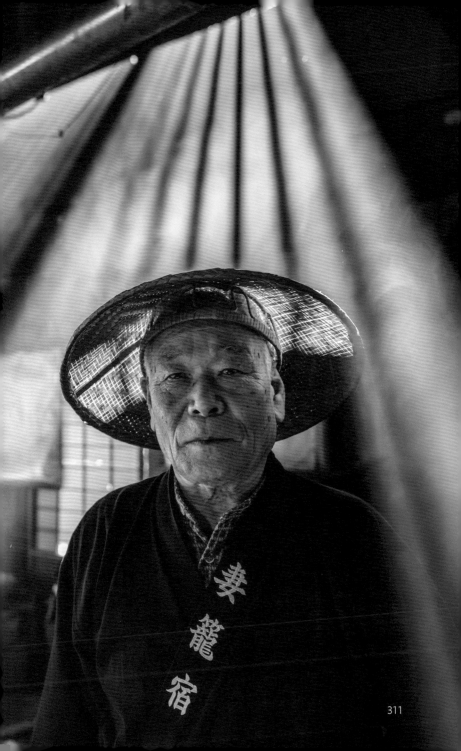

311

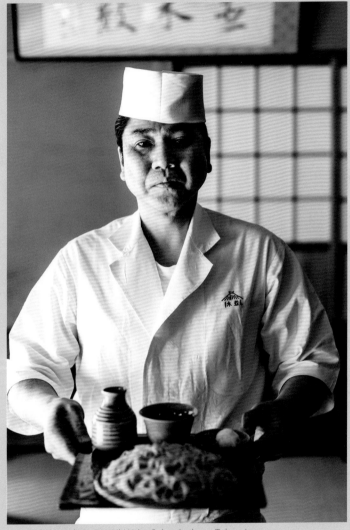

A tray of *zaru soba* at Namiki Yabu Soba, Asakusa, Tokyo, Japan
DSLR, 50MM, 1/125 SEC, F2.2, ISO 100

sometimes before I take the shot, I know if it will be used. This is confirmed at the end of each day when I sort through the images. At that point I'm building the story from the (hopefully) growing number of key shots. In the end, the final selection of 100–200 images is about balance, repeated motifs, colours and/or themes, surprises, changes in tempo and, hopefully, tender or even romantic moments.

Do you have any advice for photographers considering specialising in food and travel photography?

Success is 1% talent, 99% hard work – and those who work hard make their own luck. I would never recommend that anyone specialises in 'food and travel' (try to build other income streams, such as bread-and-butter work in the commercial field – wedding photographers have many similar skills to food and travel photographers, for example). I would also recommend that 'food and travel' photographers specialise, let's say, by region or country or by subject matter, but they should also show that they can cover other destinations and stories (this is up to a good website or social-media feed to show both the specialisms and the ability to shoot non-specialist subject matter).

ASSIGNMENT 1
PREPARE AND STYLE A FOOD SHOOT AT HOME

- Take a look at food and travel magazines to get ideas for the style and look of your shoot.
- Refer to art, food stylists and bloggers for more inspiration.
- Like fashion photographers, food bloggers often favour a desaturated look, with low-key lighting and contrast (almost monochrome in some instances), or a specific colour scheme, so find an original style or emulate one you admire.
- Consider the colour palette of your room, the colour temperature of the light and decide whether to match them with complementary food colours.
- Hot food will cool quickly, and some foodstuffs will congeal and look unappetising. Either photograph a plate of cold food, perhaps a still life fruit composition, or choose something you can control the look of.
- Do you need to find something to lay out on the table or behind the plate – perhaps monochrome or coloured card or fabric?
- Check where your main, directional light is coming from. Work with lamps, torches or reflectors as back or fill lights. Start with the ubiquitous but very satisfying straight on and top-down angles, safely using a step ladder or chair to get above everything.
- Have the aperture narrow enough to get things in focus. Try to avoid using a wide-angle lens – anything above 50mm should work well.

- Take several images, from different angles and move your props around – cutlery, glassware, napkins and condiments. If it's too fussy, take some elements away.
- Consider composing the image around the rule of thirds, with components placed in positions that are aesthetically pleasing.

REFLECTIONS

Food styling isn't everyone's cup of tea, but setting a scene forces you to think about lighting, angles and composition, as well as the interplay between colour and form. The reason still life paintings have always been popular in art and culture is that we enjoy seeing the very stuff of normal life portrayed in beautiful ways – from loaves of bread to the humble bowl of soup or goblet of wine.

Choose your best three to five images to review:

- ☐ Is the composition interesting?
- ☐ Did you style the set and think about the placement of props?
- ☐ Did you create a mini studio using special backdrops/table coverings?
- ☐ Did you consider the direction of light and compensate for any unwanted shadows?
- ☐ Did you try to use a backlight?
- ☐ Are your colours complementary?
- ☐ Did you manage a creative flat lay image?
- ☐ Is the background unfussy, and did you need to open the aperture to remove distractions?
- ☐ Does the food look appealing?
- ☐ Did you vary the images, and is there one style you prefer most?

Food photography is often shot in a studio using macro and prime lenses, lighting rigs and stylists who spray food to keep it moist and appetising. Trying to recreate that while travelling and using your general one-size-fits-all travel lens can be challenging! If all else fails, do what the Instagrammers do and get out your smartphone – it's a failsafe for quick shots of food and drink.

Making dessert, Bangkok
DSLR, 44MM, 1/60 SEC, F5, ISO 400

ASSIGNMENT 2

SHOOT A FOOD STORY IN A RESTAURANT OR BAR

- Plan ahead and research where you want to do the shoot.
- Visit or telephone the manager, explaining your assignment.
- Write a shot list and think about the magazine or platform your images might appear in.
- Ensure you have a low-light-capable lens, or that there's enough available light in the restaurant.
- Arrive early for behind-the-scenes moments.
- Use a small set-up if you want to move around during service.
- Check lighting and white balance by taking a few preliminary shots on arrival.
- Monitor shutter speed for capturing movement of hands, or waiters delivering plates of food.
- Open up the aperture to blur out other diners or distractions.
- Photograph in RAW to be able to adjust colour temperature later.
- Take a variety of images, from close-ups to establishing shots.
- Crop in tight for detail and texture.
- Add images beyond your original story idea as things evolve.
- Stay alert to where the action is, and the best angles to capture it.
- Consider focal length, and whether to get closer or further away.

GENERAL ADVICE

- Start early to capture food markets setting up or fishing boats bringing in the haul.
- If a region is known for a particular culinary scene or foodstuff, plan ahead and visit when the owner or maker will have time to see you.
- Include the people involved in every aspect of the production process – factory workers, farmhands and bakers: the list is endless.
- Include at least one good restaurant meal on any trip and take a smaller camera to capture a variety of images, without ruining the dining experience.
- Try to style some shots like a magazine food shoot. Dress the scene and arrange the placement of cutlery, glassware and condiments.
- Think about the interplay of colour, especially in food markets.
- Capture textures by cutting open fruit or getting up close to peel and skin.
- Take a variety of shots as you would for any type of photographic story. Change the orientation, depth of field and angle, and think about how these images tie together.
- If you've previsualised a 'wow' image – maybe a glass of champagne backlit by sunshine or the flames and sparks around a hot coal grill – get your settings ready.
- Think about the white balance inside restaurants and kitchens, especially if you are not shooting in RAW.
- Look for compositional patterns on plates and tables – in stylish or upmarket restaurants the interior design work has already been done, with complementary colours, glassware and furniture.

- Don't photograph other diners without permission – people get nervous if they think you'll capture them wolfing down their lunch. Avoid shooting people with their mouths open.
- Combine aspirational lifestyle images with food and drink at sunset – think rooftop bars or ocean views – and get creative with light.
- Think about the audience for your photographs – lush, jaw-dropping Instagram images or a detailed, realistic photo story in documentary style – and let that determine how you realise your shot list, tying together tone, theme and meaning.

THREE PHOTOGRAPHERS TO FOLLOW
Mowie Kay mowiekay.com
Isabella Cassini isabellacassini.com
Dennis Prescott @dennistheprescott

WILD PLACES

FOCUS ON
ANTARCTICA AND
THE EXTREME SOUTH

O f all the world's continents, it's Antarctica that is its last frontier. Reachable only in warmer months and, for the most part, by ship, it's the lack of permanent human habitation that sets it apart. It also lays claim to a host of superlatives – the coldest, the windiest, the driest – and consists almost entirely of inhospitable ice and polar desert. Yet the geographic South Pole is neighboured by other, slightly more accessible wilderness zones that draw adventurers and photographers to them in droves. Patagonia and the Chilean fjords demand time to experience their remote and otherworldly beauty, as well as practically to travel to and between them. The light that emanates from ice fields and reflects on lagoons and oceans here is what photographers dream of. And the impressive backdrop of peaks from the Andean spine as it slips slowly into the water at the *fin del mundo* creates plenty of dramatic contrasts.

< ICE AND SEASCAPES Perito Moreno Glacier, Los Glaciares National Park, Argentina
< DSLR, 175MM, 1/500 SEC, F11, ISO 200

Living in Chile made getting to the Antarctic Peninsula more achievable than it would have been from Europe, and yet it was still an immense adventure and no little expense, made more difficult by a series of problems that beset us from day one. After departing days later than scheduled we had a necessarily curtailed itinerary (no South Georgia, which still pains me to this day). Two days of suffering the tempestuous Drake Passage – some people didn't leave their cabins, strapped into bunks and moaning deliriously – were immediately followed by calm, and then another storm. Our hopes were instantly dashed by the bad news that followed the good – we were to have one afternoon's excursion to 'swim' in the warm, volcanic waters at Deception Bay and then it was straight back to Argentina to fix a broken water boiler. The chef on board had previously been plucked from a Southern Ocean-bobbing life raft after an emergency evacuation from her sinking ship. She'd certainly experienced the truism that travelling to remote places, even guided and in relative comfort, has its risks. To ease the pain, along with our refunded fares, the captain declared the bar open and we spent the next two days staggering from one side of the former Russian research vessel to the other, either through the pull of the ocean or the booze, happily watching plates smash and waves crash on the bow – somehow no longer frightening.

With my heart still set on Antarctica though, I used the ship's satellite system to contact the last-minute booking office in Ushuaia, and after one night on dry land, I was back sailing the Drake. Six days out of seven on one of the world's roughest sea channels felt like a bit of record, and I still haven't met another landlubber who's done that. Ah, but the difference being accustomed to this sailing malarkey made on day six – no buckling legs, no need for a motion-sickness patch and no sucking lemons as instructed by my father (formerly of the

> And now there came both mist and snow
> And it grew wondrous cold:
> And ice, mast-high, came floating by
> As green as emerald.
> SAMUEL TAYLOR COLERIDGE

merchant navy) when, aged 14, we'd sailed to Jersey in a force nine gale – it took days before the horizon stopped tilting, even after we'd hit terra firma. This time I stood near the bridge and marvelled at the power of the waves and the wandering albatross alongside us – this bird's ability to fly huge distances by soaring on the wind, hardly ever needing to flap its wings, is a rather outstanding feat of Mother Nature.

Standing still on the precipice of the great white continent, completely lost in the moment as ocean, nature and ship coalesced, was one of those rare but sublime occurrences. To travel is, by its nature, to move, and as humans we are built to do so. Yet there are opportune moments when it feels right to just stop – and the Covid-19 pandemic has given us a longer hiatus in which to properly take stock.

The motivation for my journeys to both polar realms was to see landscapes and wildlife far removed from my everyday world. But another, greater, compulsion driving me on, especially toward the Arctic, was the growing threat that the ice is receding and that polar bears might become extinct, perhaps within as little as 80 years.

And now, as I write this in 2021 the world is even more imperilled, the danger of extinction to many species more imminent. Young people like Greta Thunberg understandably feel angry about the state of the world and the generations that came before her to ruin it. But as a teenager I'd felt something similar, supporting Greenpeace and the World Wildlife Fund, hearing stories of climate change, poaching and pollution by fossil fuels – as did my sister and our friends. We have watched as global warming has intensified, with most governments in thrall to big business doing little, despite repeated warnings by scientists of what's to come. It's difficult not to fear for the planet's great wilderness areas – and for all of humanity too, especially in the face of recent extreme, catastrophic weather events.

But not all is lost if we make an immediate, concerted global effort. Quite rightly, that might cause one to question whether it's ethical to even consider travelling halfway around the globe simply to photograph wild places. Perhaps though, we can use our practice for recording more than just beauty – like the collective of photographers

We have lost ice in the Arctic, we have lost ice shelves in Antarctica. When you see all this life and how it is connected to ice, you realise that we will lose all levels of this ecosystem.

PAUL NICKLEN

> When I began, I just wanted to make pretty pictures… but along the way there was somewhat of an evolution. I began to see a lot of problems occurring in the world's oceans, things that may not have been evident to most people. As a photojournalist I sort of felt a sense of responsibility and a sense of urgency to begin turning my lens towards those things. I wanted it to be more like war photography.
>
> BRIAN SKERRY

at SeaLegacy – and in so doing provoke thought and create emotional connections that might make change possible. Many, understandably, will feel happier visiting wilderness areas closer to home, vicariously enjoying the further reaches of our planet through the work of fantastic documentary teams like the BBC's natural history unit and National Geographic.

Like Brian Skerry, we all as photographers travel to places of beauty initially to make pretty pictures. But in 2021 we're at a tipping point where over-tourism, industrialisation and the exponential cravings of

capitalism threaten to take away all that we hold dear. Using our skills as photographers we might just be able to remind those who dismiss the science behind global warming that there are some things worth protecting beyond growth and greed.

What's more, if we can go further, training our lens on the bigger picture, we might discover an altruistic purpose that works in tandem with our own, understandable, visceral desire to experience and record the earth's magnificence. What many of India's religions call the law of *dharma* – a Sanskrit word that explains aligning one's skills and passions with a higher purpose – encourages us to transcend our own experience in the service of something bigger than ourselves. And this, and only this, might prove to be the purest justification for any of us to adventure in wild zones in the future.

The idea to use photography to rally for conservation is not a new idea. It was born in the 1800s when photographers went out to Yellowstone and brought back images to Washington DC, and that gave birth to the national parks. Photography has that kind of power.
CRISTINA MITTERMEIER

It might appear disingenuous to suggest that travelling to the world's wild spaces can help to save them. However, it was seeing Chile's 1,000-year-old alerce trees, a reminder of his beloved sequoias in North America, that put the seed in businessman Doug Tompkins' mind to help create a conservation corridor in Patagonia – and it became his life's work, alongside wife and partner Kristine, to open the Route of Parks. Similarly, Joel Sartore's Photo Ark project has seen him work with *National Geographic* to document the world's wildlife species in the name of education, conservation and habitat restoration – ongoing since 2006.

In 2021, I was a judge for the Explorers Against Extinction's Focus for Survival annual photography competition. The power of a single image to bring about an emotional response cannot be underestimated, yet it can also be amplified by making it part of a wider conservation story. Shine your light on what inspires you, but share your passion for the natural world with those who might never have the opportunity to see what your eyes have witnessed. If you can make that part of your practice, and use your talent to raise awareness about wild places under threat, what better justification could there be for wielding a lens?

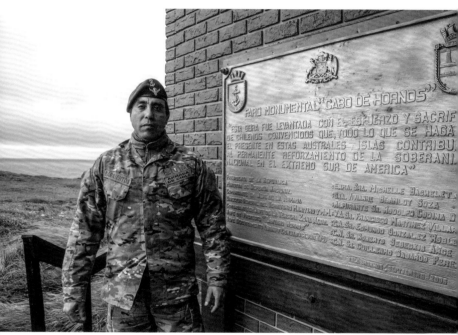

Chilean naval officer, Cape Horn lighthouse, Chile
DSLR, 24MM, 1/60 SEC, F10, ISO 250

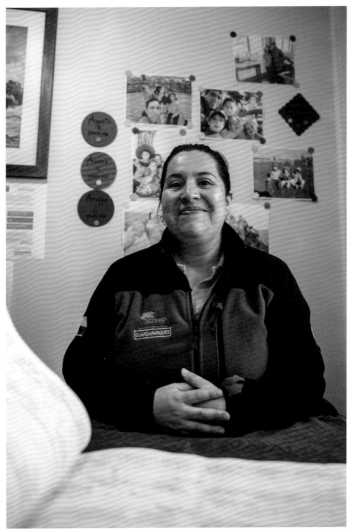

Nataly, Cape Horn lighthouse
DSLR, 28MM, 1/160 SEC, F2.8, ISO 1250

The story of how to cope in isolation is one that might resonate with many of us cut off from loved ones during the Covid-19 pandemic. In 2020 on Cape Horn, I interviewed the then incumbent Chilean naval officer, Ariel Barrientos Zapata, about life in one of earth's most desolate places.

Working regularly with Australis Expeditions in Chile as a photography guide, I've soaked up many on-board lectures about life at the end of the world. But it was talking to Ariel's wife Nataly that gave me a real perspective on what it might be like to live here. With long spells of treacherous weather, expedition ships can't risk veering too close, diminishing the family's opportunities for human interaction and the attendant gifts that bestows – literal offerings of fresh food and sweet treats from captain and crew. Yet, their young family of five – six with Paquita the dog – was at peace with the surroundings and in the swing of homeschooling, long before Covid-19 caused the rest of the world to follow suit.

On this occasion I headed straight to the lighthouse, foregoing the beautiful albatross sculpture I'd photographed previously, a tribute to those who died 'rounding the horn'. I knew the window of opportunity would be short, and the priority was meeting the people living on this infamous isle, where the Atlantic and Pacific oceans collide.

And when time is limited for photographers, it might be tempting to try to speed things along, even push a little too much to get the shot. Being asked to return to the ship just as you're about to set up your tripod is frustrating, yet we have to accept it as part of the job – and if we don't, we risk offending or even gaining a reputation as one of 'those' photographers. However, if I hadn't left Cape Horn immediately I might have had to remain there for at least another week – and the decision becomes an easy one in those circumstances!

ICE AND SEASCAPES

NARROW APERTURE | WHITE BALANCE | BRACKETED EXPOSURES

The landscape skills you've acquired will more than likely be applied to icescapes and mountainous terrain below 50° south. From the southern icefields that flow down into Torres del Paine National Park to the tabular icebergs of Antarctica, capturing the distinctive nature of the extreme south is, as with all photography, about the light. But even on cloudy days, there's something magical in the blues and whites of ice teeth and glacial lagoons. Shoot in manual and use a narrow aperture, ND graduated filters and bracketed exposures to increase the chances of capturing perfectly exposed images in constantly changing conditions. Pay careful attention to shutter speed with long lenses, especially when a tripod might be difficult to set up.

Amid these awful and icy solitudes, no voice was heard but our own. The stillness of death reigned around save only that it was, at distant intervals, broken by the thundering crash, announcing the fall of a distant avalanche, or the rending of the mighty glacier.

JOHN MURRAY

Views of Cerro Torre, El Chaltén, Argentina >
DSLR, 35MM, 1/1250 SEC, F11, ISO 200 >

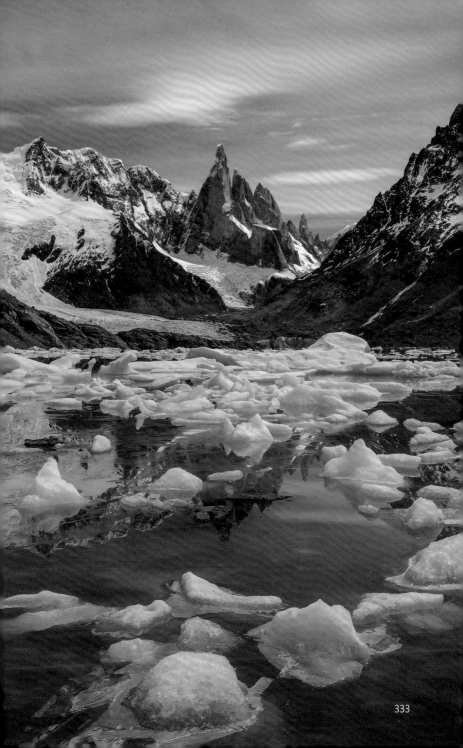

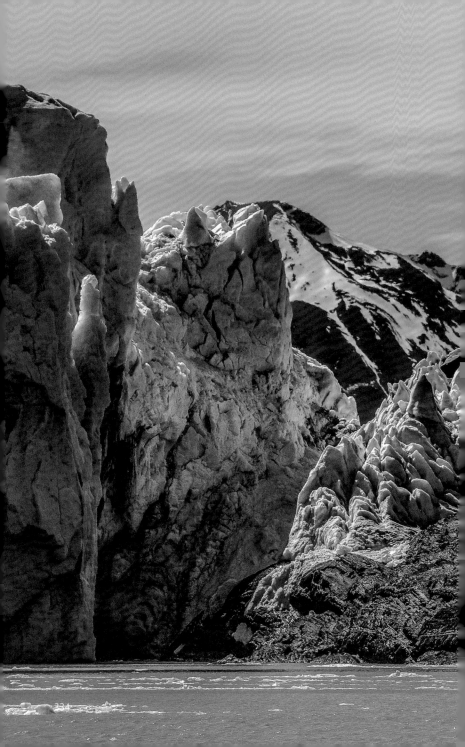

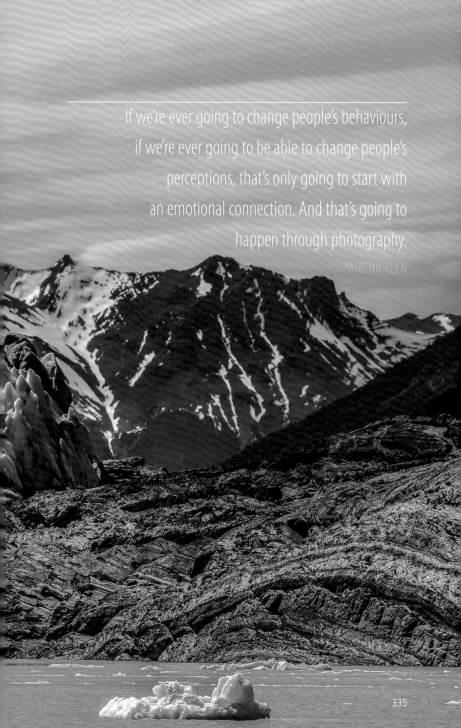

If we're ever going to change people's behaviours, if we're ever going to be able to change people's perceptions, that's only going to start with an emotional connection. And that's going to happen through photography.

PAUL NICKLEN

335

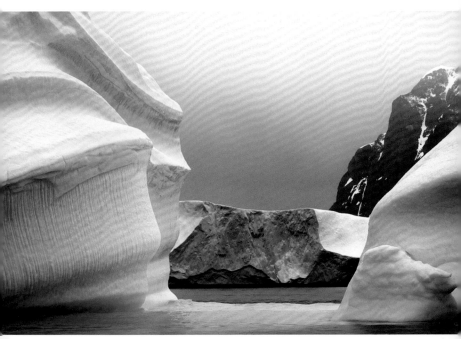

Antarctic ice sculptures
DSLR, 85MM, 1/250 SEC, F10, ISO 400

<< Lago Viedma, Argentina
<< DSLR, 35MM, 1/250 SEC, F11, ISO 100

Antarctica offers constantly shifting perspectives that will blow your landscape photographer's mind, even aboard a moving vessel One of the first awards I ever won was for a single image taken off the deck of ship as we passed a series of icebergs in the mist. Nearly all other guests were inside keeping dry and warm, but the prize I won for staying out on deck paid for the Canon L series telephoto zoom lens I'd shelled out for just before the voyage – certainly proving that you can get dramatic images in any weather if you're properly kitted out and prepared to keep working.

However, rain and mist can obscure the very thing you've come to see, to the point where a photograph just isn't going to happen. On a previous trip in Argentina's Los Glaciares National Park, I set off from El Chaltén on horseback to get to the base of Mount Fitz Roy. After some time, my group left the horses and continued the rest of the steep hike on foot. Shrouded in mist and cloud, but no less majestic for it, the photos I took in the whiteout conditions would not be published anywhere. But we had time to experience the place, to take in the silence and thin air before beginning the descent. Next morning, I looked up from my *café con leche* and saw a blue sky, and the peak of Fitz Roy perfectly framed in the guest house window. And I've since discovered that one of the best views of the entire mountain range is from the road as one approaches El Chaltén – the visitor centre has a pretty sweet view of the peaks too. My photo taken from there has been published more than once, and another prize ensued after I shot the same mountain range from my seat on the return flight to Santiago – never underestimate the opportunities for armchair 'adventure' photography!

HUMAN INTEREST

MANUAL FOCUSING | FILL FLASH | ENVIRONMENTAL PORTRAITS

Bringing your skills and experience of photographing people to bear, you'll be all set to find a human-interest story in Antarctica or the south. Temporary custodians on the island of Cape Horn, scientists at polar research bases and communities in the far south have a multitude of stories to tell. If you have time, try to manually focus and control exactly what you want to be sharp for portraits, dial up the shutter for action and shoot with a wide aperture for creative backgrounds. If using a general zoom lens for all-round photography, work at the narrower end of the range for people to avoid **distortion**. Remember to move subjects into the light or manoeuvre yourself for the best angles, using a fill flash outdoors for extra pop.

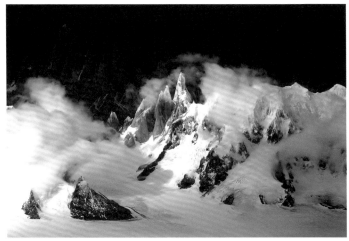

Aerial Fitz Roy and Cerro Torre
DSLR, 155MM, 1/500 SEC, F7.1, ISO 200

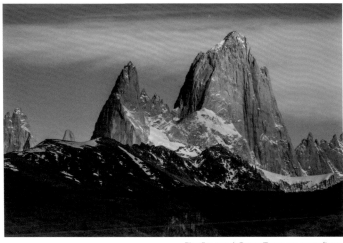

Fitz Roy and Cerro Torre on terra firma
DSLR, 170MM, 1/800 SEC, F11, ISO 200

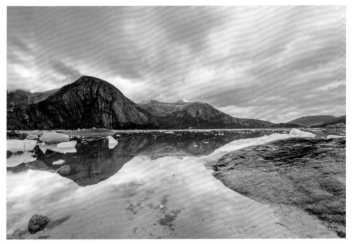

Chilean Fjords, Tierra del Fuego
DSLR, 16MM, 1/125 SEC, F11, ISO 100

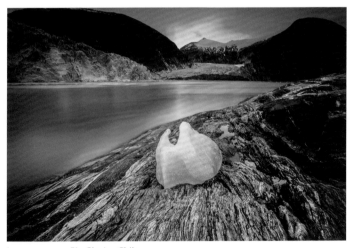

Long exposure Pia Glacier, Chile
DSLR, 16MM, 30 SEC, F22, ISO 200

It's fair to say that images of Patagonia, replete with sun-warmed majestic peaks, shimmering glaciers and jewel-coloured lakes, are the epitome of 'wow'. When the stars align and you're there in optimum light, these pictures can seem imbued with something of the sacred. But with weather there in constant flux, and bent trees the evidence of regularly howling winds, photographers are often stymied. Having a contingency plan beyond the previsualised sensational shots includes the search for stories. Topical themes like Chile's recently opened Route of Parks enabled me to pitch and land a photo-led feature with Adventure.com, using images of Chilean national parks, including Alberto de Agostini and Cape Horn. And even if the story is purely photographic, it still helps to think like a writer, honing your angle and pitching a specific narrative, rather than simply: 'I've been to Antarctica and it was amazing.' For anyone wanting to branch out into travel photography as a career, knowing how to pull a story together will increase your chances of success beyond selling single, spectacular images to photo libraries.

OCEAN LIFE

ANIMAL PORTRAITS | BEHAVIOUR | FAST SHUTTER ACTION

The southerly oceans and channels are teeming with life, and – unless diving in the water with specialist kit – bobbing about above the surface creates the usual problems. By now you're well versed in motion tracking and fast shutter speeds, but for elephant seals and other slow-moving land animals, select portrait settings for close-ups. Anticipate seasonal activity, like Peninsula Valdés's orcas, or visit penguin colonies where the animals will seemingly pose, dance around or leap into the water. Don't forget the story alongside the single images, from relationships and interactions with humans, to humorous action and play. Record sound or footage of the cacophony that invariably ensues, for sensory recall and inspiration when keywording or caption writing once home.

Of all the photographic features I've filed on Antarctica and the Southern Cone, it's invariably the cormorants, penguins and seals that make the photo editor's cut. And maybe that's no surprise, given how popular images of animals are – and the cuter the better, it would seem. Scientists at the University of Leeds, along with Tourism Western Australia, undertook a study that proved looking for 30 minutes at pictures of quokkas (page 23), the small marsupials that inhabit Rottnest Island, dramatically reduced mental stress and anxiety by lowering heart rate and blood pressure. So swell the animal portrait portfolio, alongside hearts!

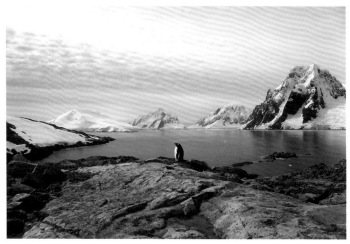

Gentoo penguin, Antarctica
DSLR, 17MM, 1/200 SEC, F9, ISO 100

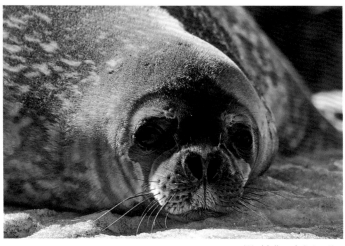

Weddell seal, Antarctica
DSLR, 400MM, 1/500 SEC, F8, ISO 400

During wildlife trips I've noticed there's often an animal whisperer who seems to manifest magical encounters out of sheer will. On the Beagle Canal it was Lori who saw orca in the distance and convinced the skipper of our small sail boat to head in a different direction – resulting in an encounter with a pod at play – and absolute whoops of delight. I still can't believe eleven or twelve of us had a front row seat as the pod, small whelp in tow, breached and frolicked for over an hour. And in Antarctica it was a Kiwi Zodiac driver who had the humpback knack. She was so renowned for it, I'd check which Zodiac she was in before moving to the back of the queue to coincide with her arrival. She'd even take detours on the way back to the ship after excursions, with a gut instinct that there'd be wild things appearing.

In contrast with the orca uproariousness in Ushuaia, this time there was hushed reverence as we sat motionless. The only sounds were the exhalations as three leviathans broke the silvery surface, their briny mist sighing out of blow holes as they gently arched in preparation to return to the depths. With their flukes and bodies so close, the long, expensive lenses bought for just this type of encounter couldn't cope, and we scrambled to change them. This might sound trite, but the experience has lived with me in a more intense, vivid way than any regrets about the better photos I might have taken. I can still close my eyes and hear that breathing, feel our soft swaying and visualise the calm, pearlescent ocean that merged seamlessly with sky.

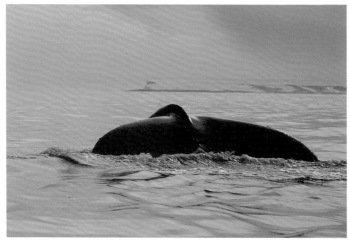

DSLR, 160MM, 1/1600 SEC, F6.3, ISO 400

Humpback whale fluking, Antarctica ^v

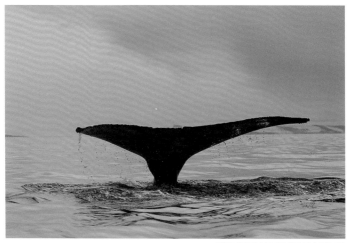

DSLR, 160MM, 1/1600 SEC, F6.3, ISO 400

Tucker Islet cormorants, Tierra del Fuego >>
DSLR, 24MM, 1/60 SEC, F10, ISO 250 >>

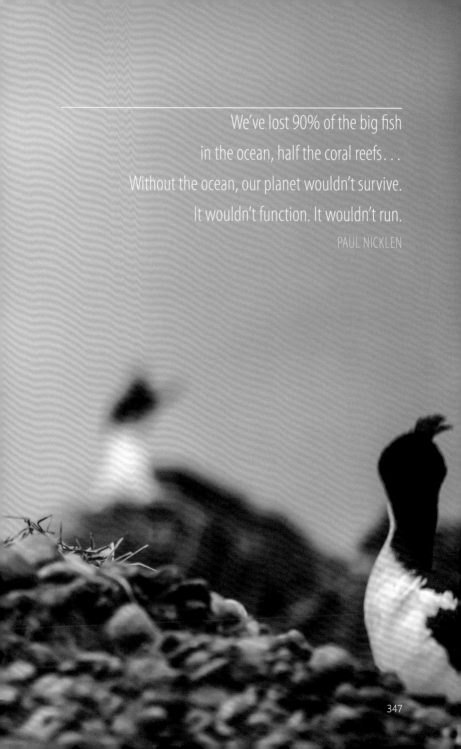

We've lost 90% of the big fish
in the ocean, half the coral reefs...
Without the ocean, our planet wouldn't survive.
It wouldn't function. It wouldn't run.

PAUL NICKLEN

Wulaia Bay, Chile
DSLR, 28MM, 1/80 SEC, F14, ISO 100

Make animals a part of a wider environmental or destination story and show biodiversity through smaller creatures. You'll be on constant alert for breaching humpbacks and hungry leopard seals anyway, but it's the smaller fauna and plants that demand a bit of extra effort, yet speak volumes on the health of our planet. Flower photography has become a genre in itself, and creatively rendered fields of wild flora and grasses make arresting landscapes – as do mossy rocks and shorelines delineated by pebbles or shiny-shelled molluscs and crustaceans.

On treks on islands in the Chilean fjords, the expedition team spend a great deal of time checking on the health of berries and trees, taking water samples and looking at kelp and other sea plants. One guide, Enzo, a keen macro photographer, took the lead on one of our photography safaris, and his perspective on the landscape of mosses and bright yellow lichen was in beautiful balance with the panoramic images of water and land taken by others, some on their phones. When it came to the end of trip show, his images were met with gasps and applause, demonstrating how a unique view and personal way of seeing will always garner attention and praise.

STRUCTURES

GEOMETRY AND STRUCTURES | JUXTAPOSITION WITH NATURAL ELEMENTS

Visiting Shackleton's hut or deserted whaling stations, it is clear that mankind's tentacles have reached even this far. Antarctica's dilapidated architectural structures make for great establishing DPS shots – decaying buildings standing ramshackle against the stark whiteness of ice or snow demand to be edited in monochrome. Shoot in manual to expose for the terrain, and use compositional lines to place a single soul in juxtaposition with looming geometric structures. Get close with macro images of girders reclaimed by moss or weeds, or use the comforts of home inside naval bases or explorers' huts to add detail to the story of mankind's attempt to exist here. Tell a more positive tale through images of research bases where scientists help to protect this last bastion of pristine nature, and include lighthouses or buoys to depict human vulnerability and bravery.

Nothing beside remains. Round the decay
Of that colossal wreck, boundless and bare
The lone and level sands stretch far away.
PERCY BYSSHE SHELLEY

Albatross Memorial Sculpture, Cape Horn, Chile
DSLR, 75MM, 1/400 SEC, F11, ISO 400

Expedition Zodiac and glacier, Tierra del Fuego
DSLR, 160MM, 1/400 SEC, F11, ISO 400

ADVENTURE

UNDERWATER HOUSING | MOTION-TRACKING | REACTION SHOTS

The very adventure of getting somewhere like Peninsula Valdez in Argentina, or sailing the tributaries off the Strait of Magellan is the subject of documentary photography in itself. From kayaking or scuba diving with penguins to taking a polar plunge or camping in Antarctica, the travel pages of national newspapers are full of stories of derring-do. As a photographer you can turn your lens on aspirational adventure, and a series of related images can really do it justice. Look beyond the singularly fabulous photo to combine a set that has progression; Zodiac drivers creating surf for dolphins to leap through, waves crashing over the bow and travellers transfixed as a vessel passes through the sublime Lemaire Strait – all of this using your people in action skills to capture peak moments of excitement and adrenalin.

FOOD AND SUSTENANCE

REPORTAGE | IN THE FIELD | FLAT LAY | CLOSE-UPS

Food stories abound in the far south of Latin America. Take reportage images of local fishing boats moored outside the fish market at Puerto Montt, and widen out the narrative with environmental animal shots of seals wallowing in the shallows, waiting for scraps. Stylishly document what's on your plate through flat lay images of restaurant meals, where patterns, interior design and lighting come into play. Seek out the provenance of local specialities – like calafate berries, Patagonian lamb and centolla, or king crab. Photograph up close the hands of chefs or market stallholders in action, and report on foraging or environmental angles. And if in Torres del Paine or another of Patagonia's national parks, take low-light pictures around the campfire as walkers refuel after a day on the trails – and set the final scene of an atmospheric photo essay on trekking as the sun sets.

DSLR, 30MM, 1/50 SEC, F2.8, ISO 200

Catch of the day: Puerto Montt Fish Market, Chile ∧∨

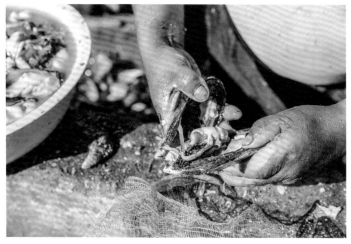

DSLR, 70MM, 1/1000 SEC, F5.6, ISO 200

THE FUNDAMENTALS

EXPEDITION PHOTOGRAPHY

Longer trips in extreme conditions require careful planning as you'll know from *Chapter 8*. Antarctica is as far away as we'll ever get from shops, so be extra prepared, particularly when on assignment. Take a decent second body (hired or borrowed if necessary) and at least one backup lens. Have enough cards, storage devices and cleaning cloths, as well as waterproof bags and good stabilisation. By now you know the drill – make an equipment list before setting off and take the most essential kit as priority, putting large, non-breakable items like tripods into hold luggage to make space in your camera bag.

SHOOTING IN MANUAL

Taking full control of the camera means that you set the shutter, the aperture and the ISO, the so-named exposure triangle, in order to create the effects you want to. You don't need to shoot manual at all times, especially when things are in flux. However, for still moments, landscape and night photography, you'll have begun to see how taking the time to control the amount of light hitting the sensor can pay off for final images. For bracketing, it helps to set the exposure carefully, by metering for the brightest and darkest parts of the scene (see below).

BRACKETING EXPOSURES

In difficult or changing outdoor conditions, using your camera's bracketing system will allow you to take a light, medium and darker image, and if none of them is perfect, work to combine the best of two

or three in your preferred editing software. Ensure you are shooting in RAW, and pay attention to the histogram when deciding how many increments you want between images – measured in thirds of a stop. Doing this will take up to three times as much space on each memory card, so be warned!

METERING

There are a number of ways to read light and exposure from within the camera. Evaluative metering takes a number of readings from within the entire frame, and sets the average exposure value, which is good for landscapes or evenly lit scenes, while centre-weighted average metering reads from a central, single point – good for portraits or centrally framed subjects. More experienced photographers switch between different metering modes, including partial or spot metering for more precise exposure of subjects, especially when in backlit or uneven lighting conditions.

UNDERWATER AND WATERPROOFING

For water-based activity like kayaking or scuba diving, you may want to look at hiring specialist equipment, including lighting. It's quite an outlay to buy underwater housing, especially for a trip where you won't be in the ocean for long. Salt water is the enemy of camera equipment, so ensure you travel with water-resistant cases or rolltop rubberised and hardwearing bags. Wipe down equipment after any Zodiac trips and take lens wipes and absorbent microfibre cloths.

AN EXPERT'S VIEW
PAOLO PETRIGNANI

Paolo Petrignani has been a professional documentary photographer since 1993, and worked with *National Geographic Italia* since 2001. An NPS (Nikon Professional Services) Photographer since 1998 and tutor at the Nikon School Travel, he studied at the Instituto Superiore di Fotografia in Rome. Having always been involved in photo-reportage and speleology, he has taken photographs in many parts of the world and in association with LaVenta geographic explorations. He has documented more than 15 important expeditions beyond Europe, from the caves, forests and deserts of Mexico and the subterranean rivers of southern Asia to the glaciers of Patagonia, Iceland and the Antarctic. He works with Nikon Italia for national and international tourism advertising campaigns. **paolopetrignani.it**

How important is research and planning for expedition work?
In my experience, but probably, I believe, a bit for all photographers that do our kind work, the important thing is preparation. So, maps, books, guidebooks, photos, all these things are useful in order to know and understand the places we're heading off to photograph, even those places close to home. I have always tended to take part in expeditions where there has been a medic present – the destinations can be so remote that in an emergency you couldn't expect to get help quickly.

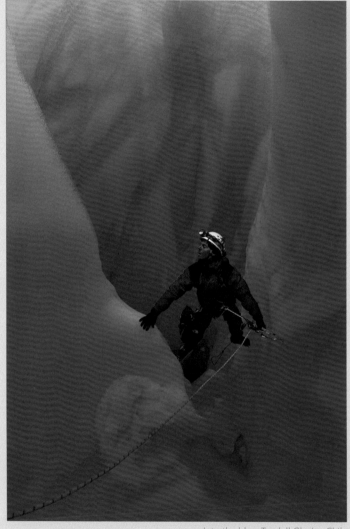

Into the blue: Tyndall Glacier, Chile
DSLR, 35MM, 1/60 SEC, F8, ISO 100

Frasassi Caves, Genga: a *National Geographic Traveller* (Italy) cover story >>
DSLR, 14MM, 0.4 SEC, F11, ISO 400 >>

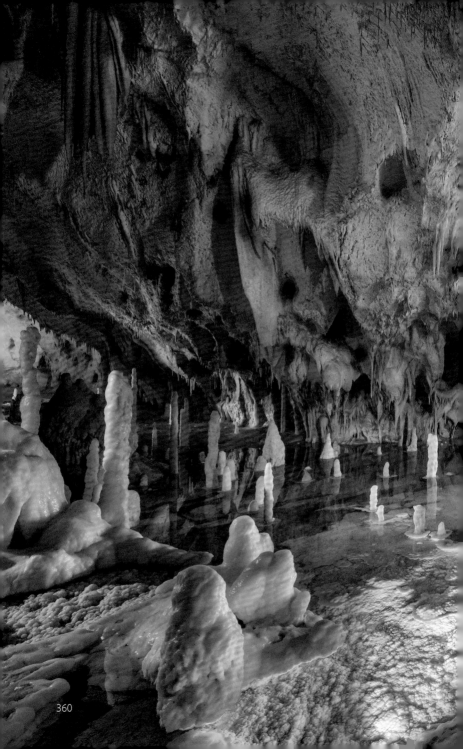

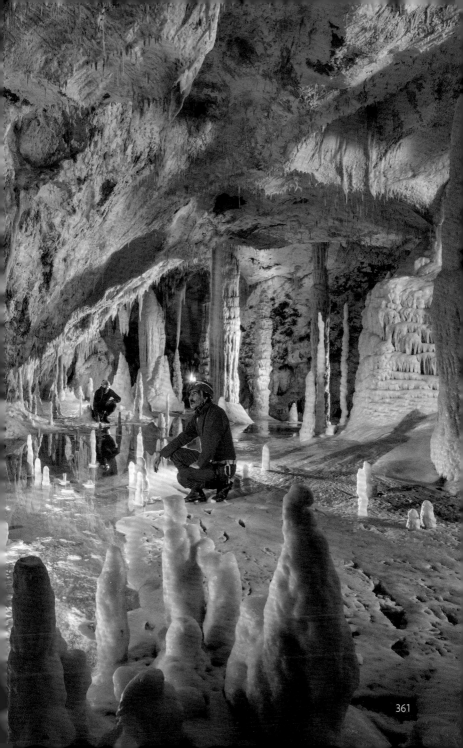

Before taking a shot, spending a moment
to explore the environment around you can
provide a unique opportunity to express
your own creativity.
PAOLO PETRIGNANI

Does expedition photography require different equipment to 'regular' travel assignments?

No, the equipment is more or less always the same, whether you're working round the corner from home or you're on an assignment in some faraway location. The kit we use depends very much on what we're going to photograph. For example, if I'm going to Africa on safari, my set-up will be different to if I'm going to a glacier in the Alps. But in any case, when I travel I try to take a bit of everything, though zoom lenses are the best option, and you should always take the three axes 14–24, 24–70 and 70–200. I love the versatile Nikon 24–70 f2.8 optic – it's exceptional and gives me assurance.

If you are photographing on an expedition of exploration, is it possible to previsualise?

Yes and no. Often you can find yourself with a quiet moment in a really beautiful place where you can set up a few shots, wait for the best light and take some great pictures. Other times, when you're in the thick of

the exploration, it's difficult to replicate that and most of the time you have to just 'capture the moment' and document whatever happens.

What's the most important technical aspect for you to get right in extreme conditions?
First of all, the best light possible in whatever situation I find myself in, after that it's important that the photography is in focus. For me the ingredients of a good photo are a mix of subject (50%), composition, light and emotional impact.

How important do you think your training has been to the success of your career?
My training has been really important. The photography school I went to allowed me to gain experience in a bit of everything, from portraits to still life, from landscape photography to street photography, but then as usually happens, you end up leaning towards the thing most suited to your nature, and I preferred photo-reportage over everything else.

Do you have advice for anyone new to photographing adventure in extreme conditions?
In outdoor photography, you work almost always with natural light and not always at times or in weather conditions that are ideal when the action unfolds.

Always make a virtue of necessity. If there is backlight, for example, to prevent the subject from being too dark, try to use a little fill-in flash. Before taking a shot, spending a moment to explore the environment around you can provide a unique opportunity to express your own creativity. Take advantage of different angles and play with light and headlamps to give life even to the darkest settings.

ASSIGNMENT 1
PHOTOGRAPH A SEA LIFE PHOTO STORY

- If there's a local seal or puffin colony, dolphin-watching tour or nearby bird cliff, book any boat trips or overnight stays ahead of time. Wetlands are a good urban alternative for herons, kingfishers and riverbank wildlife.
- Create a shot list of your ideal six to eight images. Try to show a range of activity, as well as an opening, establishing image and something with detail.
- Choose the appropriate lens for the distance you'll be working at. If it's possible to have both a wide and zoom or telephoto lens, you'll be all set – or take a smaller compact to avoid having to switch lenses frequently.
- Take your seascape or environmental shots with a narrow aperture.
- Prioritise the shutter for animals on the move and aim for some shots that freeze the action.
- Activate the AI servo mode for birds in flight and pan with them for creative backgrounds.
- Look for relationships between animals; moments of affection, territorial aggression or parental preening.
- Don't forget the people on the tour – include reaction shots to cute puffins or human bodies next to chubby seals for scale.

REFLECTIONS

When out in the field on assignment, there's a lot to keep in mind. Being prepared, staying present and dealing with difficult, changing conditions – it can all be hard work. And that's before you factor in the excitement of beautiful animals in the wild!

Choose your best three to five images to review:

- ☐ Do you have a range of images that work well together?
- ☐ Are there standout shots that could be a DPS magazine opener?
- ☐ Are the images sharp and in focus?
- ☐ Did you capture the environment and a sense of place?
- ☐ Are people part of the story?
- ☐ Did you have the right equipment for the job in hand?
- ☐ Did something unexpected make the shoot better than expected?
- ☐ Did you need to change settings?
- ☐ Did you prioritise the aperture or shutter, or work in manual – or some of all three?
- ☐ Are you happy with the way the images work together?

Creating photo stories isn't as straightforward as it seems. It's more natural to keep reacting to what's around you, taking a series of great, but possibly unrelated, individual images. It's when we try to curate a set in the digital darkroom that we often realise we're missing key images that link the narrative together. Pre-planning encourages us to think about the progression and variety of shots, and to keep a story angle in mind when we're working. It might be the hardest part of a new photographer's work, but it comes more naturally the more we're out in the field. Once you've worked with a few photo editors, you soon begin to learn what they want from you.

ASSIGNMENT 2
CREATE A NATURAL WORLD PHOTO ESSAY

- Pulling everything together from each of the key photography types, think of a theme that could form the central focus of an entire photo feature about the natural world.
- For this assignment, you need to work as if you have been commissioned by an editor to provide a coherent story. You should consider key shots – the people involved, any landscapes, wildlife or other points of interest that help create a flow and story, including the built environment and even food.
- Remember to keep the tone and style similar for each image. Check the white balance and colour temperature, and shoot in RAW to allow colour grading later if required.
- Consider the detail, as well as the bigger picture, and think consistently about the theme or message.
- Try to use manual focusing at least once and vary the aperture and shutter priority for speed, light or creativity.
- If you have filters, think about the optimum light for any key landscape images and change your metering to cope with different conditions, varying the mode from evaluative to spot or centre-weighted, and take some bracketed shots for good measure.
- Finally, from all the images you've taken, select 20–30 shots to edit, and order them according to their place in your narrative.

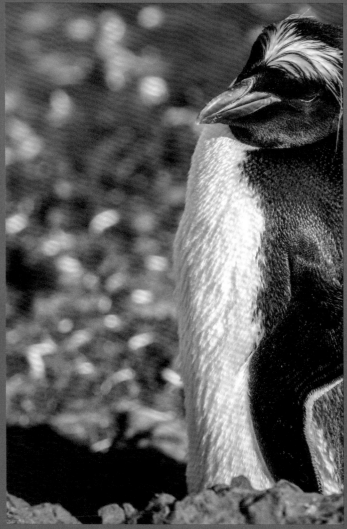

Macaroni penguin, Antarctic Peninsula
DSLR, 260MM, 1/800 SEC, F5.6, ISO 400

GENERAL ADVICE

- Be better prepared than you have ever been for any photographic endeavour! Once you're on the Drake Passage there's no dashing out to get extra SD cards. Write a kit list that can be amended for each trip you make. It's surprising how easy it is to leave gloves, adaptors or card readers behind.
- Make sure you're properly togged up – with layers, good boots, and wind- and waterproof outer shells. Ski googles work well in extreme low temperatures and can be worn over glasses to reduce the effects of strong wind and precipitation.
- Prioritise your equipment, but have a variety of kit for all types of photography. In Antarctica, you'll often be close to wildlife like penguins, so have a range of focal lengths in your armoury of lenses.
- For searching out stories in advance, do your research. See what the big travel and nature magazines have recently covered and check the news. Is there a story waiting to be told?
- Once on the trip, keep your ears and eyes open to new angles. Talk to people and listen to their points of view, recording details later for captions or articles.
- Attend on-board talks, and delve deeper if possible, by interviewing lecturers – download any information that's offered, and do additional research. Record soundscapes and moving images, and keep a short diary of sensory perceptions every day. If you do one day come back to write about a trip or create a photo story, you'll be glad you recorded how you felt at the time – and took down the name of that naval officer.

- Download and back up images as you go, ensuring that your best pictures have been kept safe – most photographers know when they've captured something incredible.
- Keep a portfolio of the best images and sort them into separate, potential story-themed folders.
- Consider your carbon footprint and that of any companies you travel with, reading up on their policies, including green energy and zero waste.
- Tie your passion for photography to drawing attention to measures that will help preserve our wild spaces for future generations.
- Above all, enjoy the wilderness and the ride.

THREE PHOTOGRAPHERS TO FOLLOW

Sebastiao Salgado @sebastiaosalgadofficial
Craig Parry craigparryphotography.com
Joel Satore joelsartore.com

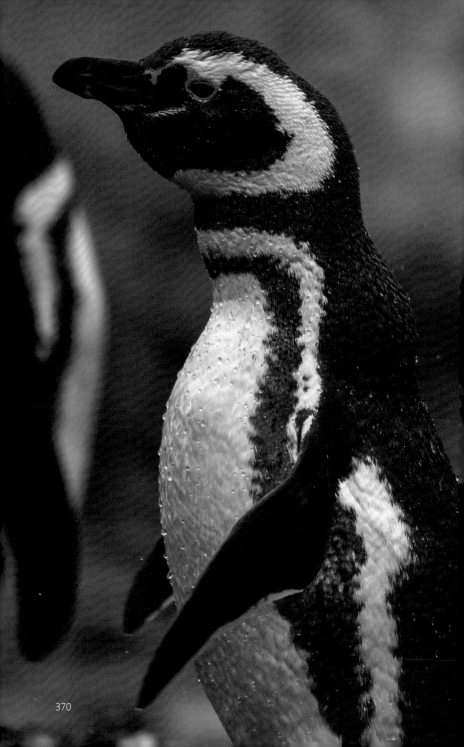

BACK
HOME

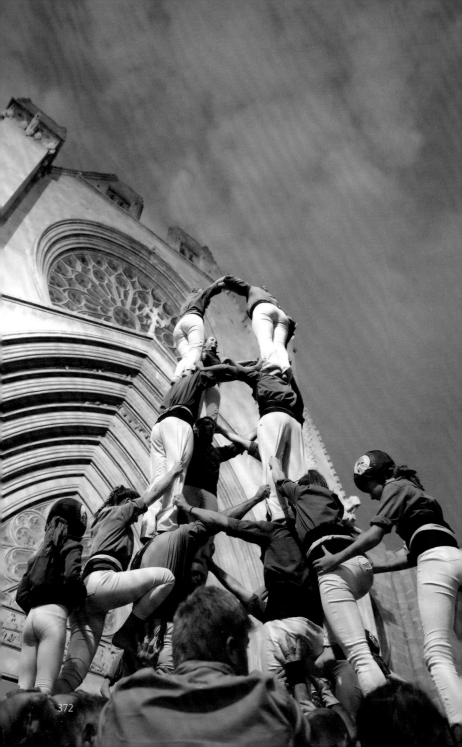

TELLING
YOUR
STORY

Now you're back home with a hard drive full of potentially wonderful images, so begins the 'real' work. It's important that we keep the initial edit rigorous, even for personal accounts where the posting of one weak shot can quickly dilute a hard-won reputation. Stick with your shot list and be mindful of when you might be too emotionally attached to the work – this can result in throwing additional, unnecessary photographs into the mix. Being objective is easier said than done, but less is definitely more when it comes to curating a portfolio.

And even once we've made a dent in things, selecting and editing those photos we consider worth sharing, deciding what to do with them is another hurdle. After all, none of us wants our best work to languish in the shadows. But making the shift from sharing work on social media to getting published by travel magazines and online platforms

< FESTIVALS AND GROUPS Castellers, Tarragona, Catalonia
< DSLR, 50MM, 1/60 SEC, F4, ISO 800

is not always straightforward – and it's probably the advice that's most requested by early-career photographers. In fact, it was the subject of the last National Geographic Traveller Masterclass I co-presented in 2021, when I and my fellow panellists, Lola and Richard, had just an hour to unpack what could have constituted a whole day's training. But while there are many ways to have one's images published, it doesn't always follow that we'll be paid for our work. We might be featured via weekly newspaper competitions and 'editors' picks' or in online photo communities, yet it's still a big leap from getting intermittent exposure and plaudits to actually making photography your profession. Validation is lovely, but we nonetheless need to pay our bills.

IMAGE SELECTION AND EDITING

Many photographers absolutely love the digital darkroom, but I must admit I'm not really one of them. I'm a firm believer in getting the image as 'right' as I can in the camera, then doing as little to it as possible afterwards. That's because years of practice has taught me that taking longer to capture fewer, hopefully fabulous, images is always preferable to a card full of *nearly* great ones that might ultimately take days of my life to 'fix'. And, if I'm honest, it's also because I want to reduce my screen time and be outside in the fresh air.

Having said that, once we become skilled in post-production, we can start to create the kind of jaw-dropping images we're used to seeing on advertising billboards and gallery walls. From magazine photo features and coffee-table books, to tourist-board campaigns and commercial clients – there are many outlets for a travel photographer's work. And each commission will demand a slightly different way of working specific to the brand or house style, the audience in question and the photographer's own preferences. There are expert practitioners

who specialise in highly processed intricately detailed pictures; however, for many travel magazines and photography competitions, only minimal adjustments are acceptable. Always check submission guidelines and entry rules first.

It often seems that many nonphotographers conflate editing with what they consider to be 'Photoshopping' – changing images and 'cheating reality' somehow – yet the editing process is as much about image selection as it is developing shots. After all, from the thousands of photographs we may have taken on one assignment, whittling those down to a folder of 'best' shots takes some time and no little skill. But it's also true that every photographer has to 'process' their work in some way – we go from the RAW 'negative' to the finished, published image in the same way the black-and-white film photographer put her work through a series of chemical solutions. There may be some magic or alchemy involved, but being creative is *definitely* not cheating – let's just call it the dark arts of the darkroom!

We can showcase diversity while also celebrating shared human values. As photographers, we have the power to impact our audience and help them see something in a new light. How will you use that power?

YULIA DENISYUK

Ideally, if we've been working to a shot list, the 'first look' is about grabbing those images we've already pre-conceived. I've certainly found that the more experienced I've become at planning, the easier the post-production process becomes. And, although I find the final edit immensely satisfying – putting the finishing touches to a set of images that hang together cohesively – that initial trawl is often onerous. It makes sense then to have a system that prevents us from getting too bogged down.

The following workflow method suits me and many of my peers, and therefore might provide a good structure for anyone starting out.

BACK-UP

First and foremost, ensure you have at least one back-up of your images before you begin working on them. I usually keep two or three, and I know of several photographers who have additional cloud storage *and* keep copies of their work in an office or relative's house. It might seem a little extreme, but our photos really are the family jewels.

BROWSE, NAME AND RATE

In your chosen editing software, open each folder of images, naming them as you see fit. I've usually created a new one for each location or specific activity as I've travelled, for example '2019 December Perth – Rottnest – Quokkas' and I may tweak the names again to make it easier to locate files later. I tend to work with Adobe Bridge initially, and swoop through, rating those photos I like the look of in terms of composition, colour and light. I search for the best version of key images from the shot list, aiming for at least one portrait and landscape orientation of each. This can be done quite quickly by highlighting choices and clicking on the five-star rating.

5G8A3055.CR2 5G8A3056.CR2 5G8A3057.CR2 5G8A3058.CR2 5G8A3059.CR2 5G8A3060.CR2
5G8A3061.CR2 5G8A3062.CR2 5G8A3063.CR2 5G8A3064.CR2 5G8A3065.CR2 5G8A3066.CR2
5G8A3067.CR2 5G8A3068.CR2 5G8A3069.CR2 5G8A3070.CR2 5G8A3071.CR2 5G8A3072.CR2

Selecting images for a story ∧∨

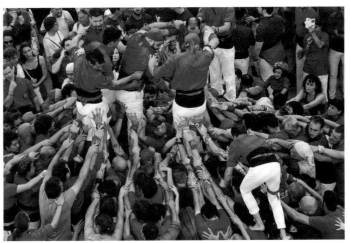

DSLR, 115MM, 1/100 SEC, F11, ISO 320

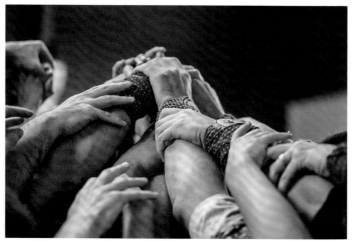

DSLR, 100MM, 1/320 SEC, F2.8, ISO 2500

Linking by colour palette ∧∨

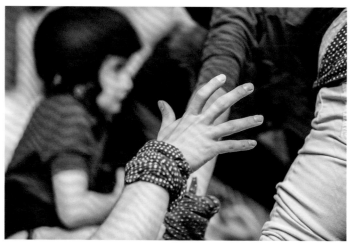

DSLR, 100MM, 1/100 SEC, F2.8, ISO 1250

A CLOSER LOOK

For any images you're not sure about, go back and enlarge them, checking for focus, detail and emotional impact. Add to the mix if you're happy, or remove the five-star rating – I sometimes give three or four stars to the 'not-sure' candidates, especially if they're images I don't love immediately, but know might work as part of a wider story. Any photographs that stand out beyond the shot list get thrown in as well.

KEYWORDING AND COPYRIGHTING

I will not tell a lie, I only keyword and caption 'best' images when I'm working on a commission or sending a photo out via email or on social media. It can be time consuming, but if **SEO** or selling to picture libraries is your goal, adding relevant information to the **metadata** is super-important. How many and what words you choose is down to the subject matter and job in hand, and there are many online tutorials to get you started. It's important to put your copyright details into the metadata too, especially if these will be sent as **cold pitches** or competition entries. Many photographers like to **watermark** their work, but as these are quite easily removed, it's wise to only post **low-resolution**, small files where possible.

CONVERTING AND PROCESSING RAW FILES

Now you have your hundred or so 'best' choices, you'll likely want to open each of those starred images in your editing application, checking for sharpness, **distortion** and dust spots. I usually do a very quick RAW conversion, sometimes as a **batch process** for key words and some individual adjustments here and there for **highlights** and **shadows**. With each batch, add a name to identify them, while keeping

the original file name in the metadata (to allow for quick searches of original files later – though most new software programmes keep the original names safe). I mostly convert images to TIFFs to keep a history of layers and **lossless compression**, and only save as JPEGs once I am ready to email a pitch (page 400) or share on social. **File and image size dimensions** can be adjusted, along with **DPI**, and you'll notice that TIFFs take up a great deal of space on your hard drive, so be prepared!

THE DIGITAL DARKROOM

How much you develop your images after the selection process is a personal choice and the details of how to do this could probably fill an entire second book. There are many manuals and tutorials to investigate if it's something that interests you – when I studied digital photography in Chile much of my course covered this, and it was an important step on the way to becoming a professional photographer.

These days, people are well versed in the vernacular of photo editing from the controls in their smartphone photo apps. Turning up the **clarity** or adding a filter is common parlance, thanks to Instagram and Twitter, though perhaps we don't always notice that filters are adjusting **tone**, **colour palette**, **dynamic range** and saturation, as well as adding **vignettes** or **blur**. For our purposes, it's important to have at least a basic knowledge of what we ourselves can do to enhance our shots.

Tweaks to white balance, highlights and shadows, clarity and sharpness are typically part of the editing process but should be kept to a minimum. Similarly, with **vibrance** and **saturation**, the amount of colour depends on when they were shot and in what lighting conditions. **Colour grading** can help to pull a cohesive story together, but it's better if we work with images that were originally shot to hang

together, rather than 'retuning' the **hues**. It can also be tempting to dial up the colour, especially if you shot on a lacklustre day, and of course this is a personal preference. There are publications that favour a desaturated look for travel, and others that like things to 'pop' – and with every few years that pass, what's in vogue changes. Look at the work you're producing and try to keep a consistent style, without falling into the trap of overprocessing (we've all been there). If you have **bracketed** images, you may want to work on a **composite**, where blending or layering the best parts of two photos can result in perfect exposure. Use **spot healing** brushes or **clone stamps** to remove blemishes, and enlarge images to at least 200% to check the sky for pesky dots (then get your sensor cleaned if you find any).

ARCHIVING

Finally, for any unrated or unused photographs, it's important they're retained in their RAW format. It's easy to have overlooked great images, especially when you're working to a deadline, so don't delete anything unless it's out of focus or horribly overexposed. Simply thinking it's a bit bleurgh isn't always a reason to put a photo in the bin. You might just be asked if you've any images from XYZ, and it's surprising what you discover a year or two down the track. Editors also request additional photos once you've submitted your personal choices, and it's often the images you don't think are your best that can make a story work. As there's never time to fully enhance every RAW file from the probable thousands you captured, it's always worth doing a further trawl once a bit of time has elapsed – fresh eyes can make a difference to your relationship with the work. For me, that's when I'm at my most objective, and less invested or emotionally attached to what I initially considered to be the 'better' images.

AN EXPERT'S VIEW
RICHARD JAMES TAYLOR

Richard James Taylor is a freelance photographer specialising in travel and location photography. His work has taken him around the world, shooting features for leading publications including *National Geographic Traveller*, *Conde Nast Traveller*, *Travel+Leisure* and *The Sunday Times Travel Magazine*. Richard also shoots commercial assignments for Belmond, P&O Cruises, Pernod-Ricard and various international tourist boards. Richard is an ambassador for LEE Filters and regularly runs tours and workshops abroad and in his native North Norfolk. **richardjamestaylor.com @richardjamestaylor**

What's the optimum amount of time you need in a destination?
It really depends on the nature of the shoot. A city-life feature could probably be covered in a couple of days; however, a feature spread over a wider geographical location obviously needs longer. On average most of my assignments take anything between a week and ten days, which is usually enough to cover the story in detail and work around any poor weather conditions. I tend to do a lot of the organisation beforehand and will usually draw up a final itinerary before leaving home, which I will use as a basis for the shoot while on location. In general, interiors, portraits and any necessary food shots tend to be scheduled for the

Icelandic horses in the Kolbeinsdalur valley, Skagafjörður
DSLR, 200MM, 1/200, F6.3, ISO 400

Magnus Andresson reunited with geldings after the Laufskálarétt round-up
DSLR, 100MM, 1/400, F5.6, ISO 800

View across the majestic Skagafjörður bay, north Iceland >>
DSLR, 165MM, 1/25, F11, ISO 200 >>

383

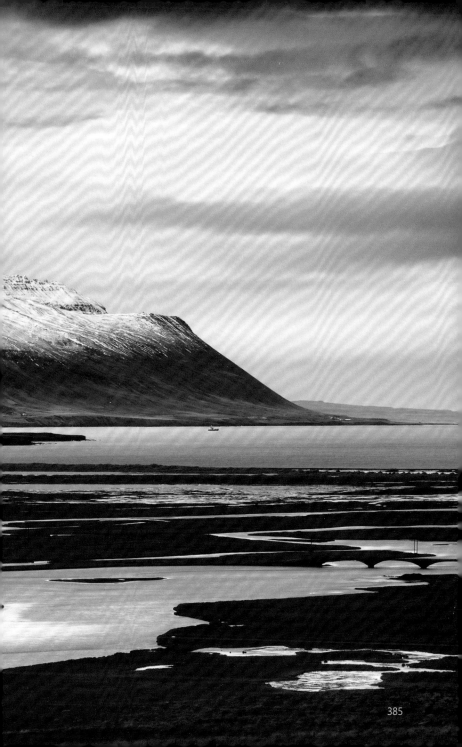

middle of the day, leaving the good light around sunrise and sunset for any exterior location shots.

Are there are any particular types of story you prefer to photograph?
Anything that involves people doing interesting things in interesting locations! I love meeting the locals, seeing where and how they live, and understanding their customs and traditions, so anything along those lines always appeals to me. While I enjoy beautiful landscapes and exploring new locations, it's always the people you meet along the way that live longest in the memory once home.

Would you agree that creating a cohesive story is one of the most difficult things to do for early career photographers?
Definitely! When shooting a travel feature, it's important to remember that the photographs should be more than just a collection of pretty pictures. They should be a visually cohesive set of images that illustrate the story you're trying to tell, preferably in an original and interesting way. It's crucial to maintain a consistent visual style during the shoot in order to pull the images together so that they look like they all belong to the same story. This can be done in a variety of ways, such as shooting in consistent lighting conditions, shooting everything with a shallow depth of field or finding a colour or other theme that runs through your shots. It takes experience to be able to visualise how the final shoot will look in the final layout and work towards that, rather than just shooting anything that catches the eye at any time.

How important is the editing process in pulling a story together?
The aim of any edit is to find the strongest images that best represent each element of your story and to present them as one cohesive

narrative, so that the picture editor, and ultimately the reader, can follow it. Therefore, the edit is critical in finding the images that best represent your story from all of the thousands you might have shot.

What advice would you give to a photographer who wants to embark on a career in travel photography and storytelling?
The most important thing you can do is to get out there and shoot! If you want to be trusted to shoot an assignment you have to show that you can do it, so set yourself assignments and shoot them as though they are real. Work in a visually consistent way and have a final layout in mind, even put one together yourself. In this way the thought processes you need to produce a good feature will become second nature to you and help set you up for a successful career.

I have to make sure I can cover a lot of different subjects so I always like to be prepared. Once on location, if weight is an issue, I try to take just the relevant kit for what I will be shooting that day.

RICHARD JAMES TAYLOR

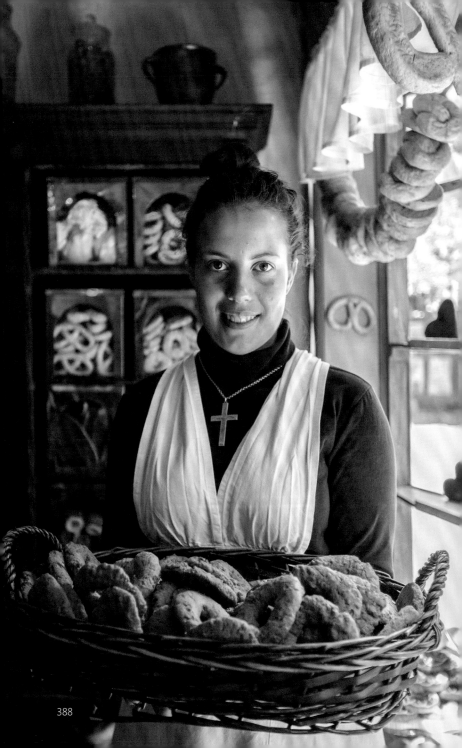

GETTING PUBLISHED

Despite there being many, varied routes into the industry, and several ways in which to work, it can be tough to make photography a full-time career. In this era of ubiquitous digital imagery, photos have become devalued as the market becomes increasingly saturated. Online platforms freely share pics under the banner of **creative commons**, and photo editors can source very cheap (or sometimes even free) images through tourist boards and picture libraries. Though the quality of readily available photos can vary wildly, as a professional travel photographer you'll inhabit a world where you're often being undercut on price. And there's a bigger discussion to be had around representation through the use of **stock imagery** – rather than commissioning the work of a photographer on the ground, 'ready-made' photos are often more aspirational and promotional in style, and thereby arguably less 'authentic'.

This might all sound a bit bleak and off-putting, but if the lure of travel photography is still strong, nothing should stop you! Start small, with free competitions and single-image entries, even exhibiting your work in intimate spaces like local cafés. Begin to build your reputation through consistently good work on social media, or take the plunge and pitch a photo story to a travel publication. Work like a travel photographer even before you become one and continue to develop your competencies with webinars or photography courses. Travel on photo tours, employ a professional to provide one-to-one tutorials or attend local events. And don't underestimate those little wins and competition shortlists along the way – they're stepping stones that will lead to the next stage. How far you travel on that road depends on you.

Apparently, there were once halcyon days where photographers could earn a decent living on the back of a few good images in a

< Portraits add human interest
< DSLR, 35MM, 1/200 SEC, F2.8, ISO 640

Do not talk about giftedness, inborn talents!
One can name great men [and women!]
of all kinds who were very little gifted.
They acquired greatness, became 'geniuses'. . .;
they allowed themselves time for it, because they
took more pleasure in making the little, secondary
things well than in the effect of a dazzling whole.
FRIEDRICH NIETZSCHE

photo library (not during my career, sadly). And, although there's long been talk of print going out of fashion, it's been my experience that the burgeoning array of paying, digital travel platforms has more than made up for any that might have fallen by the wayside. There are certainly more photographers out there trying to hustle for a bite of the cherry, but with new sites and independent publications popping up, there's always somewhere to place a story. Do your homework and you'll find a host of global print and online magazines that favour photojournalism. I choose to work with those I know and trust, but it does take a while to build relationships and contacts, so bide your time and work on amplifying your skills, profile and name.

Photo spreads from *National Geographic Traveller* (UK) ∧∨

Travel photographers often supplement their work, and it's worth thinking this through – commercial clients, events, weddings and portraits can provide a steady stream of income, while many, myself included, also work as writers, educators and photography tour guides. In the epoch of the gig economy, it's quite likely that one could photograph part-time, holding down another, possibly unrelated job, to keep the wolf from the door. I've also met many bloggers who offer photography as one of their 'content production' skills, alongside video, public appearances and podcasts. If you're that way inclined, it seems that the world of paid partnerships can make the influencer's job a lot more lucrative than the photojournalist's. I have to say, it's never been for me, and I'm not really one for posing in a floppy hat – but if I did have one, I'd doff it in their general direction as they seem to be rocking the travel world.

GET NOTICED

Not everyone will want to turn professional or even try to earn money from their photography. But if you're keen to share your work, here are some tips to help you get started.

ENGAGE ON SOCIAL MEDIA

Through your own carefully curated social media account, website or blog, you'll probably already have had some good feedback. Don't be put off if you don't have thousands of followers yet – the most important thing is to keep it professional, put your best foot forward and engage with others. Many magazines and newspapers want to share great content, so it's worth tagging those you're interested in working with – they'll also start to recognise your name over time, which will be advantageous if you ever decide to pitch for work.

Telling The Tulip Flower Story ∧∨

NETWORK

It's not so much *what* you know but *who* you know, so the saying goes. Put in the hours and mingle where you can at book signings, travel shows and photography talks. Attending events is another way of immersing yourself in the industry, and while you're being inspired, you just don't know who you might be rubbing shoulders with. When I speak at National Geographic's Masterclasses and similar events, the audiences are invariably peppered with serious photographers, there to sharpen their skills *and* make connections.

FIND YOUR NICHE

Many photographers have a style or subject matter they're associated with. While none of us wants to be pigeonholed, it does help if your Instagram has a consistent look or you have a specialism, for example wildlife, on which to focus. Most of us want to keep our options open and be able to work across all photographic genres, yet we'd be lying if we didn't say there were one or two areas that really get our juices flowing. And I think it shows when photographers have been following their bliss, be it food or astro. When I'm truly in the moment and every cell of my being is beautifully aligned with the job in hand, my work is so much the better for it.

ENTER COMPETITIONS

There are many people out there who describe themselves as award-winning and it may sound like too much trumpet-blowing. However, getting a stamp of approval can really help to propel our names into the world. Competitions are often beneficial when you first start – both to hone your skills and get your work into online galleries and exhibitions. They're not for everyone though, especially when entry fees

Wanderlust Icon Winner, Istanbul
DSLR, 28MM, 1/125SEC, F10, ISO 400

Competitions and awards can hold many benefits,

but I think it can also cause one to become

distracted and competitive for the wrong reasons.

NANCY LOVA

are high and lack of success can be demoralising. I work regularly as a photography judge and know how much effort and skill is put into each entry – as well as the different tastes and subjective preferences that need to be overcome to find a winner! Take care too that you're not signing over the copyright, and always read the rules and submission guidelines. Still, at the beginning of your career, you have little to lose by throwing your hat into the ring – while for seasoned photographers, it can be a wonderful accolade to receive a professional award, perhaps moving our work to the next level.

SELF-PUBLISH

Blogs, books and calendars are perhaps a more rewarding option for the non-competitive photographer keen to publish and develop their craft. You'll learn what works with different aspect ratios, from the layout of a landscape calendar, including the choosing of images that are worth looking at for a whole month, to selecting related photographs that hang together as a series. It can be an expensive operation, however, and being invited to 'show' your work usually requires mounting and framing it yourself. That said, selling even one print can be a milestone for any photographer, and trading through a website works for many of us as an additional income stream.

KEEP LEARNING
WORKSHOPS, COURSES AND TOURS

If you haven't previously studied photography, it's a good idea to take a few classes, either through online courses, photography tours or workshops. And even if already established, you can still improve your workflow skills and learn through the experiences of other photographers. Most big camera companies run in-house tuition, and educational

establishments like London's Central Saint Martins offer longer-term courses throughout the academic year, or shorter, more intense programmes during the summer and other university holidays. As a photography guide and tutor, I can recommend a number of excellent operators, but not all tours and guides are created equal, so do check out reviews or travel with a reputable photographer or organisation. A good starting point is to look for trips run by someone you admire, then search for online testimonials from previous participants.

PHOTOGRAPHY EXHIBITIONS

Attending photography exhibitions, whether to see the work of amateur competition-winners or the photojournalism of World Press Photographers of the Year, can be both educational and cultural. What's more, you'll likely have the chance to chat to camera brand representatives, sign up for a portfolio review and possibly find a mentor, even an unofficial one who might provide occasional support and cheerleading on social media. It's also nice to move away from the screen and see images as they were meant to be viewed – enlarged, printed and displayed to their full glory.

> My advice to anyone wanting to be a freelance photographer is to take a marketing degree first. The technical side of photography isn't so difficult. Making a living from it is harder.
>
> LISA YOUNG

WIDER READING

From the number of expert interviews and quotes throughout this book, it's clear there is a range of voices and people worth following up on, but probably too many to list here as a full bibliography. Another reason to participate in workshops and expos is to hear experts speak, buy their latest books and simply be inspired by word-of-mouth recommendations from fellow photographers. I have everything from coffee-table glossies to technical tomes, usually bought after attending fascinating talks. Read travel, wildlife and outdoor magazines that are chock-full of advice and interviews to pique your interest and enrich your knowledge. The UK has some brilliant monthly photography journals, and a year's subscription to one of these is akin to taking a further education diploma in photography, once you put into practice all the advice on offer.

KNOW THE MARKET

The best way to understand what travel publications want from photographers is to read them! Start with a subscription to your number one magazine, and think of it as a short course in style and content, familiarising yourself with the regular sections and types of images – from the single DPS and illustrated feature to fully fledged photo essay. Look at tone and stylistic preferences, and avoid pitching recent topics, themes or destinations. It's very unlikely an editor will want to commission a similar idea, and you'll have wasted your valuable time – demonstrating also that you haven't done your homework. Websites will usually provide contributor portals and sometimes useful submission guidelines, so check those out as well. If it's your first time contacting an editor, get your ducks in a row.

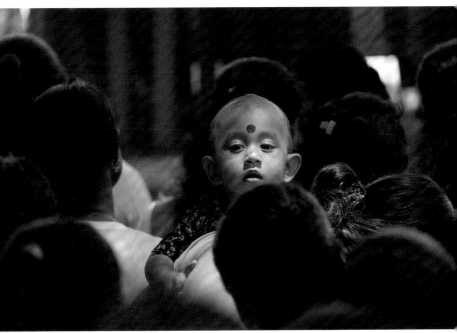

Standing out in the crowd, Sri Lanka
MIRRORLESS, 200MM, 1/40 SEC, F4.8, ISO 200

PITCH

With the courage to begin sending your work to photo editors, it helps to have curated a contact sheet or PDF with a story in mind. Going beyond the single images for 'big picture' newspaper sections or one-off shots, you'll need to make certain the edit has a cohesive narrative or thematic links. Think about the range of shots you've chosen – from establishing, wide and environmental to close-up and medium, covering people, places and nature. This entire book has highlighted the variety and types of images that work in travel photography, and it's no exaggeration to say that if you can nail the initial pitch through your selection and editing of consistent shots, you'll make a picture editor sit up and take notice.

And as an amateur photographer, you have nothing to lose by sending in work regularly. Rejection only hurts once you're professional! Seriously though, success is about resilience and grit, so keep going, and continue throwing grapes at the wall – eventually one will stick. If you don't hear back within a week, it's fine to follow up with another email or two, though there is, of course, a thin line between 'reminding' and being a pest!

Most writers and photographers allow a little time to pass, before repackaging and sending on to an alternative publication – and so on, until it lands. Always try to find the name of the commissioning editor and keep it brief – mention the angle, why you can tell this story and its relevance or topicality. For time-sensitive pieces, aim to pitch well in advance, or at least make it clear that the date is looming. A pitch might look something like the example opposite.

To travel is a natural urge, and to photograph a 'new' world is a beautiful thing. If we can get paid for this labour of love, then that just might be the cherry on the icing on the cake!

Dear _____,

A journey through Tierra del Fuego by sea passage
Rediscovering the Strait of Magellan

I wondered if you would be interested in a photo story that ties in with the 500th anniversary of Magellan's sailing of the Pacific to Atlantic strait in November 1520.

I lived in Chile for many years and have sailed the Strait of Magellan six or seven times, including twice in February. I am a UK-based writer and award-winning photographer, working regularly with *National Geographic Traveller UK*.

For travellers in search of adventure, Patagonia and Tierra del Fuego offer unrivalled landscapes and abundant wildlife. The Strait of Magellan can be navigated in some comfort with a number of small ship expeditions, travelling from Punta Arenas in Chile to Ushuaia in Argentina, by way of many of the world's most remote fjords, mountains and hanging glaciers. The fact that it was 'discovered' thousands of years before by indigenous peoples who lit fires and inspired the name, Tierra del Fuego, adds another dimension to this remote wilderness.

I have attached a few representative photos in a contact sheet, along with some links to my work below.

Please let me know if this might be of interest.

Kind regards,

Nori

AN EXPERT'S VIEW
BEN
WELLER

Ben Weller is an American photographer, writer and educator living in Japan. Ben began his career in photography as a graduate student in journalism at Indiana University. He has spent much of the past 15 years working in Japan and South Korea, covering stories for international news, travel, and trade publications. His travel work has appeared in *National Geographic Traveller*, *Virtuoso Life*, and *Lufthansa Magazine*. Ben's work focuses largely on people in action. He looks to capture real moments of people in their environment in ways that bring their stories to life. **@culturechromatic**

When choosing a photography project, what is it that inspires you?
I'm really interested in showing other people's passion. A strong human element is important in the work I do, so I'm looking for people doing something that they love. This infuses the images with energy and life, which in turn helps the audience connect. I'll look for people doing interesting things – sports, cooking, art or a craft – and try to make that the focus of the story.

Is there any kit or lens that you couldn't do without?
It feels that way sometimes, like I absolutely need a certain lens or a flash to get the image I want. But the reality is that you're never going

Lone surfer at Kugenuma Beach, Fujisawa, Japan >
MIRRORLESS, 12MM, 1/320 SEC, F4.5, ISO 160 >

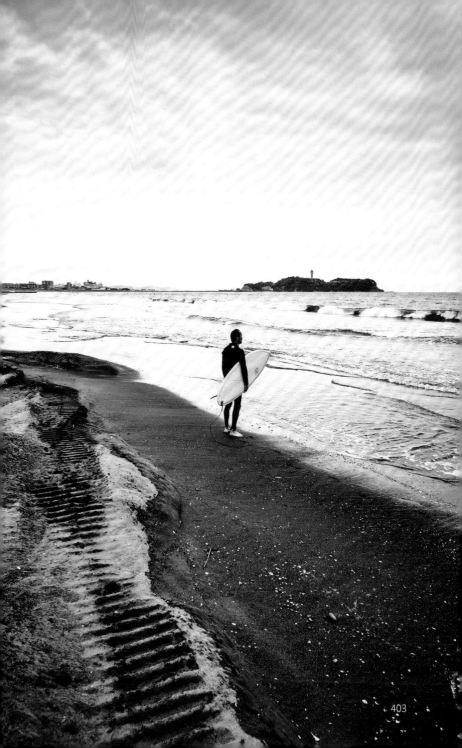

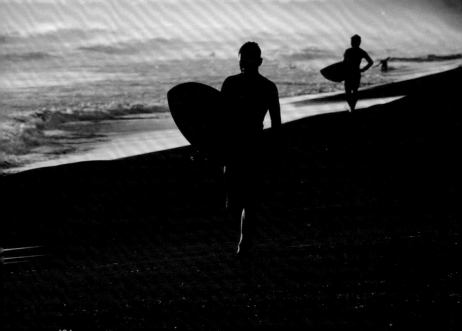

At night, if I'm not shooting, I'll usually be backing up files, captioning, typing up my notes, and cleaning gear before I get to bed. I don't expect to sleep much or have much downtime on assignments. This work is really demanding, physically and mentally. It's important to get rest when you can, to eat right, and give yourself a bit of mental processing time.

BEN WELLER

to have all the latest gear, or be able to carry it all in the field. You have to learn to work with what you have and not let gear get in the way. A wide, fast prime, 24 or 35mm, can go a long way in most situations, but I've also had images from my phone published in major travel magazines. It's better to get skilled and comfortable working with the kit you have than constantly adding more.

Do you move between aperture and shutter priority, or work in manual mostly?
I used to be a big fan of aperture priority, and I know a lot of photographers who prefer that style of shooting. I'm quite comfortable now shooting in full manual mode, but I think that just comes down to preference and habit. I don't think there is a right or wrong way, and it will always depend on the situation, the action, how quickly the light is changing and your vision for the image. Don't ever listen to someone who says pros only use manual – it's unlikely the person making the statement is a professional. In this job, it's the results that matter.

< Kugenuma Beach at dusk, as Mt Fuji towers in the distance
< MIRRORLESS, 130MM, 1/1250 SEC, F5.6, ISO 800

How do you decide which images to select for a photo story?

I work with a shot list whenever I'm on assignment. I will make sure to have wide establishing shots, medium shots, action shots, and details. For people, I'll usually include posed portraits as well as more candid environmental portraits. For landscapes, I might try to include some drone images, and pictures with and without people. In terms of orientation, I want a good mix of landscape as well as portrait, and I'm always on the lookout for the banger – that really killer shot that has opener, double-page or cover potential. Variety is key, but also consistency in terms of colour, style, and mood.

Has your photojournalism training been important in your career?

Photojournalism was really my introduction to photography, so I've never been that interested in the single image. It's more about the story, the people, the places that appear in my pictures. Keeping those elements front and centre, I think, helps me create images that have impact. It's the story that makes an image or set of images memorable. My images are real too, not setups, not overly processed or manipulated. That's central to photojournalism, and again, I think it just contributes to the overall power of the image. I've been fortunate to work with and train with some world-class photojournalists. It's not just the technical aspects that I learned from them, but their experiences from the field.

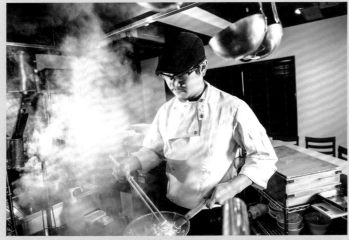

Chef Kuzamasa Saito at Nakiryu, Toshima, Tokyo, Japan
DSLR, 24MM, 1/60 SEC, F4.0, ISO 640

Malacca spices, Malaysia
DSLR, 24MM, 1/125, F3.2, ISO 3600

407

PLANNING FOR AN ASSIGNMENT
SHOT LISTS | PHOTOGRAPHY DAY SHEETS | VISUAL STORYBOARDS

Filmmakers have a number of different templates for working on location, from shooting scripts to the more logistical production call sheets. In addition to a shot list, I often end up drawing a rough storyboard of key images in my notebook, usually during downtime, waiting in an airport or while travelling by train. Seeing the intended photo essay sketched out really helps to imprint the story I hope to get in my mind's eye, and I don't usually need to refer to it much afterwards.

Don't be in a hurry, stay longer, delve deeper, peel away the layers - there's a story in images there waiting.

SUSAN BLICK

SHOT LIST

LIST KEY SHOTS WITH LOCATION | COVERAGE | COLOUR PALETTE

SHOOT/CLIENT		LOCATION PAMUKKALE		DATE JULY 24-31, 2019	
DAY ONE					
WEATHER SUNNY		**SUNSET** 20.01		**SUNRISE** N/A	
WAKE-UP CALL N/A		**MEAL BREAK** N/A		**EST WRAP TIME** 21.30	
DATE/TIME	LOCATION	NO.	TYPE OF SHOT	DETAILS	NOTES
Weds eve, Day 1	1 Pamukkale Travertine terraces	1	Establishing, wide angle, landscapes, with people. DPS opener.	Sunset 1 and recce. Leave hotel 18.00 latest. Need entrance ticket from Aliye.	No telephoto. Filter kit & tripod.
Contacts Meet Aliye at north entrance, 18.30. **Transport** Taxi to north entrance. Book for 18.15.					
DAY TWO					
WEATHER SUNNY 38° MAX		**SUNSET** 20.01		**SUNRISE** 06.04	
WAKE-UP CALL 05.00		**MEAL BREAK** 14.00		**EST WRAP TIME** 21.00	
DATE/TIME	LOCATION	NO.	TYPE OF SHOT	DETAILS	NOTES
Thursday AM Day 2	2 Hot air balloon ride	2	Establishing, aerial	Dawn. Get balloon inflating if poss.	Alternative opener.
		3	Action	Pilot? Guests? Packing away.	Get some verticals & film/ sound.
Thursday - mid-morning	3 Pamukkale town	4	Environmental portrait	Café/shop owner, interior, direct address.	Try to recce on Weds.
		5	Environmental action	Making coffee, serving food.	
		6	Portrait	Posed portraits.	
		7	Close-up detail	Hands in action.	Take flash.

PHOTOGRAPHY DAY SHEET
ITINERARY | CONTACT DETAILS | DAILY TIMINGS | WEATHER AND LIGHT

A more detailed itinerary with approximate times and locations, plus a few key shots and any contact details is another good way to keep everything in one place. Add scribbles the night before to plan your equipment for the next day and amend as you continue through the shoot. Once you begin working this way, you'll find a system that suits you, and devise your own planning methods.

SALES, RENTALS AND SERVICES

In the UK, we have a range of photography specialists like WEX and events such as the annual Photography Show in Birmingham. In Perth, Australia, I usually attend Photo Live Expo every August, where punters can get hands-on with kit, even flying mini drones and testing the latest bodies, while discounts last for the duration of the show, sometimes even beyond it. And if you want to go even further and really try before you buy, renting a lens for a couple of days might give you the reassurance you need before parting with thousands of pounds. Used gear can be picked up from reputable organisations too, and Fixation in London will clean your sensor in a jiffy while you peruse the shelves of recently added, pre-loved stock. Ask around, and find out which shops and services photographers recommend in your local area. Online forums and review sites are a great way to hear about latest equipment, with price comparisons and detailed, expert reviews.

PHOTOGRAPHY DAY SHEET

ITINERARY DAY 2 OF 7	DEST TURKEY	DATE JULY 24-31, 2019
PHOTOGRAPHER NORI		CLIENT NGTUK

EQUIPMENT/BASE	WEATHER	Wake Up Call 04.00
Return to pick up equipment/ mobile all day/ hire car? **AM** Just need wide kit **PM** Pick up tripod before	Wind 15 SW Visibility Clear Min temp 21° Max temp 39° Sunrise 06.04 Sunset 20.01	Meal Breaks 13.00 ish & 19.00 Rest break After balloon Est wrap 19.00
Evening Near hotel/restaurant recce. Take 50mm.		

LOCATION	SCENE DESCRIPTION	TIME	NOTES	CONTACTS
Hot air balloon ride	Dawn. Aerial scenes, wide establishing. People/Action Pilots, pax.	05.00 - 07.00	Ticket paid. Receipt in phone. Hotel pickup.	Balloon company – Mehmet C.
Pamukkale town	Turkish coffee. Food and drink, staff and clients. Lunch?	11.00 - 13.00	Haven't done recce. Onur looked ok on Google. All walkable.	Check local blogger accounts.
Top of terraces	Museum and Hierapolis - amphitheatre, sculpture and architecture.	15.00	Do Cleopatra's Pool, or recce for tomorrow?	Interview with museum curator/ visitor? Call ahead.
Near hotel	Restaurant/night scenes (recce for tomorrow?).	18.00 - 20.00	Do restaurant recce for tomorrow.	Sort out chef interview for tomorrow/Sat.

CONTACTS	TELEPHONE	EMAIL	TIME AND MEETING PLACE
Mehmet C		Pamukkale@balloon.com	Hotel. 05.00
Aliye – Tourism XYZ		Aliyen@pamutours.com	? Call in am.

AN EXPERT'S VIEW
NANCY
LOVA

Moscow born Nancy Lova is a travel photographer currently residing in Kent, UK. Nancy gravitates to places that hold great meaning, often with a personal story or connection to herself. Much of her work is influenced by Indian and Arabic cultures with European twists. Prior to this, she worked in the property industry. Nancy's work can be found in print and online publications such as CNN Travel, *National Geographic India*, *Condé Nast Traveler* and *Travel + Leisure*. **nancylova.com @nancylova_**

How did you get your quite recent break in travel photography?
I firstly remained consistent with my posts on social media so that my name became more familiar. Secondly I ensured my website was strong but simple in order to let my photos do the talking. Lastly, when I became confident, I began pitching to the names I envisioned myself working with - there were a lot of rejections in the beginning though but that was understandable as I was just starting out. Again I remained consistent with my pitches and didn't let the rejections get to me. Eventually I managed to get my first online feature with *Condé Nast Traveler* and then a print feature with *Travel + Leisure*.

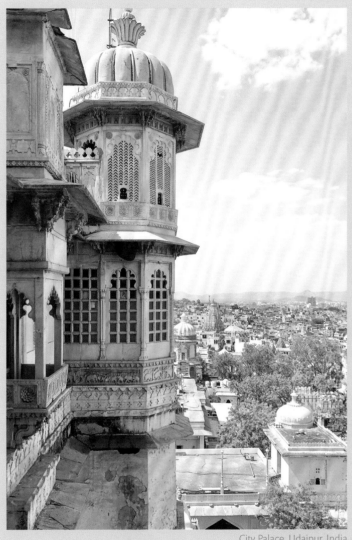

City Palace, Udaipur, India
SMARTPHONE, 28MM, 1/2400 SEC, F1.8, ISO 20

When photographing places, I tend to look for somewhere with bold colours and fine detail. Keeping the colours true to the subject is important to me as I like my photos to look natural and realistic.

NANCY LOVA

Lake Pichola from Leela Palace, Udaipur, India
DSLR, 18MM, 1/800 SEC, F4.5, ISO 200

415

Is it fair to say that much of your work focuses on photographing cities and culture?

I adore places that are rich in culture and tradition. Anything with too much glitz and glamour, I often try and stay away. Historical landmarks and houses of worship tend to be my go-to as they display the dominant religion of a place and have many stories to tell. They often provide captivating shots too. I love markets also in order to capture colour, culture and the lifestyle of locals.

Do you ever use a smartphone for travel photography work?

For my work, I mainly use my DSLR but at times, I still use my iPhone as it can be more comfortable for close ups and simple shots. Some images that I have used in articles just so happened to be taken on my iPhone and worked out really well but overall, my camera is my right hand. The shift was difficult at the start - DSLRs are heavier and need time to get used to, but once you get the hang of it, they're pretty easy to use.

Do you think having a social-media presence is important to getting noticed, and is networking or collaboration to be encouraged?

Definitely. Social media is free marketing and I've had opportunities come about simply from someone seeing my posts and stories on Instagram. I can't keep up with all the platforms: Instagram is all I use and is a great way to meet new like-minded people, and create new work and ideas. I've never collaborated with anyone although I'd love to for the right project.

What's the best part about working in travel photography and travel writing, and do you think it helps to be able to do both?

There are so many positives in travel photography. I'm constantly learning about new cultures and places, and each bit of work feels like escapism. I didn't intend on getting into travel writing: my initial intention was just photography but it kind of just happened. I was often asked to write about my experience of a place so then eventually I thought, why not do more of this and pitch my own ideas?

What advice would you give to someone inexperienced who wants to break into the world of travel photography?

Find what it is you love about travel photography and use that to influence your work. Don't look at others and their achievements or try to be like them: everyone's journey and style is different. Enjoy what you do and travel within your means - travel doesn't have to require lots of money being spent on trips. Lastly, be consistent with your pitches, social-media posts and let your camera be your best friend, because practice makes perfect.

> Find what it is you love about travel photography
> and use that to influence your work.
>
> NANCY LOVA

APPENDIX

TECHNICAL GLOSSARY

L
ike many industries and creative endeavours, photography has its own particular lexicon. Though too much jargon can be a turn-off, these shared terms, once mastered, enable us to shorthand what we want to say – a good thing really, when 'portable document format' is a bit of a mouthful! Of course, it's far better to learn these by osmosis, soaking up information in practice and bite-size pieces, rather than by rote or out of context. Once you've completed a course or photo tour, the language and what it means for your craft will start to become embodied in your physical practice, rather than something you need to remember or think about.

The following explanations of emboldened terms in the book are beginner-friendly, and just enough of what we need to get involved in the conversation. And for those who love the technical stuff, get your geek on with camera manuals, blogs and photography shows.

AI SERVO

See *Servo mode and autofocusing*, page 428.

ASPECT RATIO

Simply put, aspect ratio is the relationship between the width and height of a photograph. Camera models have different sensors which produce images in specific ratios, for example 4:3, where 4 identifies the width and 3 the height. When printing or sharing images online, the aspect ratio of the camera's sensor means photos may not always be compatible with paper or screen sizes, and there may be some resizing or cropping required. It's important to think about orientation when framing a shot, especially if you prefer the look of square images on Instagram.

BATCH PROCESSING

In Photoshop and other image editing software, it can save time to work on an entire folder at once. This might be to rename images or convert them from TIFFs to small JPEGs. More advanced batch processing can involve other elements of photo processing, but usually images will need to be processed individually if you plan to use them for professional purposes. Select all and add your copyright or keywords to the metadata in seconds.

BLUR

We all know what is meant by blur, and in photography that can often be the unintended result of camera shake or a not-quite-fast-enough shutter. But blur, when intentional, has many things to offer – creatively opening up the aperture to allow for a shallow depth of field, prompting the viewer to gaze solely on the subject in the frame, or employing motion blur (page 426) for greater, dramatic effect.

CLARITY

In image editing software programmes, the clarity slider is similar to the contrast one, dialling up the tonal range, but adding more punch and definition to the edges in particular, rather than simply the highlights and shadows.

CLONE STAMP

Along with the **spot heal**, the clone stamp is a useful way of removing blemishes or dust spots. Select a neighbouring part of the image and copy the pixels over, taking care, especially with skies, to enlarge the image and check the repair is seamless.

COLD PITCHING

When sending a pitch to a commissioning editor you've never met, make sure you've got their name right, and check submission guidelines on the publication's website. It's possible that your email could go directly to a junk folder, so allow about a week and follow up. If you still don't hear anything, send another polite reminder, and then assume they've passed on this occasion. Don't be afraid to come back to them with a brilliant, new idea. The more you pitch, the more familiar your name will become.

COLOUR GRADING

During image processing, it's possible to gently adjust gradations of colour through specific elements of mid-tones, highlights or shadows. This is a subtle way to create a more cohesive colour match and palette if working on a portfolio, but it needs to be done with care. With colour grading, it's possible to make very small tweaks, rather than a global adjustment that will change the colour temperature of the entire image.

COLOUR PALETTE

In general, the colour palette is the gamut of hues within the photograph and can be applied across a whole portfolio of images. If the colour palette is wide-ranging between each photograph, it will be difficult to make a photo essay hang together. Consider the palette of your shot list, locations and the time of day before shooting to reduce the need for drastic colour editing afterwards.

COMPOSITING

A composite is a photo created by blending two or more images in a natural-looking way. Often a better, slightly underexposed sky from a bracketed image might be added to the foreground of an exposure-bracketed middle image. However, for designers, layering and blending images can achieve more creative, even surreal, effects.

CONTACT SHEET

Contact sheets are created easily using image processing software, usually through the automate or tools functions. By producing a single sheet of images, saved either as a JPEG or PDF, you can generate your own presentation, demonstrating the variety of shots you have without inundating an editor with a batch of single images. Go further and design a PDF in InDesign, adding captions and a heading, with photos laid out as you imagine they'd work as a spread.

CREATIVE COMMONS

From licenses that allow creators to share their work without changes, to permitting collaboration and editing with credit given to the photographer, this developing area of digital commons has opened up a world of sharing beyond the usual licensing laws.

DISTORTION

The combination of lens, sensor or focal distance, can often result in distortions in images. For example, we may notice with tall buildings that vertical lines begin to converge inward, or that the horizon appears curved. Specific lenses work better for some jobs (for example, a tilt-shift to keep straight lines for architectural work) and less well for others (for example, super wide-angle lenses and portraiture).

DPI

Dots per inch or pixels per inch tell us the resolution of an image. Depending on the camera sensor, DPI determines the maximum size an image can be printed at while retaining quality. This means that we save images at the highest DPI for print and publishing.

DYNAMIC RANGE

From blacks to whites, the dynamic range of an image is the mix and number of shadows, mid-tones and highlights. In the histogram, we can see how much of a range there actually is. A very dark image would show more of the graph bunched to the left, and in a photograph with a high dynamic range, there would be both whites and blacks, and everything in between.

ESTABLISHING SHOT

Usually used as a double-page spread (DPS) or opener in a magazine feature, in the film industry an establishing shot is usually the first frame in a new scene. It allows the viewer to know where they are, thereby 'establishing' the sense of place. Intentionally remove them from a series of images and focus in on the abstract or macro to create a non-linear or non-narrative creative portfolio.

EXPOSURE BRACKETING

Choose your camera's bracketing options and select additional exposures outside of the recommended setting. You can adjust this yourself, and most people choose to start with a third of a stop on either side, depending on the conditions.

FILE AND IMAGE SIZE

The size of a file is how much space it takes up (for example, 500MB) and will often depend on what you save it as. The image size is to do with the photo's dimensions, in other words the length in pixels of its width or length. You could have a large image that's saved as a small file, and vice versa. If you're asked to send a 'small file' and are unsure what that means, ask for details – you're likely to be given a maximum file size, say of 1MB. As you save it in Photoshop or similar, you can see how large the image is by previewing it. On social-media platforms, large files are automatically compressed, while blog and website templates provide specifics – for example, maximum pixel length on the longest edge.

FOCAL LENGTH

Focal length is the relationship between the lens and the sensor when the subject is in focus. Measured in millimetres, we're all familiar with the notion of 24mm lenses or 100–400mm telephotos. It's the focal length that affects the angle of view, giving us a wider field of vision when the focal length is shorter, and a smaller area captured when the converse is true, and looking through a longer lens. Get to know your own lenses, and see what photographing the same subject at different increments on a zoom lens does to the size and angle of the subject and frame.

HIGHLIGHTS AND SHADOWS

Highlights and shadows are the areas of a photo that are often tweaked first in the digital darkroom. If you have exposed a photograph well, you should still have pixels, and therefore detail, in the highlights. If you haven't, the image will just be pure white where it's clipped, and there's nothing you can do during the edit to change this. With detail, however light, you can dial the highlights back a little if the image is too bright or contrasty.

HISTOGRAM

Get to know your histogram, especially when shooting in live view mode. You'll notice when an image is too bright or dark, alongside the exposure indicator, when the detail of the graph is bunched towards either side. The histogram is a good indicator of the dynamic range of what you're photographing.

HUE, SATURATION AND VIBRANCE

Along with saturation and vibrancy, adjusting the colour hue when you process an image can change its overall temperature, making it warmer or colder as you increase the green or magenta. Don't be heavy-handed with this, as it can it render the photograph very different to reality, resulting in a rather unnatural colour palette.

JPEGS AND TIFFS

What's important to know about JPEGs and TIFFs, apart from the obvious fact that the former are smaller and easier to upload, is that the latter are lossless, so you can save them time and again without losing quality. There are many other formats to save files as, so look at your image processing software for the benefits of PSD or PNG.

LIGHTING

Since photography is always about the light, it's no surprise that most professional photographers rely on a number of devices, in addition to natural and available light. Hot-shoe mounted, dedicated flash units link up to the camera's exposure metering system, while a number of off-camera, remote flash triggers or continuous LED lights can provide fill, directional or backlight. Foldaway reflectors are useful when travelling – compact enough to put in a backpack, but worth their weight in gold when bouncing light to fill shadows or subtly enhance a subject when a flash might be too much. And for portraits, Rembrandt lighting is a style used by studio photographers to emulate the artist – with side-lighting that creates shadows and a small, subtle triangle of light on the subject's cheek.

LOSSLESS COMPRESSION

There are several file formats that retain detail once you've worked on them. The lossless compression capabilities of the TIFF make it a favourite for professional photographers, while JPEGs flatten any data and continue to lose quality each time they are adjusted. Always try to photograph in RAW and save as TIFFs or similar when editing, using JPEGs only to reduce space in shared documents or online galleries.

METADATA

Important information can be embedded in a photo's metadata, including copyright details or keywords. When you open an image in processing software, you'll also see that the image contains the EXIF or camera data, including focal length, metering and exposure modes. Click on the metadata label in Lightroom, Adobe Bridge or similar, and type in additional information, such as captions or keywords.

425

MOTION BLUR

Motion blur entails slowing down the world, creating images that are similar to double-exposed film negatives. Creatively slowing down the shutter, we can create light trails from stars or the headlights of moving vehicles. Keeping the rest of the frame in focus with a tripod-mounted camera, we allow a waterfall to flow through the frame. Or we can pan, following moving animals to retain a face in focus, but with limbs and background rendered in translucent layers. Romanticism is created when flowers blow gently in the breeze.

NEUTRAL DENSITY FILTER

Neutral density or ND filters, work like sunglasses, filtering out light and allowing bright scenes to be toned down. They come in gradations of shading, and are measured in stops of light. Usually, photographers have a number of darker to lighter filters for different conditions and creative work. A graduated filter will be half clear, and half dark, with varieties where the border is 'hard' or 'soft' – perfect for sitting on the horizon line and keeping detail in the sky. Filters can be screwed directly on to a lens, or slotted into a holder that can hold more than one at a time, to combine effects.

PDF

Portable document formats are an easy way of flattening a design for sharing. For example, you might prepare a mock layout of how you envisage a photo story, with captions or text boxes. Not only is this a good way of sharing ideas with a commissioning editor, but it will also refine how you think about layout, and how photos work together, leaving negative space for headings – so you've also done a bit of the thinking for the picture editor.

ORIENTATION

Working with both portrait (verticals) and landscape (horizontals) orientation allows us to vary both the framing and composition, as well as create layout possibilities for magazines. Certain subjects lend themselves more to one or the other, but by switching things up we can draw the viewer in or open up the designer's options. Obviously, how we shoot depends largely on the platform's format, with square being a favoured crop for Instagrammers.

RESOLUTION

As discussed under DPI and sensors, the resolution of an image depends on the camera sensor you shot it on, and how you chose to convert and save it. For our purposes, we just need to know that when a picture editor asks to see a folder of low-resolution images, you need to save them at 72 DPI and as small files. For printing purposes, you'll save them in the maximum size and format, so probably 300 DPI and as TIFFs.

SENSOR

The camera's sensor is what converts light into data, so its size and type make a difference to price and the quality of images. From CMOS and APS-C, to medium format and full frame, sensors are always being compared by image size to the old-school 35mm film. You may sometimes hear photographers discussing the 'crop factor' of certain sensors, so this might be worth paying attention to when purchasing a new body. With each new iteration of a DSLR or bridge model, sensors are becoming more sensitive with scope for more megapixels (one million pixels – worked out by multiplying the pixels on the vertical and horizontal axes). When we see medium-format cameras

and brands like Phase One or Hasselblad with 100MP CMOS sensors, we know there's going to be immense quality, but also a price to match.

SEO

Search engine optimisation is another area of the dark arts, which involves those lovely algorithms and keyword data. If it floats your boat and you want a blog or website to come out top in search engines like Google, then do some research or, better still, hire a specialist to give you some advice on keywording and caption writing.

SERVO MODE AND AUTOFOCUSING

Known by its full name of AI Servo to Canon photographers, the servo mode is an AI continuous focusing programme that helps to keep a moving subject in focus. As it's programmed to search around looking for something to latch on to, it won't work as well in a frame full of moving subjects. However, for motion tracking of key subjects, like wildlife or moving people, activate the camera's artificial intelligence and allow it to keep up with movement. One shot AF remains fixed on a subject, so it won't refocus for moving things, while AI focus AF switches between one shot and AI servo – another choice if you can't decide whether you need servo or one shot!

SHOT TYPES

In cinematography and stills, different shot types have been abbreviated for ease. From ECUs (extreme close-ups) to establishing shots (wide, horizontal and scene-setting), it's the variety of focal distances and angles (low, high, aerial) that create flair and originality. Conversely, keep to a particular style, like the flat lay, top-down photo, for a cohesive Instagram food story or creative portfolio.

SPOT HEAL BRUSH

Use your editing programme's spot heal brush or **clone stamp** to remove blemishes, and enlarge images on screen to at least 200% with full brightness to check the sky for pesky dots (getting a professional sensor clean later, if necessary).

STOCK IMAGERY

Simply put, 'shooting travel stock' is producing images that can be sold by picture libraries and agencies to clients on any number of exclusive or time-limited releases, for which the pay will vary accordingly. Some photographers have their own libraries and sell directly.

VIGNETTING

If using filters on a wide-angle lens, you may notice that the corners of images are often much darker. Vignettes can be removed in processing, though they're also available to add as filters, creating an opaque, oval-shaped frame, reminiscent of old studio portraiture.

WATERMARKING

Adding a physical copyright symbol with your name and year to an image, however subtle, can be an effective way of keeping work identifiable online. It won't prevent downloads, but is worth doing if pitching to a publication you haven't worked with before – ensuring high-resolution images are not used without your knowledge, and that your name will remain prominent, even years down the track.

ACKNOWLEDGEMENTS

It's been a round ten years since *Wanderlust* magazine gave me a commission to photograph the wild, Red Centre of Australia. Seeing my photographs splashed across several double-page spreads and exhibited on canvas and huge hoardings at London travel events was all I needed to spur me on. And in the previous two years I'd been runner-up and a finalist, so it's fair to say *Wanderlust* had a big hand in launching me into travel photography. Listening to feedback from the judges every year honed my skills, and, over the years, *Wanderlust*'s Lyn Hughes has proven to be an inspiration, not least through her work with the Latin American Travel Association.

This book probably started ten years ago, as I began travelling on specialist photo tours, rubbing shoulders with some wonderful photographers and tutors. A trip to Bhutan solidified my love of cultural storytelling, full immersion in a destination and travelling with local guides, while a specialist tour of the Arctic with like-minded photographers and wildlife specialists sealed my fate for seeking out adventures alongside mindful considerations of climate and conservation.

More recently, it's *National Geographic Traveller* magazine in the UK that has given me a platform for my photojournalism. From photo stories on the Netherlands' flower culture, to illustrating features on Denmark and Seville, I have to thank the wonderful team of editors and designers for improving my work in their process of image selection. Events like The Masterclasses have helped me hone my explanations of photography practice, and connected me with an audience of similarly enthusiastic and talented photographers the world over. To all the editors and

designers I've worked with, from *BBC Travel* and *Telegraph Travel*, to *Times Travel*, *Love Exploring*, *Rough Guides* and Adventure.com, thank you for continuing to commission and publish my passion projects.

In Chile, a country I once called home and where I studied photography after becoming hooked on capturing Andean culture and landscapes (hence, my Twitter handle @andeanimaging) I've been fortunate to regularly work on board Australis small expedition ships. It's come full circle since I moved there in 2004; from backpacking around with a camera in Patagonia, to becoming a tutor there myself. In that time, I've joined the British Guild of Travel Writers, and got to know many in the travel media, some of whose words adorn these pages.

Thank you to all who contributed to this book, but in particular the expert photographers: Lola, Jordan, Harry, Polly, Paul, Mark, Paolo, Ben, Richard and Nancy. Thank you for offering your time, your words and, of course, your inspiring photos. And to my London film students, your creativity often takes my breath away.

To my wonderful editor Anna, it has been a joy and a hoot to work with you – (we are two, pedantic, pernickety peas in a pod) and to Pepi, our talented designer in Tuscany too – what a pleasure it has been to produce a book on a male-dominated profession with two awesome women. You together are the dream team. Any errors in the book can most definitely be laid at my door.

Finally, thanks to friends and family, but most especially to my parents, Delia and Dervish, for providing support, for giving me my own mixed cultural heritage to explore, and for inspiring me by travelling halfway round the world to settle in what's now my second home, Western Australia. The pandemic has kept us apart, but you've still been with me on this writing journey. You are always in my heart.

Nori, September 2021

'A unique and completely invaluable guide to the dark arts of travel writing. Highly recommended.'
William Dalrymple

'The most complete, accessible
and inspiring book of its kind.'
Colin Thubron

The Travel Writer's Way: Turn Your Travels Into Stories
by Jonathan Lorie

TRAVEL TAKEN SERIOUSLY

bradtguides.com/shop

BradtGuides @BradtGuides @bradtguides